Welcome to the *EVERYTHING*® series!

These handy, accessible books give you all you need to tackle a difficult project, gain a new hobby, comprehend a fascinating topic, prepare for an exam, or even brush up on something you learned back in school but have since forgotten.

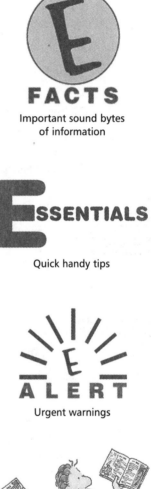

FACTS
Important sound bytes of information

ESSENTIALS
Quick handy tips

You can read an *EVERYTHING*® book from cover-to-cover or just pick out the information you want from our four useful boxes: e-facts, e-ssentials, e-alerts, and e-questions. We literally give you everything you need to know on the subject, but throw in a lot of fun stuff along the way, too.

ALERT
Urgent warnings

We now have well over 100 *EVERYTHING*® books in print, spanning such wide-ranging topics as weddings, pregnancy, wine, learning guitar, one-pot cooking, managing people, and so much more. When you're done reading them all, you can finally say you know *EVERYTHING*®!

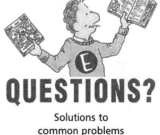

QUESTIONS?
Solutions to common problems

THE
EVERYTHING ®
Series

Dear Reader,

While researching and writing this book, I discovered a little secret I'd like to share with you: You don't have to be a techie to have fun with digital photography. I've come to realize that it's possible for anyone to enjoy the instant gratification and creative freedom that digital photography provides.

In the last few years, digital cameras have been significantly improved so they're easier to use—and more affordable—than ever. You're sure to find one to suit your needs and your budget.

Even if you're not ready to invest in a digital camera, you can still experience digital photography by scanning photos and slides from your 35mm film camera. If you don't have a scanner at home, bring your photos to a retail outlet, and they'll scan them and put the digital files on a compact disk for you.

No matter how you decide to go digital, I invite you to join me in creating, using, and sharing digital photos. I've designed this book to be your guide as you explore the exciting world of digital photography. Read, learn, experiment, and enjoy!

Sincerely,

Elizabeth T. Schoch

Elizabeth T. Schoch

THE EVERYTHING DIGITAL PHOTOGRAPHY BOOK

How to take great pictures,
send them to your friends,
and post them on the Web

Elizabeth T. Schoch

◢

Adams Media Corporation
Avon, Massachusetts

EDITORIAL
Publishing Director: Gary M. Krebs
Managing Editor: Kate McBride
Copy Chief: Laura MacLaughlin
Acquisitions Editor: Bethany Brown
Development Editor: Michael Paydos

PRODUCTION
Production Director: Susan Beale
Production Manager: Michelle Roy Kelly
Series Designer: Daria Perreault
Layout and Graphics: Arlene Apone,
Paul Beatrice, Brooke Camfield,
Colleen Cunningham, Daria Perreault,
Frank Rivera

An Everything® Series Book.
Everything® is a registered trademark of Adams Media Corporation.

Published by Adams Media Corporation
57 Littlefield Street, Avon, MA 02322. U.S.A.
www.adamsmedia.com

ISBN: 1-58062-574-6
Printed in the United States of America.

J I H G F E D C B A

Library of Congress Cataloging-in-Publication Data
Schoch, Elizabeth T.
The everything digital photography book / by Elizabeth T. Schoch
p. cm.
Includes index.
ISBN 1-58062-574-6
1. Photography–Digital techniques–Handbooks, manuals, etc. 2. Digital cameras–Handbooks, manuals, etc.
3. Image processing–Digital techniques–Handbooks, manuals, etc. I. Title.
TR267 .S35 2001
778.3–dc21 2001046300

Many of the designations used by manufacturers and sellers to distinguish their products are claimed as trademarks. Where those designations appear in this book and Adams Media was aware of a trademark claim, the designations have been printed in initial capital letters.

This publication is designed to provide accurate and authoritative information with regard to the subject matter covered. It is sold with the understanding that the publisher is not engaged in rendering legal, accounting, or other professional advice. If legal advice or other expert assistance is required, the services of a competent professional person should be sought.

—From a *Declaration of Principles* jointly adopted by a Committee of the
American Bar Association and a Committee of Publishers and Associations

Illustrations by Barry Littmann.
Photo research and acquisition courtesy of Irene Durham.

This book is available at quantity discounts for bulk purchases.
For information, call 1-800-872-5627.

Visit the entire Everything® series at everything.com

Contents

Introduction

As we enter the twenty-first century, we find ourselves living in a digital world. From compact discs to cellular telephones to PDAs to computers, we use digital technology every day to enjoy music, to communicate with others, and to access information via the Internet. Even televisions boast digital technology. It's not surprising then that photography, too, has gone digital.

What would our grandparents have thought if they'd been told that one day photographers would be able to take photographs without the use of film? Surely it would have sounded like science fiction, but that day is here, and plenty of photographers—both amateur and professional—are embracing the technology that allows images to be captured and stored digitally. In 1999, worldwide shipment of digital cameras exceeded 6.5 million units, according to Digital Camera Market Forecast and Analysis from International Data Group, a provider of industry analysis and market data. That number is expected to jump dramatically to 41.6 million units by 2004.

Here are some of the compelling reasons why photographers are choosing to go digital:

- No film needed
- Provides instant gratification
- Saves time and money
- No more darkroom (replaced by your computer)
- Offers a quick way to check your photos
- Provides an easy way to obtain an image for a Web page

Digital cameras offer photographers many benefits, but two compelling reasons typically sway people to make the switch from film (analog) cameras:

1. The freedom to manipulate the output (digital image), and
2. The instant gratification that comes from being able to access the results immediately.

With new digital cameras and countless new options popping up every day, millions of people are discovering the joys of digital photography. In 2000, 3.8 million digital cameras were sold in the United States. Even people who never thought of themselves as shutterbugs are hopping on the digital camera bandwagon. Why? Because this is one piece of high-tech equipment that's actually fun to use!

How many times have you been walking down the street, visiting relatives, or just clowning around with your kids when you see something or someone and think: That would make a great picture. A digital camera means you'll never again miss that wonderful shot.

Once you're hooked on digital photography, you won't want to leave your camera at home, and thanks to its portability, you won't have to. Because a digital camera is compact and lightweight, it's easy to carry in your pocket or purse. And since it doesn't need film, there's no need to worry about whether it's loaded. You're always ready to capture the moment, so you can grab it and start snapping away.

After you've gotten that once-in-a-lifetime shot, it's easy to download it to your computer and send it off via e-mail to loved ones near and far. Part of the beauty of digital photography is the ease of sharing photos. It's fun to take digital photos, and it's even more fun to show them to others.

With more than half of American households owning personal computers, it's no wonder that folks are embracing digital photography instead of, or in addition to, their traditional cameras. They're finding that it's a cinch to download digital photos into a PC, and it's great fun to get really creative, using software to modify a picture, then zapping it off on the Internet for others to experience. Faster and more sophisticated software programs are continuously appearing on store shelves, making the options for modifying digital images almost limitless.

The bottom line, then, appears to be this: Digital photography provides a new and exciting way for ordinary people to express their creativity. It also offers them a means to communicate with friends, relatives, and business associates in the next town or half a world away.

CHAPTER 1

What's So Great about Digital Photography?

Before digital cameras, the only way to get a digital image was to take a picture with a film camera, get the film developed, then have the photographic print or slide digitized using a scanner. Digital cameras eliminate the time needed for developing and scanning. When you own a digital camera, you can skip the darkroom and go straight to the desktop.

Photography, Then and Now

Before we take a closer look at digital photography, let's pause and take a look back at photography's roots.

The term *photography* has been around for little more than 160 years. The word is derived from the Greek words photos (light) and graphein (to draw) and was first coined by scientist Sir John Herschel in 1839. Two scientific processes, one optical and the other chemical, combined to make photography possible. Interestingly, both processes existed for hundreds of years before photography was invented.

The Optical Process: Using Light to Create Images

The equipment that became the foundation of modern photography was nothing like today's cameras. The forerunners of today's cameras were created from darkened rooms. Light came in through a small hole in the room's window shade or wall, causing an upside-down image of what was outside to appear on the opposite wall. This device was called a camera obscura, which means "dark room" in Latin.

The concept of the camera obscura has been around for thousands of years. It is believed that the great Greek philosopher, Aristotle (384–322 B.C.), knew the principle behind the camera obscura, as did the Arabian scholar, Hassan bin Hassan, who in the tenth century described in his manuscripts what can be considered a camera obscura.

Later, Leonardo da Vinci (1452–1519) wrote about the uses of a camera obscura and depicted one in a drawing dated 1519. During the same period, a Venetian named Daniel Barbaro recommended that the camera obscura be used as an aid to drawing and perspective. And in 1558, Giovanni Battista della Porta wrote a book called *Natural Magic* that told of the camera obscura being utilized as a tool by draftsmen and illustrators. From that time onward, it is thought that many artists employed the camera obscura, including Dutch artist Johannes Vermeer (1632–1675) and British artists Joshua Reynolds (1723–1792), first president of the Royal Academy of Art in London, and Paul Sandby (1725–1809), a founding member of the Royal Academy.

As time went by, the camera obscura grew smaller in size. Made from a wooden box, it had a lens attached at one end and a mirror at the other. The mirror was positioned at a 45-degree angle, with a glass plate above it. By placing a piece of thin paper over the glass, an individual could trace the image projected there.

FACTS

In 1949, Gene Turtle built a camera obscura as part of a thesis project. The Giant Camera, formerly part of an amusement park in San Francisco, remains standing today. Visitors find that once they step inside, they see the same views they'd see outside—but with greater detail than can be seen in daylight.

The Chemical Process: Bringing Images to Paper

In the seventeenth century, Robert Boyle, a chemist and founder of the Royal Society, reported that silver chloride turned dark under exposure, but he mistakenly believed that it was exposure to air—rather than exposure to light—that caused this to happen.

During the 1700s and 1800s, several people were experimenting with photosensitive materials. One of these, a German physicist named Johann Heinrich Schulze, discovered in 1727 that light could be used to change substances. He experimented with silver, nitric acid, and chalk, and found that bright sunlight turned the mixture to black. Although his discovery, in conjunction with the camera obscura, provided the basic technology for photography, it was not until the nineteenth century that photography came into being.

In the early 1800s, Frenchman Joseph Niepce discovered that exposing bitumen, an asphalt-like substance, to light caused it to harden. He coated metal plates with bitumen, then exposed them to light inside a camera obscura. After an exposure of eight hours, the plate was washed and dipped in acid, which etched the exposed metal. The last step was to coat the plate with ink and strike it on paper, producing a print of the original image. Niepce named this process heliography. Niepce is regarded as having produced the first permanent photographic image.

At about the same time that Niepce developed heliography, another Frenchman, Louis Daguerre, a successful commercial artist, was experimenting with the same process. Niepce and Daguerre formed a partnership in 1829, but Niepce died a few years later. Daguerre continued to experiment by coating a copper plate with silver, then exposing the silver to iodine fumes, creating a silver-iodide salt that made the plate photosensitive. He put the plate in the camera obscura and exposed it to light. The silver-iodide darkened, but eventually the entire image turned black.

Quite by accident, Daguerre found a solution to his dilemma. One day he left an exposed plate in a cabinet where mercury was stored. When he removed the plate, he realized that the developing had ceased and the image had stopped darkening. He named his invention the daguerreotype. When Louis Daguerre showed the first daguerreotypes to the public in the winter of 1838–1839, Parisians were amazed by the amount of detail they contained. Some likened looking through a magnifying glass at a daguerreotype to viewing nature through a telescope. Daguerre's rival for the title of inventor of modern photography, William Henry Fox Talbot, had this to say about the detail of a daguerreotype:

> It frequently happens, moreover—and this is one of the charms of photography—that the operator himself discovers on examination, perhaps long afterwards, that he has depicted many things he had no notion of at the time. Sometimes inscriptions and dates are found upon the buildings, or printed placards most irrelevant are discovered upon their walls; sometimes a distant dial-plate is seen, and upon it—unconsciously recorded—the hour of the day at which the view was taken.

At about the same time that Daguerre was developing the daguerreotype, Englishman William Henry Fox Talbot was experimenting with a similar process. However, Talbot used paper instead of metal plates and produced a "negative" image. He then took the paper negative, waxed it to make it translucent, and photographed it to produce a "positive" image. He called the resulting positive-negative process calotype. Talbot is sometimes hailed as the father of modern photography, since the basis of the process he

developed is used in photography today, but unquestionably Daguerre, too, was an essential contributor to photography's development.

The Women's Perspective

Although the originators of modern photography were mostly men, women were also experimenting with the photographic process during the nineteenth century. While William Henry Fox Talbot was developing the positive-negative process, his wife was conducting her own experiments, which she detailed in writing in 1839. And in major American cities, a growing number of women were working with daguerreotypes. In 1850, one periodical declared that in New York there were seventy-one daguerreotype studios, with about eleven women employed in them.

Women were attracted to photography because in the nineteenth and early twentieth centuries it was one of the few professions deemed acceptable for their participation. There were also many women enjoying photography as a hobby. Camera clubs were formed, and various art salons began to exhibit the work of amateur women photographers.

One notable female photographer was Gertrude Stanton Kasebier (1852–1934). Having studied at Pratt Institute in New York, she originally planned to be a portrait painter. However, she became interested in photography while a student, and her first solo exhibit took place in 1896 at the Boston Camera Club. Soon after, she opened a portrait photography studio in New York City. Her work became popular, and she went on to be a founding member of the Photo-Secession Group, the Pictorial Photographers of America, and the Women's Federation of the Photographers' Association of America.

Although histories of photography may focus on the men who pioneered the field, it is good to remember that women, too, played a part in its early days.

Daguerreotypes' Popularity Spreads

Daguerre's process spread throughout the world, with the first daguerreotypes being made in America in 1839. At first the process of creating an exposure was quite lengthy. Moving objects could not be recorded, and it was difficult to obtain portraits.

Individuals in Europe and the United States began experimenting to improve the optical, chemical, and practical aspects of the daguerreotype process to make it more workable for creating portraits. In 1840 Alexander Wolcott opened a "daguerrean parlor" in New York where he created tiny portraits using a camera having a mirror instead of a lens. Wolcott's daguerrean parlor was the earliest known photography studio.

Jozsef Petzval and Friedrich Voigtlander, both of Vienna, revolutionized the daguerreotype process. Petzval produced a portrait lens that was about twenty times faster than had been previously used, and Voigtlander reconstructed Daguerre's wooden box into one that was smaller and easier to transport. At about the same time, Franz Kratochwilz, another Viennese, developed and published a chemical acceleration process that increased the sensitivity of the developing plate. With these valuable improvements, exposure time was reduced to twenty to forty seconds, and daguerreotyping became a flourishing business, especially in the United States.

Eastman Instrumental in Modern Photography

In the latter part of the 1800s, American George Eastman advanced the photographic process to such an extent that his influence is still felt today. In 1879 he invented an emulsion-coating machine that enabled the mass production of photographic dry plates, and in 1880 he began to manufacture them. In the early 1880s Eastman began experimenting with emulsion-support bases other than glass. Working with a colleague, he developed a roll film holder, a flexible film, and a machine to produce the film. They layered the film with gelatin emulsions on a paper backing, then stripped off the backing after development.

By 1885 Eastman American Film, the first transparent film negative, was introduced. Three years later, Kodak was born, and the Kodak Camera was introduced. The camera, which sold for $25, came loaded with 100 exposures on a film roll. Once all of the film had been used up, the camera was sent back to the Eastman Dry Plate and Film Co. in Rochester, New York, for developing. One year later, Kodak #2, the first commercial transparent roll film, was brought to market.

The Eastman Dry Plate and Film Co. became the Eastman Company in 1889, and then Eastman Kodak Company of New York in 1892. In 1895

the Pocket Kodak Camera was announced, followed in 1900 by the first mass-marketed camera, the Brownie, which sold for $1. And with the Brownie, photography was no longer the province of only a few. With its wide availability and affordable price, the Brownie camera allowed even regular Joes to take up photography. This was the beginning of Americans' love affair with the snapshot.

Kodak #2 flexible film made it possible for Thomas Edison to develop the motion picture camera in 1891.

FACTS

The Digital Debate

Which are better: traditional film (analog) cameras or digital cameras? This issue is hotly debated, and it appears that the definitive answer will remain elusive for some time. Depending on whom you talk to, digital cameras are the be-all and end-all, and everyone who is anyone is rushing out to buy a digicam. But there are diehard traditional photographers who are quick to maintain that the quality of photographs produced by digital cameras cannot match the quality provided by a film camera, at least not at the same price point. In a nutshell, these are some of the specific points being hotly debated:

- Are digital prints as good as 35mm prints? Some folks think digital prints are actually better! With a 2-megapixel camera, digital prints can rival 35mm prints in quality. Working with a good printer, you can produce astounding images.
- The ability to edit on the fly is one of the main draws of the digicam. Rather than having to wade through poor shots and discard them, you can quickly delete any bloopers from your camera, leaving only the cream of the crop in memory.
- It's just plain fun. There's something tremendously appealing about using a digital camera. It's partly the instant gratification that comes from being able to upload your memory card immediately after a shoot. It's also knowing that you can effortlessly share your pix with anyone,

anywhere, thanks to the Internet and e-mail. Free photo-sharing Web sites also make it enjoyable and easy to share photos with online albums.

• The chance to have some creative recreation with your photos using a software program is another strong draw of digital photography. No more darkroom. Now with the help of your computer, you can enhance your photos in a million different ways. Or you can make greeting cards, illuminate personal or business newsletters, or add pizzazz to your Web site.

Now for the flip side:

• Film is available everywhere; memory cards are not. If you're traveling far from home, it may not be as easy to pick up more memory cards as it would be to buy more film. And it's certainly not as cheap. You can't just pop into a convenience store to stock up on memory cards. If you are traveling to a remote area, you won't be apt to find CompactFlash or Microdrives available if you need them. Instead, you will need to make a rather substantial investment in memory before ever leaving home.

• Many photographers believe that film still offers better resolution than digicams.

• Digital cameras run into problems when you're shooting in low-light locations. Film offers greater sensitivity to light, allowing the photographer a greater chance of getting a good shot in low light. With your digital camera, you may need to add extra sources of light in order to get a good photo.

ALERT

When traveling you can amass an unlimited number of rolls of film. With a digital camera, you either have to stop and download your images to a computer, or you must have a large number of digital memory cards with you—requiring not only planning ahead but also making a sizeable investment.

- Digicams run into parallax problems more frequently than film cameras. (See Chapter 9 for more on digicams and parallax problems.)
- There are more lenses available for 35mm cameras. Fewer lenses mean fewer ways to be creative with your digicam.
- Film cameras provide quicker shutter response than digital cameras, resulting in better sport and action shots.

Benefits of Going Digital

Not everyone needs, or wants, a digital camera. If you are satisfied with your film camera, you may not want to purchase a digital camera. This is especially true if you do not own a computer and are not planning to purchase one soon or at all. But there are some distinct advantages to digital photography, which you should consider before making your decision. Many folks find that it pays to have both a 35mm SLR camera and a digital camera. Here's why digital photography is so appealing:

- *It's the wave of the future.* Using a digital camera means experiencing cutting-edge photography. About every three or four weeks, a new model digital camera makes its appearance in the marketplace. And digital cameras' capabilities are expanding at what seems like the speed of light. In fact, remarkable audio- and video-machines are being manufactured. For instance, you can now enjoy multifunction digital cameras, such as Fujifilm's FinePix 40I, which shoots digital, stills, records MP3 audio, and takes digital video with sound—although not all at the same time. But even if you are not in the market for a camera that sophisticated, you may still be eager to explore the digital world for the advantages it offers.
- *No more film.* With digital cameras, you don't need to spend money on film or agonize over what type of film will best meet your needs. And if you're careful with your camera's storage, you'll never again find yourself wanting to take that beautiful sunset but powerless to do so because you just used up your last roll of film.
- *Big savings.* No more film means no more processing costs. Think of the amount of money you'll save over the course of a lifetime

on processing alone if you go digital. Although the price of a digital camera might be higher than the price of a comparable 35mm camera, not having to continually invest in film represents big savings.

- *Instant gratification.* As soon as you shoot a picture, you can immediately check the image. The immediate gratification of digital photography sure beats the time you used to spend waiting for your film to be developed, or developing it yourself in a darkroom. Also, being able to check your shots while in the field means you can delete the "outtakes" as you go along, leaving you with only the best images at the end of the day.

FACTS

As an added bonus, you're promoting a cleaner environment with your digital camera because there are no chemicals, film, or canisters to be thrown away.

- *Creative control.* Even with all of the benefits described above, one of the main reasons a photographer is swayed to purchase a digital camera is for the creative freedom it provides. Buy a digital camera, and your computer acts as your digital darkroom, allowing you to manipulate your images in a variety of ways. For instance, you can eliminate red eye, change the background of a picture, add or subtract images, turn a black-and-white image into color, crop or rotate your picture, and undertake hundreds of other modifications—all with the click of a mouse.

- *It's portable.* A digital camera is tiny enough to be tucked in your pocket or pocketbook. This means you can carry your camera with you wherever you go and never again miss out on a photo op. That portability also promotes better photography, since the more you shoot, the faster your photography skills are likely to improve.

- *Share the joy.* With your digital camera and e-mail, you can quickly and easily share your photographs with relatives and friends around the globe. And now many Web sites allow you to set up albums of your images for others to view at their leisure. Just imagine how pleased Mom, Dad, and Aunt Isabel will be when you e-mail them the latest snapshots of your bouncing baby.

- *It's good for business.* If you're a small business owner, a digital camera can be a lifesaver. For instance, real estate agents can quickly snap a photo of a property and e-mail it to a client or download it to their Web site. Photographers and journalists can send images to their editors, whether they're in the next town or halfway around the globe. Antiques dealers who market their goods on auction Web sites such as eBay can download images and get auctions rolling the very same day. For many professionals working in a variety of businesses, a digital camera can become an indispensable tool.

- *Accessible forever.* Although negatives and prints fade and deteriorate when exposed to light, humidity, and overhandling, digital images can last forever. With careful treatment, you'll have your digital images indefinitely. And if your printout of an image gets damaged or lost, simply pull up the file and print it again. Storing and sharing digital images is so much more convenient than having to take negatives to the lab and wait for reprints to be made. It saves you money, too.

The Other Side of the Coin

Even with all the benefits that digital cameras have to offer, there are some drawbacks to digital photography that you also should consider before running out and buying your own digital camera. Depending on how you utilize a camera, the level of skill you possess, and your dexterity with a computer, digital photography can seem heaven-sent or a total turnoff.

- *Image quality.* A film or photographic print contains at least ten times as much information as a typical digital camera. To produce a film-like quality photo, a digital camera would need to be filled with so many chips that its price would be astronomical. If you are going to enlarge an image to poster size, you may be better off using an analog camera to take the shot. However, if you plan to use the image for a Web site or your personal online album, the digital camera will work just fine for you.

- *Expense.* Digital photography requires a financial investment. Although you can find digicams priced as low as $50, chances are you will want to spend at least $200 to $300, perhaps more, to get decent quality

images. In addition to your camera, you'll need a computer, a good color printer, and possibly a larger monitor and a scanner.

- *Darker images.* Digital cameras are not as sensitive to light as film cameras. Outdoors, you probably won't run into a problem. But indoors you may find that it is more difficult to get a decent exposure with a digital camera. Even with a flash, you may need to add more lighting.
- *Poor resolution.* You may find that when you enlarge an image, the resolution suffers and the pixels become visible. (For more on resolution see the section "Image Resolution and Image Quality" in Chapter 2.)
- *Distorted color.* Sometimes a digital camera gets the color wrong. It won't be a drastic mistake, such as a red lake or a purple sun, but you might get orange instead of yellow, or purple instead of blue.

In order to save battery power, some digital cameras will go into sleep mode if not used for a few minutes. Therefore, you might find that there is a gap of a second or two after you press the shutter before the picture is actually taken.

From SLR to Digital

Silicon Film Technologies, Inc. has developed an electronic film cartridge, called (e)film, which allows a 35mm SLR camera to capture digital images. The electronic film cartridge is an insert that fits into the back of a 35mm SLR body. It uses 65 MB of nonvolatile flash memory to capture and store up to twenty-four 36-bit digital images and can be reused thousands of times. With (e)film, you can go digital without the expense of purchasing a new camera, plus you can use all of the lenses, flash units, and filters you already own. As your shooting needs change, you can easily switch back and forth between 35mm film and (e)film. And (e)film provides a good option for those wanting to experiment with digital photography before investing in a digicam.

Commercial Uses for Digital Photography

The pros know that digital cameras can provide some benefits that analog cameras cannot. Here is just a sampling of how professionals in many fields use digital cameras and digital images to make their jobs easier and improve the work they do:

- Photographers use digital cameras in the studio to shoot everything from fruit to fashions. They can quickly check the resulting image, and adjust as necessary. Once shot, images can be manipulated via image-editing software, then e-mailed to clients and vendors.
- Journalists love digital photos because they can be immediately transmitted to their editors via telephone lines or wireless connections. Once in the hands of their editors, the images require no lab processing; they can be used at once. The low resolution of digital cameras is not a problem for newspapers because they use low-res printing.
- Scientists use digital cameras to take videos and photographs through microscopes.
- Law enforcement agencies love the quick processing, easy enhancement, and online distribution of digital images.
- Doctors and dentists find digital cameras handy for snapping before and after shots of patients. The results can be used for reference, attached to patient charts, or submitted with insurance claims.
- Astronomers have used digital image sensors for years. In 1997 NASA's Pathfinder spacecraft carried to Mars a surface rover called Sojourner. Two digital imaging sensors helped Sojourner negotiate the rough surface of the planet. The orbiting Hubble Space Telescope has a CCD detector with a 1,600 x 1,600 pixel array.

Is Digital for You?

In the end, it's your call whether or not a digital camera is right for you. Once you've sized up your needs and considered both the pros and cons of going digital, you'll be able to determine if a digital camera should be part of your future.

Although no one can predict the future, it seems likely that the trend of manufacturing cameras with more pixels will continue. Look for better resolution and higher-quality photographs. Also, camera manufacturers are likely to improve digicams so that the amount of shutter lag is reduced.

CHAPTER 2
Understanding How Cameras Work

Although the cameras of the twenty-first century are far more sophisticated, the fundamental principles of taking a photograph have not changed. In order to understand the world of digital photography, you will need to be familiar with some technical terms. By learning the language of digital photography, you will be better able to understand the material in books, magazine articles, and Web sites that cover the topic.

How Digital Cameras Work

All film cameras contain five basic elements:

- *Lens:* A plastic or glass element that collects light and focuses an image on the film.
- *Aperture:* An opening that controls the amount of light entering the camera through the lens.
- *Shutter:* A device that can be opened or closed to control how long the film is exposed to light entering the camera.
- *Body housing:* The plastic or metal outer casing that contains the camera mechanism.
- *Viewfinder:* A lens or frame that lets the photographer view the picture being taken, either directly through the lens (in single-lens-reflex, or SLR, cameras) or through a separate viewfinder (in simple cameras).

Digital cameras are a lot like 35mm film cameras. Both consist of a lens, an aperture, a shutter, body housing, and a viewfinder. The big difference between film cameras and digital cameras is the way in which they capture an image. A film camera creates an image when light passes through a lens onto film. The film is coated with light-sensitive chemicals that react when light strikes the film, creating an image. In the developing stage, the image reacts with additional chemicals to produce a printed photograph.

Like a film camera, a digital camera also uses light to create images, but it does so with light-sensitive computer chips (image sensors) rather than film. The chips are categorized as either CCD (charge-coupled device) or CMOS (complementary metal-oxide semiconductor). The majority of digital cameras made today use CCDs, but CMOS chips are gaining popularity fast. Although they differ somewhat, both types of chips operate in essentially the same way.

CCDs are created using a special manufacturing process that enables them to transport charge across the chip without distortion. CMOS chips are made using the same processes as most microprocessors. Because of differences in manufacturing, there are several differences between CCD and CMOS sensors:

- CCD sensors create high-quality, low-noise images. CMOS tend to be more susceptible to noise (small defects in the image).
- The light sensitivity of a CMOS chip is lower.
- CMOS sensors typically consume little power, while CCDs use a special process that uses lots of power.
- CMOS chips are less expensive to make compared to CCDs.
- CCD sensors tend to have higher-quality pixels and a greater number of them. The data is saved to the camera's memory, which is located on an in-camera chip or a removable memory card or disk. By transferring the images from your camera to your computer, you can access them. Some cameras allow you to transfer images directly to a TV monitor or printer, allowing you to view and print your photos without the need for a computer.

A chip is comprised of rows of tiny light sensors called photosites that capture color and light, and then convert them into electrical charges. A processor inside your camera analyzes and translates the electrical charges into digital image data. (The brighter the light, the stronger the resulting charges will be.)

Due to these differences, CCDs are commonly used in cameras that create high-quality images with lots of pixels and superior light sensitivity. CMOS sensors tend to have lower quality, lower resolution, and lower sensitivity. The other side of the coin: CMOS cameras cost less and have great battery life. As time goes by, it seems likely that CMOS sensors are sure to improve until they equal CCD devices in most applications.

Color Your World Digital

Both film and digital cameras create images by reading the amount of light in a scene. A digital camera works much like the human eye to translate that information into the colors that appear in the final image.

Light is made up of three primary colors: red, green, and blue. Three receptors in your eye correspond to each of these colors. Each receptor senses the brightness of the light for its particular color. The brain processes the information to form one multicolored image.

Like your eyes, a digital camera captures the light intensity—sometimes called brightness value—of the red, green, and blue light. It records the brightness value for each color in separate portions of the image file, or color channels, then combines them to form a full-color image.

When images are created using these three primary colors of light, they are called RGB (red, green, blue) images. The RGB system is also called the additive color system, because when the three colors are combined, or added, in equal quantities, they form white. In our everyday lives, we are looking at RGB images when we view television sets, computer monitors, and scanned images.

FACTS

The source of color is light. All colors combined form white light. To demonstrate this, place a prism where the light can strike it. The colors separate to form a rainbow spectrum ranging from violet to red. When light strikes a surface, some colors are absorbed while others are reflected. The colors that we see are those that the surface reflects.

Image Resolution and Image Quality

Digital images are made up of pixels. The word pixel is short for picture cell or picture element. Each pixel is a tiny dot, similar to the ones that form the image on a television screen. When a digital image is viewed normally, the pixels blend together (**FIGURE 2-1**). When the image is magnified on screen, you can differentiate the individual pixels (**FIGURE 2-2**).

This effect is called pixelization. It is similar to enlarging a traditional print to the point where it develops a grainy look.

FIGURE 2-1: Digital images are made up of pixels, tiny dots similar to those that form the image on a television screen. When a digital image is viewed normally, the pixels blend together.

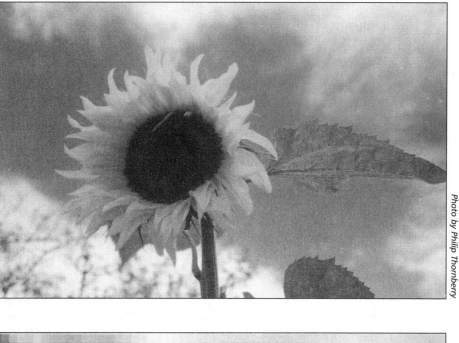

Photo by Philip Thornberry

FIGURE 2-2: When an image is magnified, you can differentiate the individual pixels.

Photo by Philip Thornberry

Each image has a set number of pixels. For instance, low-end digital cameras tend to create images that are 640 pixels wide and 480 pixels tall. To refer to the number of pixels in an image, the term "pixel dimensions" is used. Sometimes the term "image size" is also used, although this can be confusing since image size can also refer to the physical dimensions of an image. (For the purposes of this book, the term "pixel dimensions" will be used to indicate the pixel count, and "image size" will be used when referring to the physical dimensions.)

ESSENTIALS

Resolution is measured in pixels per linear inch, not square inch. For example, a resolution of 75 ppi means the image has 75 pixels horizontally and 75 pixels vertically (or 5,625 pixels) for each square inch of image.

The number of pixels per inch (ppi) creates the resolution of an image. The quality of your image will be determined by its resolution. The more pixels per inch, the crisper the image will be. That's why it's important to understand the concept of resolution if you're going to get the results you're seeking from your digital camera.

Images formed from pixels are said to be bit-mapped. Each pixel is a shade of gray or color. The number of bits in an image, or bit depth, indicates how much color information each pixel can contain. Using 24-bit color, each pixel can be set to any one of 16 million colors.

Image resolution is also stated in terms of file size. To calculate file size, we multiply the total number of pixels by the bit depth of the image, times the number of colors in the image, divided by eight (because there are eight bits to one byte).

You've probably heard the terms "bits" and "bytes." What are techies really talking about when they use these terms? Bit stands for binary digit and is the smallest possible unit of digital information. Eight bits equals one byte. Bit depth, or bits per pixel, refers to the number of bits allocated to describing the color of each pixel. Higher bit depth means a larger file size and more colors. An 8-bit image contains 256 or fewer colors. A 16-bit image contains about 32,000 colors. A 24-bit image contains approximately 16 million colors. And a 32-bit image contains billions of colors.

Determining the Number of Pixels You Need

Since higher resolution is a good thing, and the more pixels the better the resolution, you might be thinking that you want to get a camera that can produce images with as many pixels as possible. Well, not necessarily.

First you must decide how you will use your images, then you'll know how many pixels you need. If you'll be using your images on screen, such as for a Web site or in e-mail, a resolution of 72-96 ppi is fine because most monitors are not capable of displaying any more pixels per inch anyway. For onscreen images, you won't need to pay a lot for a digital camera because most inexpensive digital cameras capture enough pixels to do the job for you.

If you're planning to print your images and you are looking for the best possible output quality, you'll need a resolution of about 300 ppi. The number depends on the kind of printer you're using—you might need a few more, or you might find a few less are adequate. The manual that came with your printer should offer the exact resolution guidelines.

If you know the resolution you want your image to be, you can determine the maximum size of the image by dividing the total number of image pixels across (or down) by the desired resolution. For instance, if your camera captures 1,280 pixels across by 960 pixels wide, and your target resolution is 300 ppi, simply divide 1,280 by 300 to get the maximum width of the image, which in this case would be 4.25". To calculate the maximum height, divide 960 by 300, and you'll find out that 3.25" is the maximum width. Therefore, your image will be about 4.25" x 3.25" with 300 pixels per inch.

Although you may have surmised that higher resolutions deliver better quality, that is not necessarily true. Printers are adjusted to work with images set to a particular resolution. When you try to print an image file that's at a higher resolution than the printer is geared for, most printers will eliminate the extra pixels, causing the printed image to be of lower quality.

Trim the Fat

Every pixel adds to the size of the image file. Large image files not only take up storage space, they also use up lots of computer memory (RAM) when you're editing them. A good rule of thumb: The file size x 3 = the RAM required.

When using image files on a Web site, the larger the file, the longer time it will take to download it. It's best to keep images at just the "right" size. In other words, you want the appropriate number of pixels for your output device (screen or printer), but you don't want to exceed that amount. In Chapters 19 and 20 we'll talk more about using and editing image files.

Adjusting Pixels and Resolution

Your image-editing software will assign a default image resolution to your digital camera image. Typically, this is either 72 ppi or 300 ppi. To increase or decrease the resolution you have two choices: resampling or resizing your image.

Resampling

To change the number of pixels per inch, you can use your image-editing software to add or delete pixels, a process called resampling or interpolation. Techies refer to the process of adding pixels as upsampling and call the process of deleting pixels downsampling.

At first you may think that upsampling is a good idea. However, problems develop when you add pixels, because the software estimates the color, saturation, and brightness needed to make new pixels. Usually, the results are less than desired.

If you have an image that contains more pixels than you'd like, it is fine to downsample (delete pixels). But remember that every pixel you delete contains image information, so if you dump too many pixels you'll be reducing image quality. Make a backup copy of the image in case you are not happy with your results after downsampling. And a good rule of thumb is to downsample 25 percent or less.

Resizing

A much better approach when changing image resolution is to resize the image while maintaining the original pixel count. For instance, if you have a 4" x 3" image set to a resolution of 150 ppi and you double the size of the image to 8" x 6", the resolution decreases to 75. This means your print quality has been reduced. But if you reduce the image size by 50 percent, to 2" x 1.5", the resolution is doubled, to 300 ppi, and you've now actually improved the quality of your print.

In Chapter 19 we'll take a look at ways to resize images using image-editing software.

More about Resolution

The term resolution describes more than image quality. It is also used to describe the capabilities of digital cameras, monitors, scanners, and printers. Keep the following in mind.

Manufacturers of digital cameras frequently use the term resolution to describe the number of pixels in the images their cameras produce. For example, a camera's resolution might be stated as 640 x 480 pixels or 1.3 million pixels. These values refer to the total pixels the camera can produce rather than the number of pixels per inch in the final image. That value is ultimately determined by the photographer when using image-editing software.

To indicate the resolution a camera is capable of recording, the terms VGA (video graphics array) resolution (approximately 640 x 480 pixels), XGA (extended graphics array) resolution (1,024 x 768 pixels), and megapixel resolution (indicating a total pixel count of one million or more) are used. Pixel dimensions are a more accurate way of judging the resolution of a camera.

In a similar way, manufacturers of computer monitors use the term resolution to describe the number of pixels the monitor can display. On most monitors you can choose from display settings of 640 x 480 pixels (VGA resolution), 800 x 600 pixels, or 1,024 x 768 pixels (XGA). The ppi of your monitor depends on its physical size plus the display setting you choose.

Macintosh monitors are usually set at the factory to display 72 pixels per inch. PC monitors are commonly set to display 96 ppi. Just like digital cameras and monitors, scanner capabilities also are described in terms of resolution. Luckily, scanner resolution is usually spoken of in the same terms as image resolution. A low-end scanner commonly captures a maximum of 300 or 600 pixels per inch.

ALERT

Digital photographs can be created by digital cameras or by scanning an image from a conventional camera and digitizing it.

When printer manufacturers talk about resolution, they're measuring it in dots per inch (dpi). The concept is similar to pixels per inch. Since printed images are made up of dots of color, the dpi measures how many dots per inch the printer can produce. Typically, the higher the dpi, the smaller the dots, and the better looking the resulting image will be. You should keep in mind, however, that judging a printer only by its dpi can be misleading. Due to different printing technologies, some 300-dpi printers can deliver higher-quality results than some 600-dpi printers. We'll take a closer look at printers and resolution in Chapter 18.

QUESTIONS?

Are dpi and ppi the same thing?
Dpi and ppi are not interchangeable terms. Do not assume you should set your image resolution to match your printer resolution. Printers tend to use multiple printer dots to reproduce one image pixel. Check your computer manual for help determining the right image resolution for your model.

Overview of Resolution

Below is a summary of resolution terms and tips to help you produce high-quality images:

- Image resolution is measured in pixels per inch (ppi). To determine resolution, use this formula: number of pixels across (or down) divided by image width (or height) equals image resolution (ppi).
- For best quality prints, aim for a resolution of 300 ppi.
- When using images for onscreen display, 72 x 96 is appropriate. However, it's best to think in terms of pixel dimensions rather than image resolution when sizing images for the screen.
- Enlarging a picture can damage the quality of the image. When enlarging an image, either the pixels expand to fill the new image boundaries, or they stay the same size and the image-editing software adds pixels to fill in the gaps. In either case, the image quality deteriorates.
- To increase the resolution of an image, it is best to reduce the image size. Keep the existing number of pixels and make the image smaller.
- It's best to set your camera to capture a pixel count at or above what you need for your final picture output. You can always delete pixels later if you want a lower-image resolution, but you can't add pixels without risking damaging your image. Another good reason to do this: Although you may want a low-res image today for use on a Web site, in the future you may decide you want to print the image at a larger size and then those extra pixels will serve you well.
- More pixels will fatten up your image file. You may have enough file storage space to hold big images, but those humongous images will require huge amounts of RAM to edit. And they'll require lots more time to process your edits. On the Web, a big file means slower downloading of images, and that never makes Web site visitors very happy. When you send bigger files to your printer, the results are often reduced quality, not better, prints.

CHAPTER 3

What to Look For in a Digital Camera

It seems like everyone has jumped on the digital bandwagon, from icons of the photography world to computer and electronics manufacturers. The influx of digital cameras to the marketplace means better models to choose from at lower prices. However, having so many digicams from which to select means you need to do some research before you make your purchase.

Finding a Camera to Meet Your Needs

Although you need to establish a budget before you're ready to go camera shopping, it is also essential that you figure out what you want to do with your camera once you've brought it home. Think of shopping for a digital camera as being a bit like shopping for a car. If you're a family of four, you're probably not going to want to get a two-seater sports car. Instead, you're more apt to opt for the minivan that provides the room for your family to be transported comfortably. But if you're a single guy or gal who's looking to make an impression with your vehicle, that flashy sports car might be just the ticket.

How do you want to use your digital images? And what are you likely to take pictures of? If you're planning to use your camera to keep the family up-to-date on the new baby, then a low-end camera that is simple to operate and takes images that can be used on the Internet may well serve your needs. But if you are a serious photographer, you're likely to be dreaming of owning a digital camera that provides digital images rivaling those you now get from your 35mm camera. If this describes you, then your main concern when choosing a digicam is resolution. Of course, higher resolution means a higher price tag, so your budget will have to be big enough to accommodate your desires. If you plan to print your images, you'll probably want to find a camera that provides images of at least 1,280 x 1,024 resolution.

Getting the Resolution You Require

Let's see how digital cameras stack up when we compare categories based on resolution and use.

Less Than 2 Megapixels
- Upside: In this category you can find a camera that takes pictures that work well on the Web (for posting on Web sites and e-mail); good for the novice who wants an easy-to-use digicam
- Downside: Indoor photos will be of lower quality
- Maximum resolution: 1,024 x 768
- Storage: 4 MB

Between 2 Megapixels and 3 Megapixels
- Upside: Cameras in this category should provide consistent image quality; good for indoor and outdoor use; good selection of manual controls, including zoom
- Downside: More expensive
- Maximum resolution: 1,600 x 1,200
- Storage: 8 MB
- Other: Zoom

More Than 3 Megapixels
- Upside: Cameras in this category should provide extremely high-quality images; extensive manual controls
- Downside: Extremely expensive
- Maximum resolution: 2,048 x 1,536
- Storage: 8 MB
- Other: Advanced manual controls

Call your local camera and electronics retailers to see if they rent digicams. As digital cameras gain popularity, more and more stores are allowing consumers to take advantage of one-day rentals. It's the best way to try one before you buy.

Thanks for the Memory

When shopping for a digital camera, you're going to need to take into account the kind of memory the camera uses to store images. Some cameras have built-in (onboard) memory, usually RAM (random access memory). This means that once the memory is filled up, your picture taking comes to a halt until you can get to a computer and transfer the images you've just taken—a task that can put a serious crimp in your photo shoot.

Most new digicams are being manufactured with removable media for image storage. Simply insert a memory card or disk into a slot on the camera and you're ready to go.

ESSENTIALS

If you love to travel and want your digicam to record the trip, plan to get a camera with removable memory. Removable memory lets you carry extra storage so you'll never be caught unprepared. Two common types are SmartMedia cards and CompactFlash cards.

Cameras without removable media cost less, but it's worth it to spend the extra bucks for two good reasons:

1. Once the memory card is filled up, you can simply replace it with another card. There's no need to take a break in your picture taking.
2. With onboard storage, the transfer process to your computer is more time-consuming and less efficient. You have to be able to connect the camera and the computer via a cable, which can be a cumbersome task, and then wait patiently while the images download.

When using a camera with removable media, you won't be pulling your hair out while waiting to get a look at your images. If your camera stores images on a floppy disk, you simply remove the disk from your camera and slip it into the floppy drive on your computer. Next you drag and drop files just like you'd do with any other files on a floppy.

Other types of memory cards work with the assistance of card adapters and readers, which allow your computer to recognize the memory card as a floppy drive. This method of image transfer is much faster and more convenient than using onboard memory.

Some higher-priced cameras feature both built-in RAM and removable memory. Because a camera can access the built-in RAM faster than it can access memory on a removable device, it uses the built-in memory as a buffer. Once you take a picture, the image is saved in the buffer before being sent to the removable memory. This allows you to take the next picture more quickly. And the camera may give you the option of saving your image with various compression modes while the image is still stored in the camera's RAM. (For more information about compression, see Chapter 15.)

The two most popular types of removable media are CompactFlash (256 MB Type I and 512 MB Type II) and SmartMedia (128 MB) cards. Both formats are widely used, so if you choose a camera that uses one of these, you'll be more likely to find replacement cards when you're traveling in foreign countries. And should you decide to buy a new camera, there's a greater chance that your memory cards will work with your next model. (Learn more about removable memory in Chapter 6.)

Long-Term Shooting

If you're planning to spend the day taking photos, whether you're backpacking in the mountains or exploring a tropical island, you'll appreciate the ability of your digital camera to furnish a power supply and enough memory for a full day's shoot. Rechargeable battery packs are now available with many cameras, and if you're traveling or simply planning to spend an entire day pursuing the perfect shot, you'll want to take along a spare battery pack. When your day's shooting is done, simply plug in the charger and the next day the batteries will be ready to go once again.

Memory capacity is the other key to long-term shooting. If you're on the road, you may find Iomega's PocketZip a godsend. This compact, rechargeable, handheld drive can read both CompactFlash and SmartMedia cards. PocketZip then automatically transfers the images to a 40 MB, 2"-square disk. Once you're back at home, you simply connect the PocketZip drive to your computer's parallel port for downloading to your hard drive.

FACTS

Memory card capacity, now available in up to 340 MB per card, means you can take more shots than ever before you have to download. Downloading is quicker too thanks to USB camera connections and memory card readers that connect to a computer.

Checklist of Secondary Digicam Features

Below is a helpful checklist that you can refer to when you're evaluating digital cameras. It is designed to remind you of some of the secondary features of a digicam. Remember that the devil is in the details, and don't overlook these features or you may suffer buyer's remorse.

- *Batteries:* Find out what kind of batteries the camera uses, and how many shots you can expect to get with a set. Find out if a battery charger and rechargeable batteries are included in the camera kit.
- *AC adapter:* Do you have to pay extra for an AC adapter, or is it included with the digicam?
- *Software:* Your camera will have software for downloading images. Some digicams also include image-editing software.
- *Computer and printer hookups:* Investigate how the camera connects to your computer. Is it via serial port or a USB (universal serial bus) port? Some models offer wireless transfer, allowing you to send images to a printer or computer using infrared ports, called IrDA (Infrared Data Association) ports.
- *Frame rate:* How long does it take for the digicam to clear the image sensor, then store the image in its memory? To successfully take action shots, you are looking for the shortest lag time possible, or a continuous-capture option.

In bright light, LCD screens can be difficult to see. When examining a camera for possible purchase, take it outdoors or to a bright area so you will know how easily the LCD operates in bright light.

What You Can Expect to Spend

Let's take a look at the types of features and benefits of digital cameras available on the market. We'll then review the price points and what you can expect to get for your money.

Inexpensive Cameras (under $150)

Inexpensive digital cameras usually do not have an LCD screen or photo-quality optics. They use lower-priced CMOS sensors, similar to the ones found in Web cams. If you're looking for an introductory digicam that lets you have fun without providing fantastic image resolution (usually 640 x 480 and below), you may want to start with an inexpensive model.

Low-End Cameras ($150 to $450)

Point-and-shoot digital cameras fall in this category. They are more versatile than the inexpensive models and are fully automatic so they are easy to use. The downside is you won't get a lot of creative control with a point-and-shoot digital camera. They may or may not have a zoom, but they'll usually have an autofocus lens. Most use CCD as opposed to CMOS sensors. Resolutions range from 1 megapixel (one million pixels) to 1.3 megapixels. Because of their low resolution, printed output is limited to about 4" x 6" or so. Nevertheless, these images can be ideal for use on Web pages, in e-mail attachments, and in newsletters and other documents.

Midrange (about $450 to $700)

With price tags under $700 or so, these cameras offer resolutions of around 2 megapixels plus advanced features such as 3X to 5X zoom lenses, flash attachments, and MPEG (mini movies) capability. One of the fastest growing categories of cameras, midrange multimegapixel cameras are chosen by serious photographers who are seeking creative control of their camera's settings and the ability to generate prints up to approximately 8" x 10" and 11" x 14".

High-End/Prosumer Models (about $700 to $2,000)

If your camera budget is in the $700 to $2,000 range, you may want to consider a high-end ("prosumer" or semipro) digital camera, which offers extensive controls and expensive optics such as stabilized long zooms. Typically, cameras in this category use CCDs that are 3 megapixels and above and have very precise optics and two or three different metering

systems. Some high-end models offer TTL viewfinders and compatibility with more than one type of recording media (such as CompactFlash and SmartMedia), plus compatibility with external flash units or their own dedicated units. These cameras provide high-quality images between 4 MB and 8 MB.

ESSENTIALS

If you are seeking a camera that allows you to print images up to 12" x 17", you'll find that a semipro digicam can provide those sizes with good detail.

Professional Cameras ($2,000 and up)

If money is not an object, you may want to consider the professional digital cameras adapted from 35mm and APS (Advanced Photo System) SLR cameras. These cameras often utilize three different image sensors—one for each color—so they capture great color and provide superior resolution. Their image sensors have at least 2 million pixels, and usually even more. The great advantage of these cameras is that most of the features and accessories designed for their film counterparts also work with these digital versions.

Cameras for Special Needs

There are all sorts of digital cameras out there, but some are designed to meet specific needs.

Desktop video cameras can capture still images, but they will be low resolution and not suitable for much but casual Web use. Since the camera is attached to the computer, desktop digital video cameras are extremely limited in their uses.

Web Cams

Designed for video conferencing and Internet telephony (using the Internet to make phone calls), the video camera captures your image and sends it out via the Internet.

Handheld Digital Video Cameras

Handheld digital video cameras allow you to wander far and wide in search of the ultimate picture. Some of the models are extremely sophisticated, such as the digital camcorder, the Canon Optura Pi. It allows you to record images in three different modes: normal movie mode, digital photo mode (to which you can add narration or sound effects), and digital motor drive mode, which permits you to take 30 frames per second. When you're attending your kid's soccer game, this camcorder will help you record the action. The Canon Optura Pi allows you to take two hours of digital movies or 700 digital photos on one mini DV (digital video) cassette. Capture images on a floppy disk, view them on your TV, or download to a DV-compatible computer.

Handheld Computer Cameras

The useful and popular digital camera is being incorporated into devices ranging from laptop computers to PDAs (personal digital assistants).

For instance, Handspring has developed a full VGA digital camera, called eyemodule2, that allows the Handspring Visor handheld computer to take snapshots. The eyemodule2 snaps into the Visor handheld via its Springboard expansion slot to enable the user to capture and view images in black and white or color in a variety of different formats. Handspring users can take pictures with the eyemodule2 in full VGA to download and print high-res pictures, take Handspring Visor screen-sized snapshots saved in a compact format to conserve memory on the handheld, or record mini video clips.

FACTS

The eyemodule2 includes a special software application that allows the user to attach images to address book entries.

If you own a Palm handheld organizer, you may want to investigate a camera such as the Kodak PalmPix. The PalmPix works like a desktop camera—attach it to your organizer, then shoot, store, and review 24-bit color VGA pictures. Maximum resolution is 640 x 480 pixels, so your images are going to be low-res, and each image takes up about 100 K of Palm memory.

Chapter 4

Buying the Digital Camera That's Right for You

Now that you've learned all about resolution, pixels, and memory and have read all about what your dollar can buy, let's walk through the steps you'll need to take to get a digital camera that's just right for you.

A Step-by-Step Guide

Step 1: Establish your budget. How much can you realistically spend on your new camera? After all, the best digicam in the world won't do you any good if you simply cannot afford to make it your own.

Step 2: Decide if you want to print photo-quality pictures. And if you do, what size do you want them to be?

Step 3: Know what kinds of pictures you're planning to take, then find a camera with the features that enable you to shoot them. Asking yourself the following questions can help you determine just what features you'll need.

- Are you a casual photographer, or a serious amateur or professional? The answer to this question will determine how many manual controls your camera should have.
- Will you be photographing action shots, such as your son's soccer games? Or are you planning to take primarily stationary photos? The answers to these questions will determine the best viewfinder and lens for your camera. You may also want to look for a continuous shooting mode. Consider how many shots it can take in a row.
- Will you be shooting indoors? This will determine the quality of the flash you need.
- Will you be taking wide-angle shots of landscapes? Close-ups such as flowers growing wild? Telephoto scenes such as portraits? Your answers will help you decide the focal length of the lens you need and whether or not you should buy a zoom lens, auxiliary lenses, or macro mode. (For more on lenses see Chapter 7.)
- Will you be traveling or spending a lot of time in the field? If so, you'll want to consider the memory and power supply capabilities of the camera.

Step 4: Begin looking at various models of digital cameras. Start with the Internet and comparison shop in cyberspace. Once you've narrowed your search to three or four models, you're ready to get your hands on the real thing.

ESSENTIALS You want to make sure that you like the way the camera feels when you're holding it and shooting with it. If you are left-handed, you will be especially concerned about how the camera feels in your hand.

Step 5: Look for a well-designed camera. Go to a bricks-and-mortar retailer so you can test out the cameras you're considering. Does the camera feel well balanced? Inspect the camera controls to be certain you can utilize them effortlessly. You don't want to miss a great shot because you couldn't quickly prepare the camera to take the shot.

Step 6: Get ready to plunk down your money. Where do you want to go to make the purchase? You may decide that your local retailer is the best place to buy your camera. Or perhaps you've found an incredible deal on eBay. Remember to consider shipping and handling charges, sales tax, and whether the model you want is currently in stock.

Watch out for unbundling, a practice by unscrupulous retailers of removing items such as lens caps, battery chargers, memory cards, and software that are usually included in basic camera packages, and selling them separately.

Investigating the Choices

There are many places to turn for information about the digital cameras currently available in the marketplace. The quickest way to begin is by jumping on the Internet. There you will find all kinds of Web sites that contain information about digital cameras in general and specific models. There are also sites that offer comparison shopping so you can compare various models. Start by searching on "digital camera." You'll be amazed at the number of Web sites your search will uncover.

If you have a particular manufacturer in mind, don't miss checking out their Web site. But be sure you also explore impartial digital photography sites, many of which will compare features of various models, giving the pros and cons of each.

Researching Digicams on the World Wide Web

Check out the following Web sites to get product information, compare prices, and read reviews:

- BizRate.com
 www.bizrate.com
- CNET.com
 www.cnet.com
- DealTime
 www.dealtime.com
- My Simon
 www.mysimon.com
- NexTag
 www.nextag.com

- Price Watch
 www.pricewatch.com
- PriceSCAN.com
 www.pricescan.com
- Price.com
 www.price.com
- The Internet Mall.com
 www.internetmall.com
- ZDNet
 www.zdnet.com

The Web also offers an avenue for communicating with other digital photographers. Many photography Web sites feature message boards where you can chat with others who share your interest in digital photography. You also might want to check out newsgroups, sites where people ask and answer questions on many topics, for discussion of various models of digital cameras. Or look into photography clubs, both online and offline, for opportunities to discuss digicams with kindred spirits.

The Latest Buzz on the Digital World

Jump on the Internet to explore what's happening in the digital world or connect with others who share your interest in photography. There are numerous resources you can use, and you'll probably enjoy surfing the Net to see what's out there.

To point you in the right direction, we've included twenty-five Web sites that offer up-to-the-minute trends, news, and reviews about digital photography, general photography, and related subjects.

- Apogee Photo
 www.apogeephoto.com
- BJP Online
 www.bjphoto.co.uk
- Blind Spot
 www.blindspot.com
- Cheese Magazine
 www.cheesemagazine.com
- Communication Arts
 www.commarts.com
- Digital Camera Magazine
 www.photopoint.com/dcm
- Digital Creativity
 www.digitalcreativity.net
- Digital Imaging Magazine
 www.digitalimagingmag.com
- Digital PhotoCorner
 www.dpcorner.com
- Eye Caramba
 www.eyecaramba.com
- Kodak eMagazine
 www.kodak.com/ US/en/corp/magazine/

- LonestarDigital
 www.lonestardigital.com
- Megapixel.net
 www.megapixel.net
- OnLinePhotography
 www.onlinephotography.com
- Outdoor Photographer
 www,outdoorphotographer.com
- PC Photo
 www.pcphotomag.com
- PC Photo Review
 www.pcphotoreview.com
- Photo Magazine
 www.photomagazine.com
- Photo Metro
 www.photometro.com
- Photography Review
 www.photographyreview.com
- Shutterbug Online
 www.shutterbug.net
- Ultimate Photography
 www.ultimatephotography.com
- ZoneZero
 www.zonezero.com

Words and Pictures

The next best thing to being out in the world photographing people and places is reading about it. To find print publications on photography, start with your local newsstand or library. Following are some photography magazines that cover either digital or general photography.

- *American Photo*
- *Communication Arts*
- *DIGITAL Photographer*
- *eDIGITALPHOTO.com*
- *Outdoor Photographer*
- *PC Photo*
- *Photo Metro*
- *PHOTO Techniques*
- *Photographic*
- *Popular Photography*
- *Shutterbug*

There are a number of very good general photography and digital photography magazines, both print and online, that you can use in your search for information about digital cameras. These are wonderful resources for discovering the very latest news and trends in the world of digital photography.

Going, Going, Gone—Buying Digicams at Online Auctions

If you're in the market for a digital camera, you might consider browsing in cyberspace. One source for cameras of all types—and many other items—is an online auction. There are several, with eBay being probably the most widely known. Here are several auction sites you may want to take a look at:

- Amazon Auctions
 www.auctions.amazon.com
- eBay
 www.ebay.com
- Egghead
 www.egghead.com
- uBid
 www.ubid.com
- Yahoo! Auctions
 www.auctions.yahoo.com

Auction sites offer both used and new merchandise from retailers and private citizens. Here are a few tips to help make your online buying experience a satisfying one:

- Don't be afraid to ask questions. If you look at the pictures of the item and still have doubts, be sure to e-mail the seller and get your questions resolved.

- Investigate the seller's record. In most cases, you can view feedback from other folks who have dealt with the seller. If the feedback is negative, or nonexistent, you should think twice about buying from this seller.
- Talk to others. If you examine the seller's feedback and you have a doubt or a question, contact the last few bidders who have purchased from this seller and ask them how they fared in their dealings with him. If they say that all went well, you probably will not have a problem.
- Be sure you know the current market value of the item you're considering. Check out other Web sites to see what the going price is for the camera in which you are interested.
- Pay with a credit card. That way if a problem does arise you can dispute the transaction.
- Take advantage of an escrow service, which lets you review the item you're buying before payment is released to the seller.
- Insure the package. Make sure the insurance covers replacement value of the item.

Don't get carried away with auction fever. Just like a live auction, buying at an online auction can cause bidding wars. Don't fall victim to one and pay too much for your camera.

Find out the return policy of the retailer, so that if a problem with your camera should arise you'll know that the retailer will correct it to your satisfaction, without charging you a restocking fee.

Is It Time to Buy?

Buying a digital camera is a lot like buying a computer: It's hard to know if you should buy one now or hold out for a while. Should you pick from the models that are currently on store shelves or wait for technology—which is constantly evolving—to come out with a model that has even more bells and whistles, and probably carries a lower price tag as well?

In 1965, Gordon Moore, who was then research and development director for Fairchild Semiconductor and who later went on to become one of the founders of Intel Corporation, predicted that the density of transistors on a chip would double every eighteen months. As the ability to put more and more transistors on a chip increases, the cost per unit of computing power declines. Today, Moore's Law, as his prediction came to be called, has turned out to be extremely accurate. In the past three decades or so, the number of transistors on a chip has grown from 2,300 to 28 million.

The same expansion of technology applies in the digital world, meaning that if you wait about six months, you'll be able to buy an even better camera for less money. And if you plan to keep up with the rapidly changing digital world of photography, you can count on replacing your camera system every two to three years.

The first hurdle is to decide whether to purchase a digital camera at all. Once you've decided you do want to take the plunge into the world of digicams, it becomes a question of when to make the leap. But the truth is this: New and better models will always be on the horizon. Meanwhile, while you're agonizing over whether to buy a digicam, you could be out there enjoying one.

QUESTIONS?

What do I ask?
How much does the camera cost? What resolution does it have? How much storage does it provide? What format does it use for storage? How does it get photos to my computer? Does it have optical or digital zoom? Does it use resolution interpolation? Does it offer voice or video recording?

Care and Feeding of a Digicam

Once you bring home your digital camera, you will want to protect your investment by taking good care of it.

The first thing to do is to purchase a sturdy camera bag. Be sure it's roomy enough to hold all your supplies, including your batteries and camera

accessories. Many manufacturers of camera bags now make them to fit digital cameras. Although digital camera bags are smaller in size, they offer the same high-quality materials as 35mm camera bags. When storing your camera, use your camera bag to protect it from bumps, dust, heat, and humidity. Remove the batteries before storing it. Never put your camera near strong magnetic fields, such as those found in electric motors. If you do, your image data may sustain damage.

Put together a cleaning kit and keep it nearby so you can clean off the inevitable finger smudges, dust, and grit that will settle on your camera and accessories. Your kit can be simply a package of lens tissues, or you may want to invest in some microfiber cloths, a lens brush, and cleaning solution.

ALERT

Whatever you do, don't attempt to use paper tissues or paper towels to clean your camera lenses—they can seriously scratch your equipment. Always use specially made lens tissues or microfiber cloths.

When shooting in a wet or dusty place, put your camera inside a plastic sandwich bag in which you've cut a small hole for the camera lens. Use a rubber band to seal the opening. The bag will keep moisture and grime out of your camera.

Although your digicam can tolerate slightly more heat than 35mm cameras, you should still protect it from high temperatures. Never leave your camera in a hot car. A hot car parked in the sun will turn into an oven, and you may come back to find your camera "baked" beyond repair. At the beach, a plastic bag will protect it from sand and salty air. Covering it with a light-colored cloth will reflect the sunlight. Once indoors, never place your camera near radiators or other heat sources. If your camera is exposed to direct sunlight, let it cool down again before using it.

Cold can also cripple your camera. When shooting outside in cold temps, place your camera underneath your coat to protect it from the elements. Remember that batteries will weaken in the cold so you may want to take extras along with you.

When bringing your camera inside after being exposed to the cold, protect it from condensation by wrapping it in a plastic bag or towel until it attains room temperature. If condensation does occur, do not take it back out into the cold, or the condensation can freeze up its operation. Take out the batteries and the memory cards and leave the camera open until everything has dried out.

Treat your camera with a little TLC and it will provide you with enjoyment for years to come.

CHAPTER 5
Image Sensors

Digital cameras use image sensors to capture pictures. As you already know, there are two types of image sensors: CCD (charge-coupled device) and CMOS (complementary metal oxide semi-conductor). Not long ago, the only image sensors used in cameras were CCDs. Both types capture light in essentially the same manner, but they differ in the ways they are manufactured and how they process images. CCDs are created using a special manufacturing process that enables them to transport charge across the chip without distortion. CMOS chips are made using the same processes as microprocessors.

CCD Versus CMOS

Because of differences in manufacturing, there are several differences between CCD and CMOS sensors. But what do these technical differences mean to you in practical terms? Here's how they stack up:

- CMOS tend to be more susceptible to noise (small defects in the image). CCD sensors create high-quality, low-noise images.
- CMOS chips are less expensive to make than CCDs.
- CCD sensors tend to have high-quality pixels and more of them.

QUESTIONS?

What is noise?
Noise comes from the light sensors in your digicam, resulting in an image that appears grainy, similar to a snowy image on your TV screen. Noise tends to appear when you choose an ISO rating that is too high, or when you use image-editing software to correct an underexposed area.

Due to these differences, CCDs are commonly used in cameras that create high-quality images with lots of pixels and superior light sensitivity. However, CCD chips have a problem with blooming, meaning they tend to produce undesired halos around very bright highlights.

Blooming can occur when there is an area of concentrated light in your frame. It can happen in very bright daylight, studio light, or if there is a bright source of glare in your scene. For instance, if you're shooting a picture of the relatives gathered at the Thanksgiving table, the glowing candles on the table can cause blooming. The camera's CCD sensors will overload, then the charge from the overexposed pixels seeps into adjacent cells, causing a colored halo to form around bright or shiny objects, or as random flashes of light.

The early CMOS sensors tended to have lower quality, lower resolution, and lower sensitivity. Now, however, technology is advancing to such a

degree that CMOS image sensors will likely continue to improve until they equal CCD devices in most applications.

SSENTIALS

Prevent blooming by using a neutral density filter when shooting in full sunlight or when shooting a well-lighted scene with a darker foreground.

CMOS cameras currently offer several advantages, including lower price tags and great battery life. Also, CMOS chips are better at capturing highlights than CCDs, making them a better choice for shooting objects such as jewelry or capturing the glint of sunlight on the ocean.

FACTS

The Canon EOS D30 was the first high-end digital SLR from a major manufacturer to use a CMOS image sensor. Its high-resolution images are applicable for a variety of professional uses.

Digital Technology Is Out of This World

The National Aeronautics and Space Administration (NASA), in a quest for lightweight imaging systems for interplanetary spacecraft and other applications, undertook research to develop a computer chip that would be more advanced than the CCD developed at Bell Laboratories.

In 1992 the NASA Jet Propulsion Laboratory (JPL) expanded the CCD technology to create the complementary metal-oxide semiconductor active pixel sensors (CMOS APS). Today, the CMOS technology that enables consumers to snap digital photos also allows spacecraft to gather images for use by NASA.

Once such craft is NASA's NEAR (Near Earth Asteroid Rendezvous) Shoemaker, which orbited 433 Eros, a near-Earth asteroid 19 million miles from Earth, for a full year, providing scientists with an abundance of data that included more than 100,000 close-up images. In early 2001, the NEAR Shoemaker became the first spacecraft to touch down and operate on the

surface of an asteroid, generating even more detailed images of the asteroid's surface for scientists to ponder.

Image Sensor Resolution

In the previous chapter you discovered that digital photographs are made up of tiny squares called pixels. When you take a photo with a digital camera, each of the pixels is captured by a single photosite on the image sensor. A computer and printer use the pixels to display or print photographs.

To create the image, the computer divides the screen or printed area into a grid of pixels. Then it uses the values stored in the digital photograph to specify the brightness and color of each pixel in the grid. This process is called bit-mapping, and the resulting digital images are called bit-maps.

Once a digital image is printed or displayed on a screen, its quality is determined in part by the number of pixels used in creating the image (its resolution). The number of photosites on the image sensor determines the maximum number you are able to capture.

It's important to understand how image sensors operate in order to grasp the concept of resolution. You will need to understand resolution in order to understand the workings of a digital camera, scanner, and printer. This knowledge will help you buy and operate the equipment required by a digital photographer.

Aspect Ratio

The aspect ratio is the ratio of image width to image height, and it varies among image sensors. The ratio of a square is 1:1 (the width equals the height), and the ratio of 35mm film is 1.5:1 (it is 1.5 times wider than it is high).

The aspect ratio determines the shape and proportions of your digital images. When an image has an aspect ratio that differs from the device

on which it is being displayed or printed, the image must be cropped or resized to fit. It's a bit like trying to fit a square image on a rectangular piece of paper.

The aspect ratio of a camera can be calculated by dividing the larger number in its resolution by the smaller number. For instance, if a sensor has a resolution of 1,536 x 1,024, you would divide 1,536 by 1,024, for an aspect ratio of 1.5.

ESSENTIALS

Understanding aspect ratios will help you when you're evaluating a digital camera for purchase and when you are manipulating images with software programs.

Color Depth

Although resolution is an important determinant of the quality of an image, another equally important factor is color depth. Color depth is the term used to refer to the number of colors in an image. It is also called pixel depth or bit depth. Older computers have displays that only show 16 or 256 colors. Most new computer systems display what is known as 24-bit true color. The term true color is used, because the systems display 16 million colors, which is about the same number as can be discerned by the human eye.

You'll learn more about color (bit) depth in Chapter 17.

Frame Rate

Digital cameras experience two delays that affect the photographer's ability to capture fast-action shots. The first delay, just a second or two, occurs once you have pressed the shutter button and before the camera actually captures the image. This delay is known as the refresh rate. During this small delay, the camera is preparing to take the picture by clearing the image sensor, setting the white balance to correct the color, setting the exposure, and focusing the image. Last, if needed, the camera fires the flash, then takes the picture.

The second delay, called recycle time, is a lapse of from a few seconds up to half a minute and happens when the captured image is processed and stored.

How quickly a series of photos can be taken in succession is known as the frame rate, shot-to-shot rate, or click-to-click rate. Both of the delays described above affect the frame rate. If the frame rate is not quick enough, the photographer can miss a desired shot.

Some cameras offer a burst mode, which lets the photographer take photo after photo while holding down the shutter button. To increase the frame rate, these cameras often decrease the resolution used to capture the images. Some even divide the image sensor into sections and store a single low-res image in each section, then process them all at once. Some digital cameras reduce recycle time by temporarily storing a series of images in the camera's RAM until they can be processed. A camera with burst mode enables the photographer to easily capture action shots. More information on burst mode and action shots is found in Chapters 10 and 12.

Sensitivity

If you've purchased film for an analog camera, you have encountered the ISO (International Organization for Standardization) number, which appears on the film package. This number, such as 100, 200, and 400, represents the speed, or sensitivity, of the film. The higher the number, the more sensitive the film is to light. The ISO numbers indicate that the film speeds are doubling as the numbers increase.

Image sensors are also rated using ISO numbers, which are meant to be approximately equivalent to film ISOs. The lower the ISO of an image sensor, the more light is needed for a good exposure. A camera with a higher ISO will enhance freezing motion and shooting in low light. Image sensors' ISOs can range from 100 to 1600, but most consumer digicams are rated ISO 100. This is the reason that digital cameras often do not work well in low-light conditions, and why many come with built-in flash.

Information on operating a flash and taking photos in various lighting conditions can be found in Chapters 8 and 13.

There are some digital cameras that allow you to change the sensitivity of the image sensor, such as the Olympus C-3030 and S-2500 and the Nikon 950 and 990. You probably won't be able to boost the ISO beyond 400, but at least that will allow you to shoot in most interiors.

Remember that when you boost the ISO, you're more apt to encounter noise problems with your images.

Image Quality

The resolution of an image affects the size of the image file to some degree. The higher the resolution, the greater the number of pixels that must be stored, resulting in a larger image file.

In order to make image files more manageable, most digicams store images in a format known as JPEG, which was developed by the Joint Photographic Experts Group. The JPEG format compresses the images; the photographer specifies to what degree they are compressed.

Compressing files compromises image quality, so having some control over compression is useful. You can choose to store fewer images of higher resolution, resulting in better prints. Or you can increase compression and store more images of low resolution suitable for sending via e-mail or posting on a Web site but not suitable for high-quality prints. Compression will be discussed in more detail in Chapter 15.

CHAPTER 6

Image Storage (Memory)

With film cameras, the film serves two purposes: It records the image, and it stores the image. With digital cameras, two separate devices perform these functions. The image sensor, captures the image, and a storage device stores it. Some cameras have fixed (internal) storage that cannot be increased or removed. Once you've filled up the camera's memory, you cannot continue shooting until you've downloaded your images to a computer.

Removable Memory Versus Fixed Storage

The recent development of new storage media and associated readers allows you greater freedom. More expansive memory capabilities mean more pictures per load, giving greater convenience and the ability to capture more high-res images on a storage device. When you're equipped with the latest storage media in the field, you'll have the satisfaction of shooting for long periods without interruption.

Thanks to advances in technology, new storage media are being introduced every several months. Undoubtedly, by the time you read this text other storage media options will have been introduced in the marketplace. At the time of publication, however, the following types of removable media were available for digital photographers:

- PC cards
- Floppy disks
- CompactFlash
- SmartMedia

All forms of removable media allow the photographer to remove the storage device when it is full and replace it with another.

Several factors impact the number of images you can store in your digital camera:

- The resolution of the images
- The amount of compression used
- The capacity of the storage media

When calculating how much storage capacity you'll need in a camera, you should consider the number of shots you normally take with a film camera. (For instance, if you typically use two rolls of film with twenty-four shots each, that's forty-eight shots.) Your camera's memory will need to accommodate the same number of shots, calculated by multiplying the number of images the storage device holds by the number of storage devices you are willing to carry with you.

Flash Memory Cards

Older models of digital cameras sometimes use floppy disks or PC cards. Almost all newer models use a form of flash memory.

Flash memory cards use SRAM (static RAM technology that holds data without electric current). They come in many sizes, shapes, and storage capacities. They do not require batteries, and they do not lose images when the power is switched off. Rugged flash memory cards take up little space and use up little power.

ESSENTIALS

Their small size and light weight make flash memory cards convenient and easy to carry, so you can take lots of them with you and replace them as necessary during a photo shoot.

Types of Flash Cards

There are a number of different types of flash cards. In the past they were not interchangeable. Today, however, card readers have been developed to help bridge the gap between various models of digicams and memory cards. (More on readers later in this chapter.)

Since flash memory devices have no moving parts, they are almost indestructible. Digital Imaging magazine online recently recounted the story of Ron Rosenberg, a radio commentator from California, whose water plane crashed while he was attempting a landing, sending his HP 200LX handheld computer to the bottom of a lake. Several months later, a diver found the computer and returned it to Rosenberg. Inside he found his SanDisk CompactFlash (CF) card containing 3,000 phone numbers. Carefully drying off the CF card, he inserted it into a computer, and it worked perfectly. Such is the durability of today's flash memory cards.

PC Cards

Flash memory cards first began gaining wide acceptance when PCMCIA (Personal Computer Memory Card International Association) cards were introduced several years ago. Today, they're frequently referred to as PC

cards. These small cards, about the size of a typical business card, were originally designed to be utilized with laptop computers.

Most of the PC cards adhered to ATA (AT Attachment) standards. ATA was designed as a standard interface for storage devices such as disk drives and flash memory cards for the mobile computer market. An ATA-compatible card was guaranteed to work with any system supporting ATA, including digital cameras. An ATA-compatible card should also work with all major operating systems, including DOS, Windows, and Mac OS.

Unfortunately, not all ATA-compliant flash cards work with all digital cameras. Most major vendors do support ATA, but some camera manufacturers do not. To determine if your digital camera supports ATA, check the operating manual.

Initially, PC cards were offered in three types: Type I, II, and III. The three types were identical in length and width but differed in thickness. Type I was 3.3 mm thick, Type II was 5 mm thick, and Type III was 10.5 mm thick. Today, Type II is the leading format for PC card storage devices. Type II cards are currently available in several storage capabilities, from 128 MB to 400 MB, with a 1.2 GB card expected soon. However, few consumer cameras use Type II PC cards. Type II cards are mainly used for upscale professional cameras.

CompactFlash and SmartMedia Cards

The majority of consumer cameras today use CompactFlash cards for memory storage. CompactFlash uses the same memory storage devices as the PC cards, but does so in a much smaller package, measuring 1.7" x 1.4". CF cards are available in two types: Type I, which is 3.3 mm thick; and Type II, which is 5.0 mm thick.

Not long ago, Delkin Devices increased the capacity of its CompactFlash (Type I) memory cards from 128 MB to 256 MB and its CompactFlash Type II cards to 512 MB. Part of their eFilm lineup,

these CF cards are designed to store the maximum number of high-res images taken with today's larger megapixel digital cameras.

Lexar Media recently began marketing its USB-enabled Pro Series CompactFlash cards with 320 MB of data storage. The faster write speeds (ten to twelve times that of a standard card) make them ideal for use with high-end digicams.

SmartMedia is a major competitor of CompactFlash and is used by a number of camera manufacturers. Like CompactFlash, SmartMedia is based on ATA technology. Compared to CompactFlash, SmartMedia cards are a similar size, slightly less expensive, and gaining in popularity.

Delkin's eFilm lineup also includes a 128 MB SmartMedia card, which incorporates Samsung flash technology to provide data retention for more than ten years and up to 1 million program-erase cycles.

PC Card Adapters

PC card adapters allow CompactFlash and SmartMedia cards to be read as if they were standard PC cards. After putting the memory card in the adapter, you insert the adapter into your computer's PC card slot or into a PC card reader. The PC card appears as a drive on the computer desktop. You simply drag and drop image files from the PC card to the hard drive.

Memory Card Readers

Various manufacturers have developed memory readers, which also allow you a means of quickly and easily transferring digital images from digital cameras, as well as from MP3 players, personal digital assistants (PDAs), and the Internet. The readers enable you to copy and move digital files stored on SmartMedia and CompactFlash memory cards from one digital appliance to another, or between computers, external storage drives, and the Internet.

One such reader is the Vector Flash Memory Reader from SmartDisk. Another is ActionTec's PC805 PC Card Reader, which accepts three types of media without adapters: Type I and II AT Flash PC, CompactFlash, and

SmartMedia Cards. The external reader connects to the parallel port and keyboard connectors of PCs.

Another new card reader is the eFilm Pocket Reader from Delkin. It's tiny (about the size of a key chain ornament), lightweight, and requires no cables so it's ideal for use by digital photographers in the field. A USB connector built into the back of the unit allows it to plug into any USB port on a laptop or desktop computer. Three versions are available for CompactFlash, SmartMedia, and the IBM Microdrive.

Disk Adapters

Disk adapters allow your floppy disk drive to read SmartMedia cards. The card is inserted into the adapter, and then the adapter is put into the floppy drive. Next, you drag and drop image files from the floppy drive to your hard drive, just like you would with any other file from a floppy disk.

Storage on the Go

Recently, Minds@Work introduced a portable storage device called Digital Wallet. The Wallet offers 3, 10, or 20 GB of portable storage in a compact, handheld unit. The storage media from your digicam is inserted into the Wallet, and in a few seconds your images are downloaded. The Wallet works with most media types, including CompactFlash, SmartMedia, and IBM's Microdrive. Once you're back at your computer, you simply download your images from the Wallet.

Cutting-Edge Digicam and Storage Media

In late 2000 Sanyo announced a new type of digital disk camera. The IDC-1000Z iDshot digital camera is the first camera to utilize the iD PHOTO disk. The iD PHOTO media standards were developed jointly by Sanyo, Olympus Optical Co., Ltd., and Hitachi Maxell Ltd.

Sanyo's iD PHOTO magneto-optical disk features 730 MB of storage and is capable of saving both still and moving images. It holds approximately two hours of moving image recording at 160 normal mode (160 x 120 pixels), or about 11,000 still images. The camera achieves

high-definition still images at 1.5 megapixels and moving image clips at 30 frames per second with high-quality VGA images.

In early 2001 DataPlay announced its version of optical media. DataPlay's optical technology holds 500 MB of data on digital media about the size of a quarter. Extremely inexpensive, the DataPlay digital media are likely to retail for $5 to $10 when they appear in the marketplace in the second half of 2001, offering a low-cost alternative to flash memory cards. Digital cameras from Toshiba are expected to accommodate the DataPlay digital media.

ESSENTIALS

Before inserting a memory card into your digicam, it may need to be formatted to receive your digital images. Check your camera's manual for more details.

Caring for Your Memory Cards

The memory cards you buy for your digital camera represent a considerable financial investment. Not only that, they act as your camera's "film," allowing you to do what you like to do best-taking pictures. You'll want to get the most that you can from your memory cards and protect the images you've taken once they are stored there. Following the suggestions below will ensure that your CompactFlash and SmartMedia cards function superbly:

- Wait for your camera to finish recording the data on the card before trying to take the card out of your camera. Never remove the card while the camera is still processing information.
- Don't switch off the power to the camera while it is accessing the card.
- There are certain areas of the memory card that you should avoid touching with your fingers. On the CompactFlash card, avoid the connector on the bottom of the card. With SmartMedia, don't touch the gold section at the top of the card.
- Protect your memory cards from heat, humidity, dirt, and static electricity. If your card gets dirty, you can use a soft cloth to gently wipe it off.

CHAPTER 7
Lenses

A primary component of your digital camera is the lens. The lens is made of optical glass or plastic that has been designed to gather light reflected from the subject and project it onto the image sensor in the digital camera. The lens serves as your camera's eye, determining what your camera can see and how well what is seen is conveyed to the camera's image sensor. No matter how many megapixels a camera has, if it has a low-quality lens, the picture quality will be inferior. That's why it is important to know the details of the lens on any camera you are considering purchasing.

Focal Length

One of the most important characteristics of a lens is its focal length. On film cameras, the focal length is the measurement of the distance between the center of the lens and the film. On a digital camera, the focal length measures the distance between the lens and the image sensor. In both cases, focal length is measured in millimeters.

On a 35mm camera, a lens with a focal length of less than 35 mm is known as a short, or wide-angle, lens. One with over 65 mm is considered a long, or telephoto, lens. And lenses with focal lengths between 35 mm and 65 mm are considered normal. The 50mm lens is the most common lens.

FACTS

With digital cameras, the actual focal lengths do not provide useful information. Therefore, manufacturers typically provide the equivalent 35mm focal lengths.

By changing focal lengths, you immediately change the lens's angle of view and its magnifying power. The term angle of view describes how much of a scene the lens captures. A short lens has a wide angle of view, meaning it can capture a wide expanse of a scene. A long lens has a narrower angle of view so it will isolate small sections of the scene.

Magnification goes hand in hand with angle of view. A short lens, with its wide angle of view, requires all the objects in a scene to be reduced in size in order to fit into the image sensor. It has the effect of pushing the subject away from you. Conversely, the long lens, with its corresponding narrow angle of view, will have the effect of pulling objects in a scene close to you, causing them to appear larger.

When you choose a lens for your digital camera, the first question to ask yourself is how you plan to use your camera. If you want to photograph landscapes, buildings, and interiors, wide-angle lenses will best suit your needs. If you are interested in shooting portraits or nature scenes, telephoto lenses will do the trick. A middle ground would be a normal lens.

Determining Focal Length

How is focal length determined to be wide, normal, or long? When the focal length of a lens is close to the diagonal measurement of the film format, the lens is called normal, or close to the magnification of the human eye. When the focal length is longer than the film diagonal, it's known as long, or telephoto. When the focal length is shorter than the film diagonal, it is referred to as short, or a wide-angle lens.

Categorizing lenses is based on the film size being used, so a given focal length might be considered normal on one type of camera, wide angle on another, and telephoto on a third. The chart below lists some common film formats and the focal lengths of their normal lenses.

Film Format	Film Diagonal (mm)	Normal Lens
35 mm	43 mm	50 mm
2¼" x 2¼"	90 mm	80 mm
4" x 5"	163 mm	150 mm

The same parameters determine the wide-angle, normal, and telephoto lenses of digital cameras as film cameras.

To make it simpler for photographers to understand, references to digital camera's lens focal lengths are often referred to with the corresponding equivalent in 35mm camera lens. For instance, the spec sheet for the PowerShot S300 Digital Elph camera describes the lens as being 5.4–16.2 mm with a 35mm film equivalent of 35–105 mm.

ESSENTIALS

Keep your lens free of dust and grit and you will protect the glare-reducing coating and the glass itself. A lens cleaning kit with a blower brush and lint-free tissue is a must. Protect your lens by keeping a UV filter on it at all times.

Maximum Aperture

When taking a picture, you press the shutter release and the shutter opens to emit light from the scene to be focused onto the image sensor. To get the ideal exposure, just the right amount of light must strike the image sensor. If there is too much or too little light, you'll need to adjust the amount of light. One way to do so is by opening or closing the lens's aperture, an adjustable opening that regulates how much light passes through the lens. "Stopping" down the aperture makes it smaller so it lets in less light. Opening it up lets in more light.

The size of the aperture is measured in f-stops, which control the depth of field. With few exceptions, each f-stop lets in half as much light as the next larger opening and twice as much light as the next smaller one. From largest opening to smallest, standard f-stops are as follows: f/1, f/1.4, f/2, f/2.8, f/4, f/5.6, f/8, f/11, f/16, f/22, f/32, and f/45. F-stops are a little confusing because the larger the f-stop, the smaller the amount of light that is let into the camera. The easiest way to think of f-stops is in terms of fractions: just as $\frac{1}{16}$ is less than $\frac{1}{8}$ an f-stop of f/16 is smaller than, and lets in less light than, f/8.

FACTS

You won't find the full range of settings on any one lens. Usually, the standard lens on a digicam will be in the f/2 to f/16 range.

The maximum aperture of a lens determines how much you can open it. The maximum aperture is also referred to as the maximum iris, or the speed of a lens. Although lenses are referred to by their focal length, the description of a lens also carries a second number, such as 2.0 or 3.5, which indicates the maximum aperture of the lens. Larger maximum apertures, such as f/1.8, let in more light than smaller apertures, such as f/3.2, allowing you to take better shots in low-light situations.

Focusing Methods

Although most digital cameras with noninterchangeable lenses are either fixed focus or auto focus, there are other possibilities.

Fixed Focus

A fixed-focus lens is a simple lens with no moving parts; the lens cannot be adjusted. The camera captures sharp images of any subject within a certain distance from the lens, usually from six feet to infinity. Objects outside that range will appear out of focus. Usually, objects that are too close to the camera will appear blurry because the focus is adjusted for a specific distance from the camera to infinity.

FACTS

The minimum focusing distance specifies how close to the subject you can place the camera. That is, it controls your ability to take close-up shots. If you are planning to take a lot of close-up shots, be sure to check the minimum focusing distance of any camera you're thinking of purchasing.

For many years most simple cameras, like the Kodak Brownie, had fixed-focus lenses. Millions of people took pictures and were happy with their snapshots, and since the pictures were seldom enlarged they provided acceptable quality.

Today, low-end digital cameras typically are equipped with fixed-focus lenses. If you're a beginning digital photographer, you may want to start with a camera that has a fixed-focus lens. However, you should note that fixed-focus lenses provide the photographer with fewer options and, therefore, fewer creative possibilities.

Manual Focus

Manual focus permits the user to adjust the focal point from three different distances, which allows for more creative control. Typically, the settings are macro mode (extreme close-ups), portrait mode (for subjects about twelve feet from the camera), and landscape mode.

Autofocus

An autofocus camera offers a more precise and versatile system than a fixed-focus camera. Cameras with autofocus automatically adjust the

focus depending on the distance of the subject from the camera. Sometimes an autofocus camera will also offer focus lock. This feature lets the photographer stipulate exactly what object the camera should focus on. Usually this is accomplished by centering the subject in the viewfinder, pressing down the shutter button halfway to "lock" the focus, then reframing your shot and taking the picture.

Some high-end digital cameras allow the photographer to set the focus point a specific distance away, such as one foot or four feet. When taking a shot of a scene with many elements, this can be a useful feature. For instance, if you are shooting a picture of a woman standing in front of a statue, the autofocus may lock on the statue rather than on the individual.

ESSENTIALS

Autofocus adds to the expense of a camera, but it typically renders better images. With the demand for print quality in digital images on the rise, more and more manufacturers are producing digital cameras with autofocus.

Types of Lenses

Lenses are generally categorized as integrated, interchangeable, zoom, and macro.

Integrated Lenses

An integrated lens is part of the camera and is not detachable. Some integrated lenses allow you to add supplementary lenses. Typically, supplementary lenses screw onto the lens barrel thread or slip over it with a friction mount. A supplementary lens changes the viewing angle of the lens or allows it to focus more closely than it would in macro mode.

Interchangeable Lenses

An interchangeable lens can be detached from the camera and replaced with another lens having the same type of mount. Professional photographers rely on interchangeable lenses to create desired effects

depending on the situation they are shooting. If you are considering purchasing a digital camera with an interchangeable lens, be sure to investigate the number and types of lenses that can be used.

Zoom Lenses

A zoom lens has a variable focal length, meaning it allows you to adjust the focal length over a variety of ranges. The range of focal lengths a zoom lens covers usually is specified by its magnification. For instance, a 3X zoom lens will enlarge or reduce the subject in an image by three times. Usually, the equivalent range when used on a 35mm camera also is given, such as 38 mm–114 mm.

Zoom lenses are either optical or digital. An optical zoom lens truly changes the amount of the subject falling on the image sensor. This results in every pixel in the image containing unique data, providing a final photo that is crisp and clear. The advantage of an optical zoom is its ability to take more detailed pictures of faraway objects. An optical zoom's magnification level is measured in degrees, such as 2X or 3X. A 2X optical zoom means that if the camera's minimum focal length is 50 mm, the lens has the ability to take photos up to 100 mm.

FACTS

The term optical zoom refers to a lens that magnifies an image using a real multifocal lens, as opposed to a digital zoom that only enlarges the center by 50 percent.

A digital zoom takes a part of the normal image and enlarges it to give the appearance that you have zoomed in on the subject. The digital zoom adds new pixels to the image using interpolation.

If you are given a choice, you should always choose the optical zoom over the digital zoom. The digital zoom lens is not really zooming. By enlarging part of the image it is only giving the appearance of having zoomed in on the subject. With an optical zoom, you can vary the focal length. When you zoom in, the focal length increases (**SEE FIGURE 7-1**). When you zoom out, the focal length decreases.

FIGURE 7-1:
Using a zoom
lens, the pho-
tographer was
able to capture
the exquisite
detail of an
old piano.

Photo by Philip Thornberry

Macro Lenses

A macro lens allows you to focus while standing very close to your subject in order to take close-up shots. It is designed to maintain superior sharpness and contrast when focused on a subject that is very near the camera. Most macro lenses are made in a single focal length. Although some have wide-angle or telephoto focal lengths, typically a macro lens has a normal field of view.

FACTS

A lens can be made of glass or plastic elements. Glass tends to provide higher optical quality and greater resistance to scratches. Lenses are coated to cut down on reflections that can occur on the surfaces of lens elements, causing a blurring of the image. Read reviews of lenses in photography magazines and Web sites to determine which ones are of highest quality.

Some digital cameras can focus as close as one or two inches from the subject. This capability will be appreciated by the nature photographer hoping to catch the opening buds of wild orchids in the spring or tiny

crabs scampering down a beach. A macro lens can come in handy even around your own home. With a macro lens on your digicam, getting down on your knees for a close-up shot of your new kitten can provide delightful results.

ESSENTIALS

In addition to shooting close to the subject, the macro mode allows you to use your camera like a scanner to make digital images of illustrations, analog photographs, and other objects that would otherwise be scanned on a flatbed scanner.

Taking a Closer Look at Macro Photography

The world is a marvelous place, especially when viewed close up. Digital cameras that have noninterchangeable lenses typically feature a macro, or close-up, mode. To get the best effects from your macro photography, keep these tips in mind:

- Check your camera's manual to see what the range is for your macro mode. (It can vary from a few inches to as much as eighteen inches.) Then stay within that range.
- It's difficult to know how your image will really look if you depend solely on your viewfinder. You're better off previewing your shot with the LCD screen. This is often true but especially when shooting in macro mode.
- If your digicam is equipped with a zoom lens, set it at the maximum wide-angle position. Otherwise, it will be difficult to focus correctly to get that macro shot.
- If your digicam has an adjustable ISO setting, set the sensitivity higher. This increases the depth of field, bringing your macro shot into focus.
- Forget about using your onboard flash. Usually the flash is designed to work further than the macro range.
- It's essential to keep the camera steady. Use a tripod.
- If your camera offers a manual focusing feature, use it to take a great close-up shot.

- All digicams offer autofocus. Sometimes an autofocus camera also will offer focus lock. This feature lets you stipulate exactly what object the camera should focus on. Usually this is accomplished by centering the subject in the viewfinder, pressing down the shutter button halfway to "lock" the focus, then reframing your shot and taking the picture. Review the playback to make sure the focus was exact.

Lens Accessories

One drawback to less expensive digital cameras is their lack of interchangeable lenses. However, if a camera has a screw-thread ring inside the front of the lens barrel, it can probably accommodate supplementary lenses and filters. When shopping for a digital camera, you may want to look for one with an interchangeable lens capability, especially if you plan to take many different types of photos.

Filters

Photographic filters are used to correct the color of light or provide a special effect. Some important filters are as follows:

- *UV (ultraviolet)*—A UV filter removes ultraviolet light, which commonly shows up in the background of distant shots as a bluish haze. The UV filter causes your photo to look more like the scene you see when taking the picture. However, a UV filter is also a great tool for protecting your camera lens so you may want to leave it in place even when you are not photographing landscapes.
- *Polarizing*—Polarizing filters remove glare caused by reflected light and tend to improve color saturation. A polarizing filter will darken a blue sky and add richness to colors.
- *Light*—Balancing filters are available in either neutral density or color temperature converters. When taking pictures in brightly lit situations, a neutral density (gray) filter will reduce the light coming through the lens so that you can use a wider aperture to get less depth of field. Color temperature converters change the color of light to balance the type of film being used. But in a digital camera, color temperature

converters are unnecessary since you can achieve the same effect by using your camera's color (white) balance.

Lens Hood

A lens hood, or lens shade, hinders unwanted light from striking the lens. It also affords your lens some protection from knocks and bumps.

Lens Cap

A lens cover is a little thing, but it can offer big protection for your camera's lens. Lenses on digital cameras are particularly susceptible to scratching and smearing as the cameras are so small that your fingers may wind up on top of the lens.

Look for a camera with a lens cap that automatically covers the lens when the camera's power is turned off. Barring that, attach your lens cap to the camera with a string to help prevent your losing it. Try to hold onto the lens cap that came with your digital camera; because the digicam lens caps are so small, it's hard to find replacements. If you do come across a lens cap that fits your digital camera, it might be a good idea to invest in a spare.

Evaluating a Lens

When purchasing a digital camera, many folks forget to consider a very important component of the camera: the lens. Along with the image sensor, the lens is the part of the camera that will most critically affect the quality of your photographs. The tips below will help you judge the lens on the camera you're considering purchasing:

- Who made the lens? If it is a manufacturer known for making high-quality optics, such as Nikon, Canon, or Olympus, this is an indication that your images will be crisp and colorful.
- Does the lens use plastic or glass optics? Generally, glass optics are better, although high-quality images can result from both.
- Can you attach filters to the lens?

- Test drive a zoom lens. Stand ten or twelve feet away from a group of people, look through the lens, and zoom all the way out to wide angle. How many people are in the shot? Try out the telephoto end the same way. Remember to consider the types of shots you'll be taking. The goal is to get as much original image data into the camera as possible.
- Is the zoom lens motor driven? Or can you zoom manually? If it's motor driven, you'll use up your batteries faster. You also will want to note how long it takes to zoom.

FACTS

If the 2X or 3X zoom lens on your digicam doesn't provide enough power for you, you may want to take a look at the Canon PowerShot Pro90 IS. Its 10X zoom offers a range of coverage equal to a 37 mm to 370 mm lens on a 35mm camera. Telephoto lenses are perfect for capturing shots of distant subjects, but they make it difficult to hold the camera steady enough to get a crisp picture. Canon has designed its Image Stabilizer so the PowerShot Pro90 will get clear photos, even at full zoom.

CHAPTER 8
Flash

U nless you're a professional photographer, the chances are good that the camera you're using—whether film or digital—has a built-in flash. Typically, when shooting indoors, the flash will work adequately if the subject you're shooting is within ten to twelve feet. Although your built-in flash will permit you to take a photo in a low-light environment, it will not provide the same effect as natural lighting. Rather, pictures taken with an on-camera flash tend to look similar, since the flash produces a flat light that minimizes surface textures.

Limitations

You will need to experiment a bit to see what your digicam's flash can and cannot do. Most built-in flash units are small and are designed to light up subjects close by. If you're in a situation where you're shooting a large area, such as at a sporting arena, the flash can't possibly illuminate the whole scene. If you try to shoot the entire stadium, you're likely to end up with an underexposed photo.

Some more expensive models have stronger flashes that work at longer distances. Or they may have a hot shoe, a mounting device that enables the addition of a flash unit.

Try out your flash in several different situations. Take a series of indoor shots with your subject standing or sitting at different distances from your camera. Take shots of your subject in front of a light source, such as a window, with and without the flash to see how a flash can "fill" in darkened areas.

Settings

Some cameras allow you to adjust your flash unit to one of the following modes:

Auto Flash

The camera gauges the available light and fires the flash if needed. In certain situations, the resulting image can be well lit, but the background may be almost black. Some high-end cameras avoid the problem of silhouettes by firing the flash if they detect a backlit situation.

Because every flash has a useful range, the effects of the auto flash will depend on how bright a light it produces and how far the light has to travel. Flash light becomes dimmer the farther it has to travel. The further away the subject is from the camera, the less light will be reflected back to the camera. Objects closer to the camera will appear lighter than objects in the background.

When you are taking a photo of a scene with multiple subjects at different distances from the camera, the exposure cannot be correct for

all of the subjects. Usually those closest to the camera will be properly exposed. The farther the subjects are from the camera, the darker they will appear in the picture.

Fill Flash

The fill flash mode allows you to add light to an image without affecting the exposure settings. A photographer will turn on the fill flash mode when he wants to add light to the backlit (shadowed) areas in the scene he is shooting. For instance, if a subject is standing in front of a large window, turning on the fill flash will help illuminate the subject's face so that he or she does not look like a dark shadow. A photographer can also use fill flash in normal sunlight when he or she wants to fill in the shadows on the subject.

SSENTIALS Fill flash is a great feature of modern cameras because it shortens editing time by avoiding the problem of unwanted shadows in the first place.

Night Flash

Night flash, or night portrait mode, combines a flash exposure with a longer capture speed. This mode is ideal for shooting room lights or an evening sky with a brightly lit subject. If your camera does not have night flash, the next best thing is to use fill flash, although the results will not be quite as good. Another option is to take separate pictures of the foreground and the background and blend them using editing software.

Red-Eye Reduction

This mode helps to reduce the "red eye" effect that occurs when a flash is reflected in the subject's eyes. Red-eye reduction works by firing a low-power flash, or burst of flashes, just before the primary flash is fired. The low light causes the iris of the eye to close slightly, diminishing the chance of the flash being reflected there.

FACTS

The bad news is that red-eye reduction is not always totally successful. The good news is if your subject does end up with red eyes, you can correct the problem with image-editing software since you're using a digital system.

There are five ways to combat red eye in pictures:

- Move the external flash farther away from the camera lens
- Tell the subject not to look directly at the camera
- Increase the overall lighting in the area where the picture is being taken
- Use the red-eye reduction mode on your camera
- Use image-editing software to remove red eye

Slow-Sync Flash

Some cameras offer a slow-sync flash, which increases the exposure time beyond the normal flash. This mode helps illuminate background shadows that normal flash mode misses. The slow synchronized mode works by allowing the shutter to remain open longer than normal so that the background appears lighter.

Sometimes when using slow sync, fast moving objects or a shaky camera will cause images to blur. To avoid blurring in your photo, use a tripod and/or photograph stationary objects. If you want to make lemonade from lemons, use blur creatively for interesting effects. For instance, using slow sync to photograph moving cars can create blurry trails in the resulting image, conveying a sense of speed in the photo.

External Flash

This mode lets you use a separate flash unit similar to ones used with 35mm SLR cameras. In this mode, the camera's built-in flash is turned off and you must manually set the correct exposure to work with the flash.

FACTS

If your digicam's built-in flash is leaving you with underexposed images, consider the Digital Flash enhancement kit from Sunpak. Retailing for $49.95, the kit includes the Sunpak Digital Flash system, which can be used with any digicam or film camera having a built-in flash, hot shoe, or PC synchro contact. See *www.tocad.com* for more details.

Additional Light Sources

Hot spots and red eyes are some of the problems that can arise when shooting with a flash. If your camera works with an auxiliary flash unit, you can move the flash away from your subject, which will help reduce these problems. However, if your digicam does not accept an auxiliary flash, your best bet may be to turn off the flash and use another source of light.

Slave Unit

Your digital camera may be designed with a built-in flash and no connection for an additional flash unit. You can still get the benefits of an external flash by using a device known as a slave unit.

ESSENTIALS

Many digicams discharge an invisible pre-flash before the regular flash. The problem with standard slave units is this pre-flash triggers them, so they fire prematurely. A Digi-Slave with trigger mode two solves this problem.

A slave unit is a small battery-operated flash unit with built-in photo-eyes. The slave unit fires a flash when it senses another flash of light. There are some slave units that are designed specifically for use with a digital camera. If you're taking photos at your brother's wedding reception and the room is dimly lit, you can sprinkle slave units throughout the space.

Then, when you take a picture, all the slave units will go off at the same time, allowing you to get a great shot in the well-lit room.

Additional Lights

If you already own studio lights for use with your film equipment, they will come in handy with your digicam. If not, you may decide to purchase some inexpensive photoflood lights, the same kind that are used with video camcorders.

Another option is to use what you already have at home. Look around the house for creative solutions. Placing a subject near a window may provide enough light to do the trick. Turn on small table lamps or purchase clip-on lights at the hardware store for extra lighting. Or create a backdrop using a white sheet or board and—voilà!—you've created your own mini photography studio.

ALERT

Whatever your light source, do not aim it directly at your subject. You'll get far better results if you allow the light to bounce off background and onto your subject. This technique is called bounce lighting.

Getting the Correct Exposure

Controlling the amount of light that hits the CCD in your digital camera is one of the necessary components of capturing an image successfully—and it is one of your biggest challenges as a digital photographer. Too much or too little spoils your final image, rendering it too light or too dark. Having certain tips and tools at your disposal, along with lots of practice, will allow you to wrestle with the unpredictability of light and come up a winner.

Photographers use gray cards, available in camera stores, to help get correct exposures. Place the gray card in front of the subject so that it is in the same light as the subject. Move in close to the card so that all you see in the viewfinder is the gray card. Tip the card so that it appears as bright as possible and has a slight glare. Then tip it again to eliminate the glare and read the camera meter to find the proper settings.

Film Speed

Conventional film cameras use film of different speeds, or ISO ratings. In a similar way, CCDs in digital cameras have ISO ratings that indicate their sensitivity to light. The higher the ISO rating, the less light is needed for full exposure. For instance, a CCD with an ISO rating of 400 needs less light to achieve full exposure than a CCD with an ISO rating of 100.

If your digicam allows you to change the sensitivity of the CCD from one shot to the next, you can adjust the ISO setting as the lighting dictates. For instance, in a low-light situation you can increase the ISO setting to get as much light as possible striking the CCD.

Backlighting

When you are photographing a subject with a bright area behind him that is casting him in shadow, you're encountering the challenge of backlighting. Most folks know that when shooting outside on a sunny day the sun should always be behind the photographer. But sometimes it is simply not possible for you to set up the shot this way.

ESSENTIALS

The sun creates backlighting when it is behind your subject, casting shadows on him. However, you should be on the lookout for other backlighting situations caused by things such as white walls or windows so you can take action to avoid an underexposed photo.

A problem arises when backlighting occurs because the camera's light meter reads the scene as being overly bright and shuts down the aperture to compensate. The end result is a photograph that is underexposed.

What's the solution? First, if your camera has an exposure override, you can easily correct the problem by opening up the aperture or slowing down the shutter. By giving your subject a few more stops of light, your image will come out looking good.

You cannot always avoid backlighting, but there are ways to take a great photo anyway, even if you can't move the sun or other source of light. Here are some tips to keep in mind:

- Start with the rule we all learned with our first cameras: Position your subject so that the sun is behind you, not him.
- Let the subject stand where he is but move yourself so that the sun is behind you.
- Turn on your flash. Your camera may refer to this mode as fill flash mode as it allows you to use your flash in any light condition.

Shooting at Night

Taking photographs at night is easier today thanks to digital cameras and a few good accessories. Because your can preview your shot using the LCD screen on your digital camera, you can be quite certain of what your exposure should be. When shooting at night, be sure to use a tripod to hold the camera steady and a cable release or self-timer. Experiment with different shutter speeds.

CHAPTER 9

Batteries, LCD Screens, and Viewfinders

Digital cameras are powered by batteries. The LCD and the flash tend to drain battery power. Using the wrong batteries or shooting without conserving your batteries may result in your running out of battery power quickly. Familiarize yourself with the different types of batteries, LCD screens, and viewfinders.

Alkaline Batteries

Alkaline batteries work in most digicams. Although you may be tempted to buy these economical batteries, they are not a good choice—they won't last very long. In cold weather, alkaline batteries will die right away. Only turn to alkaline batteries if you're caught short and there's nothing else available. Alkaline batteries are primary batteries, meaning that they're nonrechargeable. For a digital camera, your best bet is to use rechargeable batteries and a battery charger.

Choosing Rechargeable Batteries

When selecting your digicam, be aware of what batteries the camera uses. A rechargeable, or secondary, battery is usually designed to have a lifetime of between 100 and 1,000 charge cycles, depending on the materials from which it is made. Rechargeable batteries used in digital cameras generally last from 500 to 800 charge cycles, or about one to three years of average use.

NiMH

Nickel metal hydride (NiMH) batteries are the most popular batteries for digital camera use because they are rechargeable, nontoxic, and relatively inexpensive. Since they're designed to be used with power-draining equipment, they can offer you more pictures per charge than other types of batteries. According to one manufacturer, NiMH batteries can last 40 percent longer than the same size NiCd battery. In digital cameras, NiMH batteries can typically run three to four times as long as an alkaline battery from a single charge.

SSENTIALS

NiMH batteries need to be run through three to six charge cycles before they reach maximum power. Keep this in mind if you are using your new digicam in a situation where you need to get the maximum number of shots out of each recharge.

NiMH batteries are also preferred because they don't have problems with memory effect. Made from nontoxic materials, NiMH batteries are more environmentally friendly than other types of batteries. The battery retailers we checked with all recommended NiMH batteries for use in digital cameras.

NiCd Batteries

NiCd (nickel cadmium) batteries are the most widely used type of rechargeable household battery used in small portable devices such as digicams, radios, laptop computers, and cellular phones. You can recharge them quickly, and they last for hundreds of charge cycles. NiCd batteries perform well in low temperatures, but they do have a problem with memory effect. Cadmium is an expensive, and toxic, metal. Consequently, producing NiCd batteries is expensive, as is disposing of them. To combat the increased costs, some manufacturers are actively recycling components of NiCd batteries.

ALERT

Never mix batteries of different types in the same camera. For instance, don't mix NiMH batteries with NiCd batteries.

Rechargeable batteries, especially NiCd batteries, run into problems if they are not fully drained before being recharged. Attempting to recharge a battery that hasn't fully lost its charge can result in its not taking a full charge, or not delivering its full capacity, or both. When you recharge a NiCd battery that is half full, it will always need to be recharged when half full and will only take half a charge. The memory problem is caused by potassium-hydroxide crystals building up inside the battery cells. The build-up interferes with the chemical process of generating electrons during the next battery-use charge. To fix the problem, either leave the camera and LCD on to fully discharge the batteries or utilize a battery charger.

LiIon

LiIon (lithium ion) batteries are one of the newer types of rechargeable batteries. They last about twice as long as NiMH batteries,

they don't lose their charge as quickly when stored, and they do not have any memory-effect problems. The downside is they are harder to find and cost more than other types of rechargeable batteries.

Battery Chargers

When buying your digicam, find out if it comes with a battery charger. The newest battery chargers rely on microprocessor technology to provide rapid charge to your batteries in about one to three hours. (Otherwise, it can take up to twelve hours to recharge batteries.) Another advantage of a battery charger with microprocessor control is that it can determine when a battery is fully charged. Then it will either begin trickle charging or shut off completely. This prevents overcharging of batteries.

When purchasing a battery charger, find out if it can "trickle charge" the batteries. Once the batteries have been fully charged, trickle chargers continue to supply a small charge to them. There are differing opinions on the effectiveness of trickle charging. Some battery manufacturers do not recommend it. The best battery chargers send only an occasional pulse charge, rather than a continuous low rate of charge, to a battery that is already charged. Excessive trickle charging tends to dry out the electrolyte that makes a battery work, thereby ruining the battery.

Here are some things to consider when choosing a battery charger:

- Can it charge both NiMH and NiCd batteries?
- How long does it take to charge a set of batteries?
- Can it condition NiCd batteries?
- How many cells can it charge at one time?
- Does it have an optional 12 V power cord so you can plug it into your car's cigarette lighter when you're on the road?

FACTS

Every battery has two ratings: volts and amp-hours (Ah). The Ah rating also may be shown in milliamp-hours (mAh), which are one-thousandth of an amp-hour. For instance, 1Ah is equivalent to 1,000 mAh.

Getting the Most from Your Batteries

The batteries you purchase for your digital camera reflect a financial investment. Maybe even more important to a photographer, they must be operating properly or a photo shoot will come to a standstill. To get the most from your batteries, follow these pointers:

- Keep batteries clean. A clean battery will make a better connection with the camera.
- Use a cotton swab and alcohol to get rid of dirt.
- Do not leave a battery in a charger for more than twenty-four hours. This will shorten the life of the battery.
- New batteries need to be broken in. Fully charge then discharge them several times so that they attain their maximum capacity.
- Use the battery on a regular basis. Usually, a battery needs to be used once in two to three weeks.

Keeping Batteries Ready to Use

When charging and using batteries, you should always do so in sets so that you know all the batteries in one set are totally drained. Either label or color-code them to help you keep track of their use. To avoid problems, do not mix and match old and new batteries. And always have at least one spare set of batteries.

ESSENTIALS

Getting ready to take off on a photo shoot? Be sure to check your batteries first. Always keep an extra set charged and ready to go. And if you're planning on a long day of taking pictures, it might be a good idea to take several sets of batteries with you. Then, like the Boy Scouts, you'll be prepared.

When your batteries wear out, don't dump them; instead, recycle them to help protect Mother Earth. Frequently they can be returned to the store where you purchased them. Many stores gather old batteries together and then recycle them.

Prolonging Battery Life

You may have heard it said that batteries will keep their charge longer if you store them in the freezer, especially if you're planning on storing them for a long time period. The current thought on this subject seems to argue the point. The battery retailers we spoke with did not recommend storing batteries in the freezer for two reasons:

1. Freezing can cause liquid electrolyte to freeze and stress, or perhaps rupture, the seals.
2. Most batteries are designed to work between minus 40 degrees and 100 degrees Fahrenheit, so a freezer will have no impact on the battery's life span.

Extremely high temperatures can have a negative affect on battery life, so you'll want to avoid storing batteries in direct sunlight, but there is no need to put them in the deep freeze. Simply store your batteries in a cool, dry place, and be sure to recharge them fully before using again, and you should reap the most from them.

Avoid problems with charging due to dirty contacts on the battery or charger. Periodically clean the contacts with a cotton swab dipped in isopropyl (rubbing) alcohol.

When using your digicam, be aware of how long it runs on each charge. When you start to notice that a charge isn't lasting as long as it used to, it is time to think about replacing your batteries. No matter how well you care for them, batteries do not last forever.

Buying Batteries on the Web

To keep your camera going, you're going to need to keep your supply of batteries well stocked. You may find it easier to track down the batteries

you need for your digicam by jumping on the Internet. Here are a few popular sites that offer batteries for sale online:

- Batteries.com
 www.batteries.com
- Battery City
 www.battery-city.com
- Duracell
 www.duracell.com
- Photobattery.com
 www.photobattery.com

- Quest
 www.questbatteries.com
- Unity Digital
 www.unitydigital.com
- Warehouse Battery
 www.warehousebatteryoutlet.com

Once your NiCd, NiMH, or LiIon batteries are dead, call the Portable Rechargeable Battery Association at 800-822-8837 or log onto their Web site (*www.batteryrecycling.com*) to learn how to recycle them.

LCD Screens

FIGURE 9-1:
One great advantage of a digital camera is the LCD screen, which allows the photographer to preview a shot.

Photo courtesy of Kodak.

Most digital cameras utilize an LCD screen (**SEE FIGURE 9-1**), which is a small monitor that displays an image before you take a photo or once it is shot and stored in the camera. The LCD also displays menus that allow the photographer to change the camera settings and delete images from memory.

An LCD will suck up power. Turn it off and use the optical viewfinder. When you do use the LCD display, reduce the brightness, or use the black-and-white mode if your camera has one.

An LCD screen's size is specified in inches. Like a TV set, the screen is measured diagonally. They typically range between 2" and 3", although some cameras have larger ones. LCDs offer several useful purposes:

- The photographer can use the LCD screen to preview the picture before he or she snaps it.
- Once the image is taken, the photographer can review it in the LCD screen and decide to keep it or delete it.
- The LCD screen lets you scroll through your saved images. Depending on the screen on your digicam, you may see just one image or thumbnails of a group of images.
- The LCD screen often provides you with a true TTL (through-the-lens) view of the scene being photographed.

If your camera has both a traditional viewfinder and an LCD, you can frame pictures using either one. However, when shooting close-ups, most cameras will force you to use the LCD to avoid parallax error. (See the next section, "Viewfinders," for more information.)

Some cameras with LCDs do not have traditional viewfinders. This requires the photographer to compose shots using the LCD. It can be difficult to shoot pictures using the LCD for framing, because you need to hold the camera a few inches away in order to see what you're shooting. There are other downsides to LCD monitors, including the following:

- They add extra weight to the camera.
- They suck up battery power.
- Shooting in bright light can make it tough to see the LCD.
- An LCD adds to a camera's price. In some camera packages an LCD is an optional accessory, while other manufacturers include it in the basic camera outfit.

It's difficult to see some LCD screens in bright sunlight. To solve that problem, you may want to purchase a hood for your LCD screen. One source on the Internet is Hoodman Corporation *(www.hoodmanusa.com)*. They offer four different sizes of hoods that are designed to work with more than thirty brands of digital cameras and digital camcorders.

Viewfinders

Better digital cameras offer both LCD screens and optical viewfinders. Optical viewfinders provide a view of the scene you are shooting, but they don't show you whether or not it is in focus. In addition, the view they show is not exactly the same view as seen by the lens. Typically, this is not a problem, although it can produce difficulties in close-up photography when parallax causes the view you see to be slightly different from the one the lens sees.

If your camera has a metering system, there may be intelligence (lights and dials) shown in the viewfinder. There may also be markings to indicate what your camera sees when in telephoto or wide-angle mode. Some digicams provide an indicator in the viewfinder that lets you know when the strobe is recharged.

Like popular 35mm SLRs, some digital cameras come with viewfinders that provide TTL (through-the-lens) viewing so that what you see is what you get. Light entering the lens is divided by a prism so that part of the light displays the image in the viewfinder, and the rest passes directly through the image sensor.

Some optical viewfinders offer a diopter adjustment for photographers who normally wear glasses. The photographer can change the setting so that he or she can see though the viewfinder without wearing glasses.

What Is Parallax Error?

On many film and digital cameras, the viewfinder utilizes a separate window from the camera lens. The viewfinder is located about an inch above or to one side of the lens, so it "sees" the subject from a somewhat different angle than the lens. The image, however, is captured from the point of view of the lens, not the viewfinder.

The viewfinder contains black lines, called framing marks, that help you set up your shot to avoid cutting off the top of the picture, an example of parallax error. As you get closer to your subject, the greater the chance that parallax error will occur. Some cameras utilize framing marks on their viewfinders to indicate the framing boundaries for close-up shots. Your camera manual can explain the uses and meanings of the framing marks featured on your camera.

QUESTIONS?

Why have both an LCD and a viewfinder?
The advantages of having both an LCD and a viewfinder, simply put, are these: The LCD allows you to review and delete images on the camera and the viewfinder ensures easy picture-taking, especially on sunny days when using an LCD can be troublesome.

When checking out an optical viewfinder, consider the following:

- Can you easily see through the viewfinder?
- Is it too tiny?
- If you wear glasses, can you comfortably see through the viewfinder while wearing them?
- Is there any information in the viewfinder?

If your camera features an LCD screen, think about these points:

- Can you see it well?
- Does it work well in bright light?
- How about in dimly light situations?
- Is it big enough to be easily used?

CHAPTER 10

Creative Controls and Other Features

L et's admit it: Sometimes we're taken in by eye appeal. That sleek, high-tech digital camera . . . well, it's hard to resist. Pick up the camera and see how it feels in your hand. Still, regardless of how appealing it is, you want to use your digital camera to produce amazing pictures. In this chapter we examine some of the creative controls that digicams offer.

Creative Controls

Your digital camera comes with a number of creative controls. These automatic features may include the following:

- Autoexposure
- Autoflash
- Autofocus
- Color balance

In most situations you'll want to use these automatic systems. After all, even the professionals frequently take advantage of them. But there will be times when you are seeking greater creative control. In those instances you will need to override the automatic settings. Let's take a closer look at what these automatic settings can do, what effects can be accomplished by overriding automatic controls, and how you go about doing so.

Autoexposure

As we noted in Chapter 5, controlling the amount of light that hits the CCD in your digital camera is one of the necessary components of capturing an image successfully—and it's one of the biggest challenges faced by any digital photographer. Too much or too little light will spoil a final image, causing it to be too light or too dark.

Although it's very convenient to let the camera automatically adjust the exposure, there are times when the camera can be fooled and it's best to take the matter into your own hands. Of course, it's possible to use an image-editing software program to correct any "mistakes" of exposure. But image information in the shadowed or highlighted areas will have been lost and cannot be reclaimed.

FACTS

The odds of creating a properly exposed photo are greater when you manipulate the exposure while shooting rather than waiting to correct mistakes while editing.

There are a number of circumstances when you might choose to control exposure yourself. For instance, if you are shooting into the sun, photographing on a snowy mountainside, or shooting a brook in a shady forest, you will likely choose not to let the camera automatically set the exposure, since these are situations that can fool the camera.

To control the amount of light that exposes the image, the photographer can adjust either the aperture or the shutter speed. When using automatic exposure control, the camera makes one or both of these adjustments.

Some midrange and high-end cameras give the photographer more creative control over f-stops and shutter speeds. Low-end digicams are typically fully automatic. These are the exposure systems that you are likely to encounter:

- *Fully automatic:* The camera automatically selects both the aperture and shutter speed.
- *Aperture priority:* You choose the aperture (controlling depth of field), and the camera sets the best matching shutter speed for desirable exposure results.
- *Shutter priority:* You choose the shutter speed (controlling motion), and the camera selects the best matching aperture for best results.

In a brightly lit scene, such as on a snowy mountainside, the camera will use a fast shutter speed and a small aperture. In a low-light situation, such as a shady forest, the camera uses a long shutter speed and a wide aperture. If you can't get the results you want using fully automatic exposure control in difficult lighting situations such as these, using aperture priority or shutter priority modes can prove useful.

Metering Systems

A digicam uses built-in light meters to measure the light reflecting off the subject. There are several different ways in which the camera's metering mechanism calculates exposure. The metering mode you choose will depend on the particular shot you're taking.

- **Matrix Metering**—Works by dividing the frame into a grid or matrix. Then it analyzes light at different points on the grid and chooses an exposure that best captures both the dark and light sections of the scene.
- **Center-Weighted Metering**—Measures light throughout the scene but gives greater importance (weight) to the center quarter of the image area, assuming that that is where the primary subject is located.
- **Bottom-Weighted Metering**—Measures light throughout the scene but gives greater importance to the bottom of the image area.
- **Spot Metering**—Measures the light only at the center of the image. If your background is much brighter than your subject, such as in a backlit situation, spot metering will provide satisfying results.

Exposure Compensation

To gain creative control of exposure, you can use exposure compensation, also known as exposure value (EV). This allows you to increase or decrease the exposure from what the autoexposure setting typically delivers.

The settings are different from camera to camera, but usually they appear as +2, +1, -1, and -2, with zero representing the default autoexposure setting. To obtain a brighter image, in a backlit situation for example, you "dial up" using a positive value to increase the exposure. For a darker image, choose a negative value, thereby decreasing exposure. You might choose a negative value when photographing a scene on a sandy beach. Exposure compensation lets you choose the exposure that is most likely to produce the results you're seeking.

ALERT

Even by previewing your shots with an LCD screen you can wind up with disappointing results. Your LCD screen does not provide a 100 percent accurate representation of your image. Your actual image may be lighter or darker than it appeared when you previewed it.

It takes a lot of practice to get to the point where you know when to lighten or darken a scene. One feature of a digital camera that makes it easier: the LCD screen. Because it lets you preview your shot, you don't have to guess whether or not the exposure needs adjusting.

One way to avoid a poorly exposed image is to use a trick that professional photographers often employ. It's called bracketing. The bracketing process means that you take three shots: one at the recommended exposure setting, a second shot that's lighter, and a third shot that's darker, thereby bracketing the recommended exposure with two additional shots. By taking a series of shots at different exposures, you're far more likely to obtain one that's to your liking.

Aperture-Priority and Shutter-Priority Modes

Using exposure compensation, you can lighten or darken pictures. But to get even more creative, you may want to have more control over the shutter speed and aperture settings. Doing this, you can control the effect of motion and depth of field on your images.

Selecting aperture-priority mode gives you control of the aperture. You set the aperture, frame the shot, and then press the shutter button halfway to set the focus and exposure. At this point, the camera analyzes what aperture you have chosen and selects the corresponding shutter speed that will result in a well-exposed image. In the same way, when you select shutter-priority mode, you decide on the shutter speed, and the camera sets the correct aperture.

Exposure compensation control lets you correct exposure. Here are some typical settings and how they are used:

- *+2:* Used when there is high contrast between light and dark areas in a scene.
- *+1:* Used with sidelit or backlit scenes, such as snow scenes, beach scenes, sunsets.
- *0:* Great for evenly lit scenes.

- *-1:* Good for scenes where the background is darker than the objects in front of it, such as when an individual is standing in front of a brick wall.
- *-2:* Used when the background is very dark and takes up a large portion of the image, and you are striving to maintain detail in the brighter areas of the scene.

Autoflash

As discussed in Chapter 8, a camera with a built-in automatic flash gauges the available light and fires the flash if needed. Because every flash has a useful range, the effects of the auto flash will depend on how bright a light it produces and how far the light has to travel. The further away the subject is from the camera, the less light will be reflected back to the camera. Objects closer to the camera will appear lighter than objects in the background.

When you're taking a photo of a scene with multiple subjects at different distances from the camera, the exposure cannot be correct for all of the subjects. Usually those closest to the camera will be properly exposed. The farther the subjects are from the camera, the darker they will appear in the picture. In a shooting situation such as this, you will probably want to turn off the automatic flash and use a fill flash or take other actions to insure a properly lighted photo.

Autofocus

As discussed in Chapter 7, most digital cameras with noninterchangeable lenses are either fixed focus or auto focus. A fixed-focus lens is not adjustable. The camera with a fixed-focus lens captures sharp images of any subject within a certain distance from the lens. Objects outside that range will appear blurry.

Sometimes an autofocus camera will also offer focus lock. Using the focus lock, the photographer can center the subject in the frame, lock the focus, then reframe and take the shot. When taking a shot of a scene

with many elements, this can be a useful feature because it allows you to specify which object you want to be in focus.

ESSENTIALS Autofocus is a more precise and versatile system than fixed focus. Cameras with autofocus automatically adjust the focus depending on the distance of the subject from the camera. Resulting images will turn out clearer when taken with an autofocus lens.

Adjusting Color Balance

You've probably heard the expressions cool colors and warm colors. In fact, different light sources really do have different color temperatures, which means they are made up of varying amounts of red, green, and blue light. Color temperature is measured in degrees Kelvin. For instance, a 100-watt incandescent bulb measures 2,850 degrees Kelvin, noon light measures about 5,500 degrees Kelvin, and average daylight is approximately 6,500 degrees Kelvin.

When we take a close look at different sources of light, we can distinguish different colors. Have you noticed how your household lamp throws a golden light on your living room? And fluorescent bulbs cast a cooler, greenish light.

Normally the human eye compensates for different lighting conditions. Film photographers use special films or filters to compensate for different light sources. However, most digital cameras automatically adjust for the correct color temperature, a process called color balance or white balance.

FACTS Color balancing determines what combination of red, green, and blue light the camera should perceive as pure white under the current lighting conditions. From there, the camera determines how all other colors can be accurately represented.

Shooting a photo at the wrong color balance is a much bigger problem with a film camera than it is with a digital camera, since it is easy to compensate for color balance of a digital image by using image-editing

software. However, it is good to note that you will suffer some loss of definition during the editing process.

Usually, the manual settings for color balance on a digital camera are as follows:

- *Daylight or sunny* (for shooting in bright outdoor light)
- *Cloudy* (for shooting when it is overcast outdoors)
- *Tungsten/incandescent* (for shooting under standard household lights)
- *Flash* (for shooting with the camera's built-in flash)
- *Fluorescent* (for shooting under fluorescent lights)

Some high-end digital cameras allow you to override the automatic color balance system. Why would you want to adjust the color balance manually? Because you can sometimes achieve a desirable effect, such as when you're shooting a candlelit dinner scene. By overriding the color balance feature, you'll be rewarded with a moody image exhibiting a warm glow. Or sometimes the color balancing system does not remove all unwanted colors. By choosing a different color balance setting you may be able to correct such problems, making colors appear truer.

Continuous Mode

With some digicams you can snap an entire sequence of photos. These images can be used to make short movies for a Web site or an animated GIF. There are several ways digicams allow you to capture a series of photos, including the following:

- By depressing the shutter, a digital motor drive or burst mode lets you snap picture after picture.
- Time-lapse photography is achieved by taking a sequence of photos at designated intervals.
- Video recording mode allows you to take low-resolution video in MPEG or JPEG formats.

Panoramic Mode

Panoramic mode enables you to take snapshots that are wider than they are high. Digital cameras frequently include panoramic mode.

Some digicams simply capture a band across the middle of the image sensor, leaving black (unexposed) bands at the top and bottom of the photo. The preferred method is to create multiple-image panoramas. This is achieved when you take a series of images while slowly turning in a circle. Then the camera uses special panoramic software to "stitch" the images together, forming one 360-degree panorama. Many digicams come with this panoramic stitching software. This software provides a handy tool when you want to shoot three or four photos and stitch them together to form a city skyline or a coastline scene, for instance.

One such software program is QuickStitch from Enroute Imaging. Because it is made up of only three main screens, it is fairly easy to learn. You can use it to stitch together from two to thirty-six pictures, vertically or horizontally. The program combines overlapping photos to create virtual reality-like panoramic images up to 360 degrees. The panorama can be outputted to a graphics file or a QuickTime VR movie. QuickTime 4 Pro is a suite of software from Apple that plays digitized video, audio, and "virtual reality" movies. When you add your panorama to a QuickTime file, it becomes part of a virtual reality movie with which a user can interact by moving the mouse to pan and zoom over the scene.

ESSENTIALS

Just like some point-and-shoot cameras, you can find digital cameras that offer a date/time indicator for a permanent record of when the shot was taken. Some are displayed in the image area, while others are hidden in the image file and can only be seen when using software.

Self-Timers/Remote Controls

A self-timer mechanism delays the shutter release for about ten seconds, allowing you to jump into a picture before the shutter releases. This is a useful feature when you want to take a self-portrait or include yourself in a group shot.

Wireless remote controls make it a little less stressful, allowing you to walk—not run—to get in the shot. Once you're situated, you simply click a button on the remote and the camera snaps the image. Of course, that leaves you with the question of where to hide the remote.

CHAPTER 11

What Makes a Photograph Memorable

In order to take photographs that capture the viewer's attention, you need to know the elements that combine to form visual impact. These include the visual elements of shape, line, pattern, and texture; composition; angle of view; color; and light. Just as an artist uses paint and canvas to create a painting, a photographer has tools at his disposal to create a memorable picture. Among these are the four visual elements found in an image, the four building blocks of a photo: shape, line, pattern, and texture.

Shape

As a photographer, you can create dramatic impact by emphasizing shape. One way to do this is to make a single shape the focus of your image, capturing it against an uncluttered, contrasting background. To do so, you may have to get in close to your subject, or change the camera's angle to rid your picture of distracting details.

In more elaborate compositions, shapes become the building blocks of your image. They can mirror each other in form or provide contrast to create balance or tension. In **FIGURE 11-1**, the photographer chose to shoot upward, capturing the shapes of the skyscrapers without the distraction of the people and cars on the street below.

FIGURE 11-1: The surprising image of sky-scrapers relies on shape for visual interest.

Photo by Elizabeth T. Schoch

Line

Our eyes follow lines. Lines lead the way, showing us direction and distance. Lines define shapes. They can convey action or force. One of the most important uses of line is to lead the viewer to the center of interest in the photograph.

ESSENTIALS

The great American photographer Ansel Adams once said, "There are no rules for good photographs, there are only good photographs." As you're taking photos with your digital camera, be aware of the shapes around you. How can you use them to form an eye-catching image?

Lines are a tool the photographer uses to create depth in a photograph. A flat, two-dimensional image takes on life when parallel lines recede to a distant point, creating a sense of perspective and beckoning the viewer to the faraway point.

See how the lines of the stream in **FIGURE 11-2** draw us into the distance, giving the impression that the stream flows on forever.

FIGURE 11-2:
The lines of the stream beckon us into the distance.

Photo by Elizabeth T. Schoch

You can utilize hard-edged lines to create impact, while curving lines suggest a softer, more graceful feeling. When composing a picture with several elements, lines can be used to direct the eyes of the viewer from one form to another. They can link objects usually considered unrelated. And they can provide information about the action in the picture. Frequently, the opposition of curved and straight lines is used to express action.

The S curve is one of the most common and graceful lines used in composition. An S curve often draws the eye past several points of interest. S-curve compositions typically produce a feeling of calm. Look for an S curve when composing a shot.

Other simple geometric shapes can enhance your photo compositions. The strongest of these is the triangle. A triangle in your composition can add effective visual unity to your image. A V shape typically accentuates

perspective and pulls the viewer's eye to the focal point of the picture. The C curve can be useful for framing the main element or drawing the viewer's eye into the picture.

Pattern

FIGURE 11-3: The world is full of patterns. We find them when we take the time to look up, down, and all around us.

Photo by Janet McCanna

Patterns are formed when lines, shapes, or colors are repeated, as in **FIGURE 11-3**. Typically, a photographer uses patterns to create a sense of harmony. At the same time, other feelings can arise from photographs showing patterns. Because of their strong visual impact, even the slightest suggestion of a pattern can catch our eye, especially when the elements join together by chance. For instance, this photo in **FIGURE 11-4** of seagulls flying suggests freedom and lightness.

Patterns are all around us. Once you begin looking for them, you will find them everywhere. This photo in **FIGURE 11-5** taken at Chicago's O'Hare Airport shows a myriad of patterns surrounding the people making their way through the airport. Look for patterns in your own world, and begin experimenting with them to see what effects you can achieve.

Bear in mind that a pattern alone can make for a dull photo. Be sure that a pattern is strong enough to stand alone before you shoot it. Often, you'll want to include additional elements to provide visual interest.

FIGURE 11-4: Patterns are everywhere, as this photographer discovered one day at the beach when she saw these flying sea gulls.

Photo by Elizabeth T. Schoch

In the photo of the airport, the people add interest and also help the viewer understand what he or she is seeing. In the image of the gulls over Lake Michigan, the lighthouse and the jetty leading to it contribute to a more engaging composition.

FIGURE 11-5: Having your digital camera handy can mean unexpected photo opportunities. Here, the neon lights above an airport's people-mover provide man-made patterns.

Photo by Elizabeth T. Schoch

Texture

Photo by Elizabeth T. Schoch

Texture appeals to our sense of touch. When used in a photo, texture adds a feeling of realism to the image. You can utilize texture to portray the nature of a surface: rough, smooth, jagged, bumpy, and so forth.

Texture gives a three-dimensional sense to an image, causing the elements to be seen as forms. It helps the viewer perceive the heaviness and bulk, softness and hardness, and roughness or smoothness of the objects.shots.

In **FIGURE 11-6**, the photo taken of a tropical island pond surrounded by palm trees uses texture to convey the lushness of the vegetation that grows in the sultry South Pacific climate.

FIGURE 11-7: A highly textured subject, such as the red rock formation shown here, can result in a dramatic image that makes us want to reach out and feel its roughness.

Photo by Janet McCanna

The shot of the red rock formation in **FIGURE 11-7** is all about texture. When viewing the image, we can immediately imagine how the rock would feel beneath our hands.

Composition

The photographer combines the visual elements—shape, line, pattern, and texture—to create a picture. He or she may decide to isolate one element, or use a combination of any or all of them.

As a digital photographer, you need to build, or compose, your image using the visual elements. Unlike a painter, you cannot simply pick and choose your objects, colors, or placement of each (except when combining elements using image-editing software). But you do have certain options that impact the composition of an image, including the ability to move closer or farther away from your subject, to choose how you angle your camera, and to decide whether to shoot from above or below your subject.

FIGURE 11-8: In this picture, the viewer's eye focuses on the tree, then travels to the stark landscape around it.

Photo by Elizabeth T. Schoch

There are guidelines to good composition discussed below. Learn them and experiment with them. See how the resulting images change as you change your approach to a scene. Although it is important to know the rules, don't be afraid to break the rules when it is advantageous to do so. There is no right way to take a photograph.

Your goal is to create an image that quickly and clearly conveys your intended message. Composition is not a haphazard matter. You will need to analyze the elements in a scene, then adjust them for the effect you are seeking. Sometimes you will isolate a single element for a simple but striking image. Other times you will use a combination of elements to tell your story. You

may decide to go for a symmetrical, harmonious picture. Or you may deliberately choose to convey a feeling of disharmony and uneasiness.

Perhaps you will choose one main element to dominate the picture, with lesser elements supporting the focal point. This will prompt the viewer's eyes to lock onto the main element, then travel around the frame, as in **FIGURE 11-8**. The main element may be larger in scale or brighter in color than other elements in the picture.

Balance and Imbalance

Although you may think that it is desirable to arrange the elements in a picture symmetrically by placing the main subject in the center with other elements spaced evenly around it, this is exactly the sort of composition you'll want to avoid. A perfectly symmetrical image can appear rigid and uninspiring. To pique a viewer's interest, an image typically contains two main attributes: tension and movement.

FIGURE 11-9: The light and dark areas of this winter scene create a balanced image that is pleasing to the eye.

Photo by Elizabeth T. Schoch

Balance in a successful image comes from the less obvious: the visual weight given to various elements in a picture. You can obtain this type of

balance by using contrast, such as bright colors balanced by muted ones, dark objects balanced by lighter backgrounds, or very detailed objects balanced by open areas (**SEE FIGURE 11-9**).

Graphic designers and interior decorators know a secret that photographers can adopt for more effective photographs: An uneven number of elements is more pleasing to the eye than an even number. If your composition is too balanced, it will result in a bland picture. One good approach is to set up your shot with one main subject and two supporting elements. The main element may be larger in scale or brighter in color than other elements in the picture. It is easy to compose with three elements, but two elements generally do not work well because your eye does not know where to rest. The exception is when one element is the main focal point and the other is a supporting element.

The Rule of Thirds

FIGURE 11-10: This picture of palm trees in the South Pacific successfully utilizes the rule of thirds.

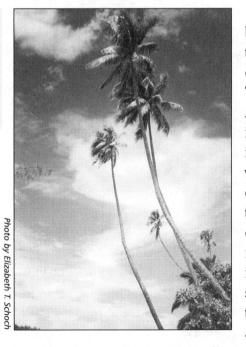

Photo by Elizabeth T. Schoch

One trusted formula for achieving balance is known as the rule of thirds, and painters have successfully employed it for hundreds of years. To utilize the rule of thirds, do this: As you peer through the viewfinder, imagine lines dividing the image into thirds, both horizontally and vertically. Subjects placed near one of the four intersections formed by the lines gain immediate off-center emphasis. On the other hand, elements situated at diagonally opposed intersections seem balanced. When subjects are located at three of the intersections, they can form a striking triangular composition.

In other pictures, the imaginary lines divide a scene into pleasing two-thirds/one-third proportions.

The rule of thirds can be utilized when photographing all subjects, but it works particularly well when you are shooting a relatively small subject photographed against a large expanse or a plain background.

Another way in which the rule of thirds can prove useful is helping the photographer decide where to place the horizon. You can easily arrange the composition by placing the horizon along one of the frame-dividing lines. For instance, in this photograph of a beach on the Polynesian island of Moorea (**FIGURE 11-10**), the photographer placed the horizon line one-third of the way up from the bottom of the frame, thereby placing the emphasis on the palm trees stretching into the sky.

Angle of View

By changing your camera angle, you can change the viewpoint of your photos, along with their tone and impact. A scene will change dramatically when it is shot from above or below as opposed to eye level. You may need to get down on the ground to achieve the results you're seeking.

FIGURE 11-11: An interesting image was created by shooting an ordinary revolving door from above.

Photo by Elizabeth T. Schoch

Because we usually view the world from eye level, photos taken at a normal eye-level angle communicate realism. We give power to objects by shooting them from below, so that they appear to tower over us. By shooting from above, objects become diminished, but the arrangement of objects often becomes more discernible.

FIGURE 11-11 shows a photo of a revolving door that was shot from above. Imagine how ordinary the picture would have seemed if it had been taken from ground level. But because the photographer used an unusual angle of view, she was rewarded with an eye-catching image.

The angle of view can have a dramatic impact on open landscape images. When you shoot from a low angle, more sky is revealed and the spaciousness of the landscape is emphasized. When you shoot from a high angle, the horizon is positioned near the top of the image and the land seems to stretch out to infinity.

QUESTIONS?

When do I use high or low angles of view?
High or low angles of view can be used to reveal patterns and textures not normally perceived at eye level, simplify a composition, isolate a subject against the sky or a plain background, or eliminate a cluttered environment. When shooting the photo of the sunflower in Figure 2-1 in Chapter 2, the photographer used a low angle of view to isolate his subject against the background of the sky.

Try taking a series of pictures of the same scene from different angles of view. How does the angle of view affect the emphasis of the picture? What is being communicated by each image? As Ansel Adams said, "A good photograph is knowing where to stand."

Framing

A simple compositional technique known as framing will help you draw a viewer's attention to your image. A window, a doorway, and a tree can all act as frames when positioned around the subject of a photo, as can abstract shapes, shadows, and blocks of color. A frame will direct the viewer's eye to the central element of a picture, but it can also do more than that: A frame can cover unattractive foregrounds or other distracting details, add depth to a photo, and identify the photo's setting. For example, a window can be used effectively to frame a scene.

Color

Color determines the mood of a picture. When the predominant colors are warm ones, such as yellow or red, the mood is bright and cheerful. Cooler blues, lavenders, and greens can convey a calm and tranquil

mood, suggestive of a sparkling mountain brook or a leafy glade. Contrasting colors create drama, while dark grays and black evoke a somber mood.

As a digital photographer, you can manipulate color, both when shooting and when working with image-editing software after you've captured the image. While shooting, be tuned in to the colors around you. Simply by moving around and changing your angle of view, you may be able to combine colors to better express the story you want your image to tell.

Color determines the mood of a picture. Warm colors convey cheerful feelings, while cooler colors communicate relaxation. Contrasting colors are exciting. You can choose to effectively combine many colors in your image, use a controlled palette of just one or two colors, or utilize just a splash of lively color for impact.

Another way to use color in photography is to compose your picture to include a brightly colored object against a subdued background. The color will draw the viewer's eye to the bright item and make it a focal point, even though it may be relatively small in size.

Take care when framing your shot to note where colored objects are located. Bright patches of color in less important parts of the scene will draw the viewer's attention there. Don't overload your images with colorful objects; the result can be a busy image that leaves the viewer feeling slightly uneasy.

Light

The other critical component of a good photo is lighting. A photographer uses light in the same way that an artist uses paint. As we discussed in Chapter 2, light is the source of all color. All colors combine to form white light. When light strikes an object, some colors are absorbed and others are reflected. For instance, a fire truck looks red because its surface is reflecting red and absorbing all other hues. An object appears white when its surface reflects all colors, and black when its surface absorbs them.

Learning the characteristics of light will help you produce better images. First you must observe light and learn how to take advantage of its color, quantity, quality, source, and direction to create the right mood for your picture.

The sun is the most common source of illumination. During the course of a day, the sun's light shifts from dawn's soft radiance to harsh midday brightness to the delicate rosy glow of sunset. Once the sun has set, the night is filled with cool tones. When shooting a city skyline at sunset, the buildings will be tinged with the pinks and lavenders of the twilight sky. But under a noonday sun, those same buildings will be starkly lit. Bright, sunny days are good for capturing brilliant images. Overcast days produce more subtle color combinations. Seasons, too, will change the effect of light upon a subject.

A great photograph requires great lighting. Time of day, and the resulting angle of light, affects form, contrast, texture, and color. Professionals know when the best times to shoot are. Here is an overview of how light changes throughout the day.

- *Predawn:* Pink, dreamy light; ideal for shooting bodies of water and landscapes
- *Dawn:* Crisp, golden light reflects on subjects facing east
- *Early morning:* Soft light
- *Midday:* Harsh sunlight; best for shooting monuments, buildings, and urban streets
- *Late afternoon:* Warm, golden light; ideal for people and landscapes
- *Sunset:* Beautiful skies, especially twenty minutes before and after the sun sets
- *Dusk:* The purple glow in the sky does wonderful things to skylines
- *Night:* If you're willing to experiment, you may get some interesting effects

When you experiment with light and your digital images, you'll see that the placement of the main source of light strongly affects the photo. A subject can be lighted in three primary ways: from the front, from the back, and from the side.

Photo by Philip Thornberry

Taking a picture with the sun behind you results in frontlighting, which provides an even illumination of your subject and tends to produce natural-looking colors. However, since shadows are cast behind the subject, it can appear rather flat, lacking depth and volume. You can turn this to your advantage when you are shooting to emphasize patterns and when you prefer that forms appear as two-dimensional shapes.

Lighting your subject from the side will better convey a three-dimensional form. For most photos, sidelighting is the most effective type of illumination. You can use sidelighting to emphasize texture, especially when the light crosses the surface of your subject at a low angle. It also can be used to emphasize the roundness of shapes.

Backlighting, lighting that comes from behind a subject, can be difficult to use correctly, but properly executed it can produce dramatic results. With strong light, the subject will turn into a silhouette. With weaker light that is balanced by other light from the front or side of the subject, backlighting may produce what is known as rim lighting. Rim lighting refers to a slightly darker than normal subject that is circled by a halo of light.

Lighting from above, such as the light emitted by the noonday sun, tends to produce unflattering shadows on both people and scenes.

However, sometimes it can be utilized to produce drama, such as when shooting images of urban buildings.

Overcast days provide soft light that reveals more subtle colors and detail. When shooting on a sunny day, you can sometimes capture subjects in open shadow for diffused light that reveals vivid color usually lost in harsh, direct light.

SSENTIALS

Sunlight not only changes throughout the day, but also from season to season. By studying these changes, you will learn techniques for effectively tackling the challenges presented by different lighting situations. And you will discover new ways of using your digital camera as a creative tool to express your unique message.

Late September and Shine

Lighting can make or break a photo. Here, the photographer adjusted the exposure to compensate for the lighting conditions, resulting in two correctly exposed images that emphasize the loveliness of nature.

Radishes

Using the close-up mode of a digital camera, the photographer created colorful and dramatic pictures focusing on everyday items, such as these radishes captured in an open-air market.

Summer Evening

The great photographer Henri Cartier-Bresson used the term "the decisive moment" to describe an image that tells the full story of a particular moment. This photo, taken at Dublin's Trinity College, is a stunning example of a decisive moment—many elements make the photo complete.

Somewhere and The Bridge

The photographer approached the Ha'Penny Bridge in Dublin, Ireland, in two very different ways. In **Somewhere,** he isolated one of the bridge's ornate lighting fixtures and created dramatic impact by emphasizing its shape. In **The Bridge,** he captured the *reflection* of the bridge in the River Liffey. The photographer then used image-editing software to increase the contrast, thereby making these photos even more spectacular.

French Castle and French Castle Zoom

These two shots show what can be accomplished with a zoom lens. In the first photo, we see an opening in the wall where soldiers positioned their weapons. In the second photo, the photographer has zoomed in to show what can be seen when looking through the opening.

Palm Leaf

Look to nature to create colorful and dramatic photos using subjects like this textured palm leaf.

Saco River, Spring and Saco River, Winter

A similar subject can result in distinctly different images. Although initially struck by the ways in which time has affected the subject, both photos elicit a feeling of serenity, thanks to the reflections on water.

Moorean Sunsets

These photos, taken on a beach in Moorea, work well because they feature bold subjects with simple shapes caught in silhouette against the spectacular sunset in the South Pacific sky.

Snowy Tree and Coronation Plantation

The contrast between **Snowy Tree** and **Coronation Plantation** is a prime example of using nature to create diverse and unique pictures. In **Snowy Tree**, the photographer captures the beauty and calm of a winter landscape. By contrast, **Coronation Plantation** shows the wind whipping through the trees and the cloud movement before an impending storm.

The Roses

Many artistic effects can be created using image-editing software. This simple picture of red roses is lovely in its original form. However, it can be manipulated to produce some stunning effects. The photographer used the ripple filter, the embossing effect, and the twirl filter to produce the versions shown here.

Music by the Sea, Wilder, and The Valves

The photographer adjusted the contrast, color, and sharpness of these three photos to create images that are even more pleasing than the originals. The picture of windswept branches has been manipulated for a painter-like effect.

Summer and The Gate

Simple subjects often make the most compelling photos. The appeal of a weathered gate is showcased against an expansive azure sky. In the close-up shot of the sunflower, the blue sky again serves as the perfect backdrop for the flower's natural beauty.

Late September

Shine

Radishes

Summer Evening

Somewhere

The Bridge

French Castle

French Castle Zoom

Palm Leaf

Saco River, Spring

Saco River, Winter

Snowy Tree

Photo courtesy of Elizabeth T. Schoch

Moorean Sunset

Photo courtesy of Elizabeth T. Schoch

Moorean Sunset

Photo courtesy of Elizabeth T. Schoch

Coronation Plantation

Photo courtesy of Philip Thornberry

Original

Ripple

Embossed

Twirl

Music by the Sea

Wilder

The Valves

Summer

The Gate

CHAPTER 12
Taking Great Pictures

Anyone can be creative with a digital camera. It's not the camera that's important; it's the photographer. With camera in hand, you will choose what scenes to shoot, when to shoot them, and from what vantage point. Let's assume that you've just purchased your camera. You're eager to get started, but you're not sure where to begin. Read the manual that came with your camera. The manual will act as a map, guiding you along your journey into digital photography.

Getting Ready to Shoot

Once you've read the manual and feel confident that you know how to operate your camera, take a moment to consider the basics of snapping a picture. You'll want to always stand with your feet planted firmly. Hold the camera nice and steady (or use a tripod). Gently take a deep breath and hold it, then slowly squeeze the shutter. For still lifes and landscapes, a tripod will ensure that your photo doesn't turn out blurry. A cable release makes it easy to get that shot once your camera's attached to the tripod.

Inspiration is all around you, you just have to take the time to look for it. Magazines are an easy and inexpensive resource for the photographer looking to expand his or her horizons. Start with a publication that's known for outstanding photography, such as *Life* or *National Geographic*. It's true that monthly issues of *Life* are not available on the newsstands any more, but you can view some of its spellbinding images online at *www.lifemag.com*. *National Geographic* also offers online galleries at its Web site, *www.nationalgeographic.com*. Study the composition, lighting, and use of color in each photo. What message was the photographer attempting to convey? What techniques did he or she use to communicate the idea?

ESSENTIALS

Looking for inspiration? Turn to the more than one million images found online at TimePix (*www.thepicturecollection.com*). Many of the pictures were originally published in periodicals such as *Time, Life, Sports Illustrated, People, Fortune, Money,* and *Entertainment Weekly.* The collection also includes historical images of just about every subject imaginable.

Workshops and Classes

Photography workshops are held all over the world. It's a great way to turn some vacation time into an experience of learning about, and practicing, photography. You'll get immediate feedback from the instructor, plus you'll benefit from the opportunity to interact with others who share

your passion. As digital photography grows in popularity, more and more digital photography workshops and classes are springing up.

FACTS

One abundant source for photography workshops is the Maine Photographic Workshops of Rockport, Maine *(www.thework shops.com)*. In 2001 they offered more than 150 courses, including a variety of digital photography workshops.

Another option is to take an online or home-study course. The New York Institute of Photography offers several home-study photography courses that utilize CD-ROM, videotapes, audiotapes, and books to convey the information. They have recently introduced Digital Photography: The Complete Course, which explains digital technology and offers techniques for using it to capture high-quality digital pictures.

Don't forget to look in your own backyard. There's apt to be a photography class available at your local community college, university, or adult education program. Digital photography is gaining popularity so fast that you should be able to find a way to learn more about it without having to venture far from home. Remember, too, that even though you're working with digital photography, many of the approaches to taking a good photo will remain the same as with film cameras.

ESSENTIALS

Take cues from today's photographers. Examine their work and see what it is that draws—or offends—you. Just keep in mind that you're looking to learn something and be inspired, not imitate them.

Taking the Picture

Exploring digital photography should be a joyful experience. After all, photography gives us the opportunity to express our feelings. If you are pursuing photography, you've felt the satisfaction that comes from producing a photograph that works. Effective photos move people. They can make us feel uplifted or dispirited, nostalgic or repulsed, regretful or homesick,

serene or agitated. Every picture conveys a message. The trick is to make it the message you intend.

FACTS

"A photograph never grows old. You and I change, people change all through the months and years but a photograph always remains the same. How nice to look at a photograph of mother or father taken many years ago. You see them as you remember them. But as people live on, they change completely. That is why I think a photograph can be kind."

—Albert Einstein

As with other skills, your skill as a photographer will increase the more you practice, practice, practice. Using a digital camera makes it even easier to learn by trial and error. First of all, you can preview your shot in the LCD screen. If you don't like what you see, you simply delete it and try again. Second, you benefit from the instant feedback and are able to make adjustments in lighting, angle of view, and composition as necessary. And third, you don't have to spend money on film and processing in order to create dozens of images.

FIGURE 12-1:
Not everyone has a beautiful violin like this one in their home. But the digital photographer can find other everyday objects to transform into memorable shots.

Photo by Philip Thornberry

The first step to being a good photographer is learning to see the world as the camera sees it. When we look around us, we automatically and unconsciously screen out a lot. Clutter seemingly disappears from our view. Not so with the camera; it will record everything in a scene. As we look at the world, we are viewing it in three dimensions. The camera produces a two-dimensional image. And our eyes adapt to the lighting, but the camera's does not. The photographer learns to recognize and make alterations for these differences.

Take a look around you right now. What do you notice? Good photos can be taken anywhere. And although it would be a grand adventure to travel the globe taking pictures, it is not necessary to venture far from home to capture intriguing images. Seemingly ordinary subjects can make extraordinary photographs, as with the violin in **FIGURE 12-1**.

An important skill for the photographer is previsualization: the ability to imagine how the photo will look. This only occurs when the photographer understands how the camera "sees" and how it will capture the image. Previsualization for the digital photographer requires an understanding of composition, light, and how a digital camera works.

Where to Begin

Start with your passion. Besides photography, what else do you enjoy? Perhaps you love to play sports, listen to music, or collect antiques. Maybe in your spare time you like to read a bestseller, shoot hoops with your kids, or dance the night away at a local club. You can combine other interests with your passion for photography, especially when you're using an easily portable digital camera. Next time you're heading out to the club, take along your digicam. You'll be rewarded with great action shots of people on the dance floor. Bring your camera with you to the next flea market or antique show, and you'll have a means of recording the treasures you decide to bring home plus the merchandise you left behind.

Recording Everyday Life

Don't wait for a special occasion. Start carrying your camera with you wherever you go. You'll get more practice, which will help you move faster toward your goal of being a crackerjack photographer, plus you'll end up with some engaging images you never would have dreamed of.

What about carrying your camera to work with you? Even an ordinary workday holds plenty of potential. Don't wait until you reach the office to start shooting. There's no reason you can't take pictures from your seat on the bus or train. If you're commuting by car, you'll need to keep your attention on your driving. But you might be able to shoot out of the car window when you're stopped at a red light. Maybe during your tedious commute you've already entertained yourself by framing certain shots in

your mind. Pack your digicam in your briefcase tomorrow, and you can start turning those imaginary images into the real thing.

FIGURE 12-2:
Walking through the downtown area of a large city, the photographer noticed the strong lines and angles of a building and emphasized them to create this striking image.

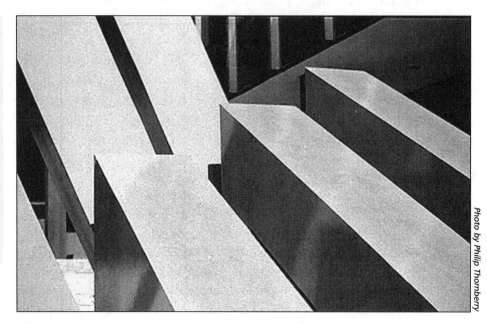

Photo by Philip Thornberry

Familiar Faces

Most of us take snapshots at the holidays, but consider taking pictures of your favorite people on a regular basis. Your kids, friends, and relatives are all potential subjects. Maybe taking portraits will even become your specialty. (You'll find more tips on portrait photography later in this chapter.)

Capture your loved ones while they are carrying out their daily routines. What about a picture of the baby having her nightly bath? Your preschooler would be delighted to have you look over his shoulder while he finger-paints his next masterpiece. And your great Aunt Isabel would probably be flattered if you asked to take a photo of her in her garden next to her prize rose bush.

FIGURE 12-3: All animals, large or small, can be subjects for satisfying images. Taking her camera to the barn allowed the photographer to capture a young friend grooming her horse.

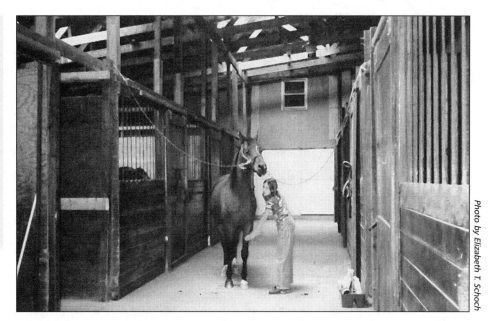

Photo by Elizabeth T. Schoch

Developing a Personal Style

Sooner or later, most photographers find that they are drawn to a particular subject, such as portraits, landscapes, travel photos, and so forth. As you take more and more photos, you will develop a personal style that will become increasingly apparent in your images. You may find yourself attracted to certain subjects or techniques. Although it is helpful to notice the styles of other photographers, it is not necessary to imitate them. Your own style will develop naturally. Don't force it. Just enjoy the process, and you are bound to find your individual approach to digital photography.

Don't force yourself to choose a specialty. It isn't necessary, and it isn't advisable. Just experiment and see where your photography leads you. This is about being creative and having fun, not fitting into any particular mold or following any rules.

Little Things Mean a Lot

A good photographer pays attention to details in order to be rewarded with excellent images. Remember these tips for better digital pictures:

- When shooting people, get close to your subject. People make better subjects when they're interacting than when they stand stiffly.
- Closer is better. Many mediocre shots would have been impressive if the photographer had only moved closer to his subject.
- Use flash outdoors to eliminate shadows.
- Avoid wide-angle distortion.
- Do not center all your pictures in the frame. Use the focus-lock feature on your camera to avoid this problem.
- Partial images can be very dramatic. Shoot close-ups or crop to provide interesting images.
- Avoid excessive compression of your digital images. You lose detail each time an image is compressed.
- At night, turn off the auto flash and use a tripod for better images.
- Image-editing software is a great tool, but it will never replace a good photographer. You want to think about the composition as you're setting up a shot.

Time and Its Effect on Photographs

Time can have a profound effect on photographs. The following sections examine some of the relationships between time and the images captured by photographers.

The Decisive Moment

There are many ways in which time can influence photography. The great photographer, Henri Cartier-Bresson, is a proponent of a technique known as the decisive moment. This term refers to his belief that in every event there is a specific moment when all the elements combine to create an image that tells the full story of that moment. In his book, *The Decisive Moment,* he wrote: "A velvet hand, a hawk's eye—these we should all

have. . . . If the shutter was released at the decisive moment, you have instinctively fixed a geometric pattern without which the photograph would have been both formless and lifeless."

FIGURE 12-4: This photo of the diver illustrates Henri Cartier-Bresson's decisive moment technique, where a single moment in time tells a complex story.

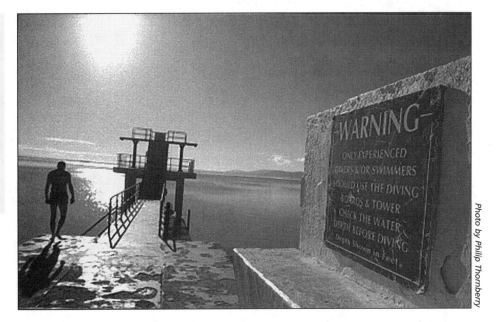

Photo by Philip Thornberry

Action Shots

Another way that time influences a photo is when the photographer freezes the action or captures movement. Action shots bring to mind pictures taken at sporting events, but you can record any movement or action and create a memorable image. If you've ever captured the action of your son's football game, you've experienced the relationship of time and photography.

Time and Nature

When we view serene scenes of the natural world we are seeing the effects of time on the environment. Photos taken in different seasons remind us that although seasons change, and the landscape changes with them, the serenity of the natural world remains.

You don't need to go far to witness the effect of time on the environment. Simply look out the window to discover seasonal changes in your own yard, or take a walk to a nearby park. As a photographic exercise, you may even decide to take a series of shots of a particular outdoor scene to record the ways in which it changes with the seasons.

Time and People

Since time affects people too, we glimpse time when we view pictures of children, teens, adults, and seniors. When subjects of different generations are photographed together, we are especially struck by the cycle of life. During the course of our busy days, we don't often stop to reflect on the ways in which time changes us. Seeing a photograph can make us pause and consider the passage of time.

CHAPTER 13

Types of Photographs

S ome photographers enjoy taking specific types of photos, including portraits, landscapes, still lifes, nature scenes, and urban streets. In this section we will examine some of the different subjects people like to photograph and the best ways to capture them as digital images.

Portraits

People are the most popular subjects of photographs. A truly good portrait conveys something about the subject's personality. When taking portraits, you're going to have to gain the subject's cooperation in order to capture a good image.

When photographing your family and friends, avoid stiff, posed pictures. Don't make your subjects stand awkwardly facing the camera. Place them in a natural, comfortable position. Allow them to sit or lean against something so they will feel, and look, more relaxed. Usually, you'll want to make eye contact to create a feeling of intimacy. Get close and concentrate on the person's head rather than their entire body.

If your subject is looking right at the camera, be careful that she's not squinting into the sun. Change your shooting position, or try to find a bit of open shade so she can look away from the sun. Use a fill flash to avoid shadows on the subject's face.

When taking pictures of children, get down to their level for a better angle of view. You may want to forego posing them. Instead, wait until they're involved in an activity, then catch them at play.

Regardless of whether you're photographing kids or adults, warm up with some "practice" shots so that everyone involved gets used to the camera and relaxes a bit.

ESSENTIALS

When shooting indoors, turn on your camera's red-eye reduction mode, the overhead lights, or have the subject look at a light before you take the picture. These techniques help avoid that scary red-eye syndrome.

Taking Better Portraits

Because we so often want to capture our loved ones in pictures, you may find it useful to review the following pointers on taking portraits:

- Never shoot directly into the light
- Take some warm-up shots to give your subjects a chance to relax

- Consider using props that convey your subject's personality
- Get close to your subject
- Avoid the red-eye effect when using the flash
- Remember that you may not be able to quickly take a series of photos due to shutter lag
- You may want to use a tripod to steady the camera, especially when shooting in low light
- Candids typically catch people with more natural facial expressions than posed shots
- Let kids become absorbed in what they are doing before your take the photo

FACTS

American photographer Annie Leibovitz (1949–) is recognized for her portraits. For the last twenty-five years her work has appeared in several magazines, including *Rolling Stone, Vogue,* and *Vanity Fair.* Her portrait of John Lennon on a bed with Yoko Ono is one of Leibovitz's best-known works and is also the last portrait of the Beatle before his death. Her recently published book, *Women,* includes portraits of American women from diverse backgrounds, including actresses, a soldier, miners, showgirls, and farmers. Leibovitz says, "In a portrait, you have room to have a point of view and to be conceptual with a picture. The image may not be literally what's going on, but it's representative."

Candids

Candid shots can be marvelous. Catch the action when people are involved in an activity.

In these instances you can get a good shot without making them stop and face the camera. If you're outdoors, the folks you're photographing may be looking around at the scenery and you can catch them enjoying the view.

If you carry your camera with you wherever you go, you'll find plenty of opportunities to shoot candid shots of strangers. You'll need to be

prepared to act quickly to make the most of spontaneous photo ops. Candid shots can reveal far more than posed portraits, since they catch people unaware and, therefore, looking more natural. When taking a candid shot on a busy urban street or in the middle of a gathering, timing is crucial for success. A good candid requires capturing the decisive moment that Henri Cartier-Bresson talked about. Your goal is to capture the one specific moment that tells the full story of that moment.

One good way to approach candid photography is to make yourself invisible during the process. Perhaps you can find a corner at the party where you can unobtrusively sit and wait for the right time to shoot. Or you can take a more active approach by walking through a busy urban area with camera in hand, looking for interesting subjects among the people shopping, strolling, and hurrying to work.

Some people are not going to welcome your taking their picture. Avoid anyone who looks unfriendly, and explain what you are doing if anyone approaches you.

You'll need a fairly good optical zoom on your digicam to be able to remain removed from your subject while shooting. Remember to turn off your flash.

Pets

Man's best friends are also popular subjects for photos. We think of our pets as members of our families, so it's not surprising that we love to include their images in our photo albums. Candid shots work especially well, since it is hard to keep your dog or cat sitting at attention for very long. You can try using a squeaky toy to draw their attention toward the camera, or wait and snap a candid shot the next time your son or daughter is playing with your dog. Move outdoors for some good action shots, such as throwing the Frisbee in the park or running together at the beach.

Those who want to photograph pets can find inspiration in the photography of William Wegman. Mr. Wegman is known for dressing up his Weimaraners and using them as models in his photographs. His images of his dog, Man Ray, and three other Weimaraners appear in books and on posters, T-shirts, calendars, magnets, mouse pads, and more. His Web site *(www.wegmanworld.com)* tells how he began photographing dogs and why he has continued to do it for the last twenty years or so.

ESSENTIALS Although cats and dogs are the most popular household pets, don't overlook the hamster, bird, or gerbil that calls your house home. Even smaller animals can figure into your photography plans.

Landscapes

An imaginative photographer can create a beautiful landscape, whether he's visiting the White Mountains of New Hampshire or the tropical island of Moorea. Landscapes are simply photos that portray an outdoor place, regardless of its location.

When confronted with a scenic vista, many photographers are inclined to use a wide-angle lens to capture as much of the view as possible. However, it can be better to use a telephoto lens to zero in on an especially interesting portion of a scene. Regardless of your approach, you should attempt to present your landscapes with as little clutter as possible.

Your goal when photographing a landscape is to capture the spirit of the place. What is it about the scene that attracts you? Perhaps it's the late-afternoon sunlight shining on the ocean waves as they lap the shoreline. Maybe it's the cloud shadows on the mountains beyond the forest. Light has a dramatic effect on landscapes, as does weather. Be aware that the quality of light, like the weather, is constantly changing. You must shoot quickly if you wish to capture that setting sun or those dark storm clouds that will soon deliver rain. See **FIGURES 13-1**, **13-2**, and **13-3** for some dramatic landscape images.

FIGURE 13-1: By photographing the Irish countryside from above, the photographer created a pleasing image that relies on soft shapes and rich colors for visual impact.

Photo by Philip Thornberry

FIGURE 13-2: Natural scenes evoke a gamut of emotions; maybe that is why so many photographers are drawn to the outdoors.

Photo by Philip Thornberry

You don't have to be a student of landscape photography to recognize the name Ansel Adams. His powerful black and white images capturing the loveliness and majesty of the American western landscape are frequently seen on calendars, posters, and in books. A visionary who understood the importance of protecting the environment, Adams spent some of his early years photographing the Yosemite Valley, an experience that provided lifelong inspiration. Adams is known for his development of the Zone System, a classification of his approach to exposure, processing, and printing. The Zone System was based on the concept of previsualization, the ability to imagine how the finished photo will look given a particular set of conditions. The Zone System provided

a means of controlling the optical, mechanical medium of photography with adroitness, similar to the way an artist wields a brush and paints. Adams's legendary technical genius enabled him to take an ordinary scene and transform it into a radiant photograph.

FIGURE 13-3: This photograph of beautiful Ireland emphasizes the spaciousness of the landscape.

Photo by Philip Thornberry

Panoramas

Sometimes nothing else will do but to capture a panoramic image of a scene. Use the panoramic mode on your digicam to take a picture of that sweeping vista. Panoramic shots are especially appropriate for subjects such as city skylines, seascapes, mountains, and bridges.

When shooting in panoramic mode, watch the edges of the viewfinder to be sure you're including only what you really want.

Take care to keep the horizon level near the middle of the frame. If you don't, the horizon will bend, either upward (if the horizon is too low), or downward (if it is too high).

If you have panoramic software that allows you to "stitch" images together, you can take a series of images while slowly turning in a circle. Then the camera uses the software to form one 360-degree panorama. Many digicams come with this panoramic stitching software.

Sunsets

Few people can resist the splendor of a spectacular sunset. To catch all the glorious color, you must be prepared to act fast. Take a series of shots and vary your position. In some photos, include elements in the foreground. In others, fill the frame with sky. Remember that the colorful sky is really what you are trying to capture, so even after the sun sinks beneath the horizon you can continue shooting and end up with some good images.

Still Lifes

Although fruit may be the first thing that comes to mind when you hear the words "still life," just about anything can qualify as a subject for a still life. A still life simply refers to an inanimate object, or group of objects, composed and captured in an interesting way. For centuries, painters have used still lifes as a means for exploring and learning about their craft, and photographers can do the same.

FACTS

When photographing a still life, you have complete control over the creative process and can experiment with shape, light, color, texture, and composition. Still lifes tend to be more time-consuming because you must first set up the shot. By paying attention to detail and allowing your creativity to surface, you can create a memorable still life image.

Many of the photographs used in advertising are still lifes. Open a magazine and study them for clues to what works and what doesn't. Notice what draws your eye, paying attention to the use of lighting, color, composition, shapes, and texture. You will see that photographers use

techniques such as patterns (repetition of shapes and lines), a combination of complementary or clashing colors, and a focus on one main object when creating noteworthy still life images.

When setting up your own still life, everyday items you have around the house can be used to make a statement if they're arranged well. To make it more than just a snapshot, you will need to consider the texture, theme, and composition of your image. Your choices of subject, placement, and lighting will be the keys to creating successful still life images.

Pick objects of complementary or contrasting color or shape, things that will work together to convey a story, or objects that are found together in nature. Arrange them so that they are leaning against or are placed next to each other. Larger items will become the main focal points of the composition, with smaller objects placed in front of them.

Vary the lighting for different effects, but consider your subject and the outcome you are trying to create. Soft, diffuse lighting will give the image a soft quality, like a painting. Stronger light is more appropriate for use with a still life composed of contemporary or angular items. Varying the angle of the light also changes the mood of the shot. Lighting your still life from above will make it appear more grounded. If you light it from below, the objects will cast high shadows and appear larger.

When shooting indoors, you may want to take a tip from the pros and create backdrops for your still life. Any solid-color cloth can be used, as can professional seamless background paper that is available in a variety of colors and textures.

Working outdoors, you'll probably use natural lighting to complement objects found in nature. Try shooting in open shade for best results. If extra light is required, bounced flash lighting or a photo reflector will add more light to the scene.

Edward Weston (1986–1958), considered one of the great masters of twentieth-century photography, began taking pictures at sixteen and had his first photography exhibit, at the Art Institute of Chicago, while still a teenager. He is known for his classic black-and-white nudes, portraits, natural landscapes, and still lifes of peppers, shells, and rocks. Weston used large-format cameras and available light to create sensuous images of lyrical beauty. He was a contemporary of Ansel Adams, Alfred Stieglitz, Paul Strand, and Georgia O'Keeffe. Edward Weston was a founding

member of Group f/64, a group of purist photographers that was founded in 1932 and included Adams, among others. Of Weston's photographs, Adams said, "His work illuminates man's inner journey toward perfection of the spirit."

Silhouettes

You can create interesting images with silhouettes. A silhouette is an outline of a subject filled in with black or a dark color set against a lighter background.

Capturing a silhouette is not particularly hard. The light must be behind the subject you want to silhouette so that you are, in effect, underexposing the subject.

Silhouettes have the most impact when you incorporate an opaque object and a bright background. Look for a bold subject with a simple shape, one that the viewer can easily recognize. The background can be any light-colored expanse, such as the sunset sky, the glittering sea, or even a light-colored building.

To get the best exposure, turn your viewfinder towards the brightest area of the scene, then lock in the exposure and reframe the shot. If your camera has exposure compensation, take a reading of the bright area, then bracket the shot so you can choose the image with the exposure that you like best.

Cities

The movement, color, and exuberance of city streets make them an ideal place for taking photos. Amidst the urban commotion you'll find all matter of subjects, including eye-catching architecture, captivating faces, lush public parks and gardens, fountains, green markets, and historic landmarks. Even the public transportation—taxis, buses, and subway cars—can be fruit for your digital images.

If you're new to the city or just visiting, take a walk to really get a feel for the flavor of the city. You'll be part of the street's hustle and bustle so you'll be able to spot interesting details as you stroll around. Think about

what you'd like to shoot. Are you looking for anything that grabs your attention, or do you have a particular subject in mind?

If you're in a city with a long history, look for opportunities to show the old and the new side by side. For instance, if you're visiting Boston's Back Bay, a shot of the Romanesque Trinity Church dwarfed by the contemporary glass behemoth, the John Hancock Tower, would show an interesting juxtaposition of the historic and the modern.

For a different perspective on a city, you might want to get above or beyond the action. Looking down on streets, they become lines forming interesting patterns. For a good vantage point, see if the city offers an observation tower. Or if you're staying in a high-rise hotel, you may be able to shoot photos from your room.

You may need to get away from the city to get an expansive view. To shoot from the water, take a boat or ferry ride. Even a bridge, such as San Francisco's Golden Gate, can offer a fantastic place from which to photograph a city.

The city can look a little lackluster at midday, but in the evening it takes on a glamorous glow. Try shooting at twilight when there is lots of blue light left in the sky and see how the buildings glimmer. Just before sunset you can shoot from the west to catch the setting sun lighting up the city skyline. Skylines often make breathtaking images, especially when captured in dramatic evening light.

ESSENTIALS

When taking pictures at dusk or dawn, it becomes difficult for your digicam to judge the right exposure. Take a series of shots so you'll be guaranteed satisfying results.

Turn your travel images into a slide show, and you can share your exciting adventures with everyone you know. With a digital camera and the right software, you can produce a show that bears little resemblance to the proverbial "sleep fest" slide shows of the past.

Just like your trip, your show should have a beginning, middle, and end. Ideally, it will include a variety of close-ups, panoramas, and wide-angle shots.

When visiting metropolitan areas, walk through busy urban areas with camera in hand. Keep your eye open for interesting subjects, such as people shopping or making their way to work, and architectural details that will convey the mood of the city.

Open-air markets, with their colorful produce stands, merchandise vendors, and shoppers haggling for the best bargains, can be fodder for your photographs. City parks can reveal lovely fountains and gardens, while urban skyscrapers can be used to produce striking graphic images.

If your trip takes you to a tropical destination, the beaches, luscious flowers, and colorfully garbed people all combine to spark your imagination. When traveling by cruise ship, you'll have all sorts of opportunities to get photos, both onboard the ship and when stopping at ports of call. You can shoot scenery from the deck of the ship, capture the impressions of the island markets, and even record the action at the ship's buffet table or dance floor.

When combined into one slide show, a medley of images can provide a wonderful view of the places you've seen.

Architectural Details

FIGURE 13-4: There are many ways that architectural details can be captured with a camera. An elaborate lighting fixture in a bank provided the photographer with the inspiration for this photo.

Photo by Janet McCanna

Although it is fun to capture the magnificence of a famous structure, such as the White House or the Eiffel Tower, many buildings offer subtle architectural details that make exquisite images on their own. Menacing gargoyles, centuries-old weathervanes, and luminescent stained glass windows are just some of the compelling details that can be used to create whimsical photos.

A building's many details combine to give the structure its architectural style. Think of the elaborate gingerbread of a Victorian

house, the stainless-steel exterior of an Art Deco diner, and the fluted columns of a Greek Revival courthouse—all details that immediately declare the style of the building.

FIGURE 13-5: Although we often see photos of St. Patrick's Cathedral in New York, in this picture the photographer chose to show just its elaborate door rather than the entire ornate building.

Photo by Elizabeth T. Schoch

The best photos of architectural details are ones that are tightly composed so that the subject fills the frame. Depending on how far you are from your subject, you may be able to use a normal lens or moderate telephoto. If you are too far away, you'll need a more powerful telephoto lens. Be sure to note the lighting. Ideally, it will be coming from the side so that texture and details will be readily revealed. If you are concerned about capturing color, a hazy day will offer the most saturated hues.

If you're interested in shooting architectural details, begin by taking the time to look for them. Although you may first think of visiting cathedrals and historic structures, remember that even a simple country barn or city diner can offer interesting shapes and patterns. As you begin to become more and more aware of the details of the buildings around you, you may be surprised at how many can be used effectively in your digital images. **FIGURES 13-4** and **13-5** show some of the many ways that architectural details can be captured with a camera.

Close-Ups

If your digital camera has a close-up mode, you can enjoy taking intimate shots of the world around you. Nature offers a limitless array of possibilities, from the elegant butterfly perched on a garden bush to tidal pools hidden amongst seaside rocks. Even in your own home, anything can be a possible subject for a close-up, from a coin in the palm of your hand to a pile of paper clips on a desk.

If you can select the aperture on your camera, use the minimum aperture when taking close-ups to provide as much depth of field as possible. Getting the right light can be tricky, and you may get better results if you turn off the flash and use available lighting. Be sure you aren't throwing a shadow onto your subject. Use a tripod to avoid camera shake.

Good Pictures Are Everywhere

You need not be a globetrotter to take impressive photos. Start in your own backyard. Or take a walk down the street where you live. The great photographer, Edward Steichen, took hundreds of pictures of a tree near his home in Connecticut. "Each time I look at these pictures," he said, "I find something new there. Each time I get closer to what I want to say about that tree."

How good are your photos? If you think your digital images are prize winners, find out by entering them into a photo contest. Here are just a few of the photo contests offered on the Web:

✑ Apogee Photo
www.picture.com

✑ Black River Publishing
www.brpub.com

✑ Cat Craze Photo Contest
www.catcraze.com

✑ DigitalPhotoContest
www.digitalphotocontest.com

✑ International Library of Photography
www.apogeephoto.com

✑ Photo Trust Online Photo Contest
www.onlinephotocontest.com

✑ Wolf Camera Photo Contest
www.digitalphotocontest.com

Photography Log

It is very easy to forget the details of an image you've taken. Here is a log that lets you record all the pertinent information about your photos.

Frame	Date	Aperture	Shutter Speed	Lens	Notes
0					
1					
2					
3					
4					
5					
6					
7					
8					
9					
10					
11					
12					
13					
14					
15					
16					
17					
18					
19					
20					
21					
22					
23					
24					

CHAPTER 14

Downloading Images

Downloading refers to the transfer of images from your camera's storage media to a storage device located on a computer, printer, or other device. Downloading is accomplished by connecting the camera directly to the computer using a cable, or removing the media from the camera and inserting it into a special drive. You can also utilize wireless technology to make the transfer.

Connecting Your Camera with Cable

You can connect your camera to your computer or other device in several ways. Most digicams come with software and a transfer cable. To transfer images, you insert the cable into a port on your computer. The type of port your computer uses will determine the length of time it will take you to download your images.

Usually, the process of transferring image files from your camera to a computer using a serial port or USB begins with the downloading of the thumbnails for each file. The thumbnails take the place of a contact sheet, allowing you to view your images. Using the thumbnails, the photographer decides what files to download and what files to delete.

Typically, the transfer process happens this way:

1. Using the computer, open the camera's software
2. Open the picture files
3. Choose the ones you want to transfer to the computer
4. Select the directory to which you'd like to transfer the files
5. Select "transfer selected images"
6. The downloading process begins

ESSENTIALS
When downloading images without a memory card reader, you'll save your battery power if you plug your camera into an electrical outlet using the camera's AC adapter. Because downloads can take several minutes, using the AC adapter will keep you from draining your camera's batteries.

Serial Ports

When digital point-and-shoot cameras were first introduced, the only way to download pictures from the camera's memory to a computer was to connect the camera directly to the computer using a serial cable. Today serial ports are generally used for connecting analog modems so that the user can access the Internet. But some digicams still use serial ports to connect to a computer. A serial cable transmits information one bit of data at a time, which makes for a very slow process.

The upside of using a serial port is that most every computer has one (except Macs), so any camera can be downloaded to any computer. One downside is the extremely slow transfer rate of the serial connection, which is limited to 150 to 230 kilobits per second (Kbps). The other drawback is you have to have your computer handy in order to download your stored images to it.

Downloading using a serial cable is the slowest way to transfer images to a computer. It takes about five or six minutes to download 8 MB of images. To download your images using a serial cable you'll need special software, and glitches can occur during the transfer process.

Parallel Ports

Faster than serial ports, parallel ports can carry 8 bits of data at a time. They are normally used for printers and certain kinds of external storage devices. Many card readers plug into a parallel port.

SCSI Ports

SCSI (which stands for Small Computer System Interface) connections transfer data at a rate of 40 Mbps (megabits per second) to 640 Mbps, making it up to fifty times faster than USB. Used by Macintosh computers more than PCs, SCSI is fast, but it has certain drawbacks. Before you start your computer, you must connect and turn on the SCSI device. Although a SCSI port can accommodate up to seven devices, they must be "daisy chained" by plugging one device into another. SCSI requires a bit of patience to utilize as it's a fairly complex method of connection and can be difficult to operate.

If you need a fast and easy way to connect a SCSI device to a USB-equipped PC or Macintosh computer, check out the USBXchange from Adaptec. It even includes an adapter for the larger classic SCSI connector. See their Web site, *www.adaptec.com,* for more info.

USB Connections

Computers manufactured after around 1998 typically have a USB (universal serial bus) connection. Downloading via the USB is a much

faster and easier way to transfer your images than using a serial cable. USB can transfer images at up to 12 Mbps, which is about fifty times as fast as the fastest serial connection. Downloading 8 MB of images via USB should take you less than one minute. If your computer has a USB, you may want to purchase a USB-compatible digicam.

Besides saving you time when you download, another great advantage to using a USB camera is it's hot swappable. Hot swappable is just a fancy way of saying that you don't have to turn off the computer or the camera when you plug or unplug the camera from the USB port. With USB, you can daisy chain up to 127 devices on a single USB port, which makes it easy for you to custom-build a system. You can use USB with CD-ROM drives, hard drives, and video equipment.

FireWire

Even faster than a conventional serial bus port is FireWire, a high-speed, high-performance serial bus. FireWire was introduced by Apple Computers in their Power Macs, but today it is used throughout the electronics industry. (FireWire is the name patented by Apple, but it is also referred to as IEEE 1394 and i.LINK.)

FACTS

FireReaders line of card readers from FirewireDirect allows the user to plug the reader into a PC's FireWire port for operation. It comes in models for CompactFlash and SmartMedia versions. Each allows hot swapping so the user is able to replace cards without restarting the computer. The reader is designed for use with digital cameras, MP3 players, PDAs, and other devices.

FireWire transfers data from a computer to another device very quickly—at 100, 200, or 400 Mbps—fast enough for digital camera images and uncompressed digital video. Some people believe that FireWire is quickly becoming the data transmission standard of the digital world. FireWire is easy to use and is hot swappable. It permits up to sixty-three

devices, such as digital cameras, digital camcorders, music devices, printers, and scanners, to be connected to one port.

FireWire is compatible with Apple PowerBook G3 and PowerMac G4 computers, the iMac DV, Compaq 5600 Series desktop computers, several Kodak DCS digicams, the Sony Vaio, Canon's Optura Pi digital-video camera, the Canon EOS D2000, and the Nikon D1 digital camera, among others.

ALERT

It's easy for computer users to accumulate a mass of power cords and cables what with computer, monitor, mouse, and keyboard all needing to be connected. Label your power cords and cables each time you install a new piece of hardware to avoid the frustration of figuring out what each one does.

Downloading Directly from Storage Media

Even faster than serial or USB transfers are downloads that work with removable storage media such as CompactFlash and SmartMedia. Here are some of the options if your digicam uses removable media:

Floppy Disks and Floppy Disk Adapters

If your camera uses a floppy disk as storage media, you simply remove the disk from your camera and insert it into your computer. It couldn't be easier. Of course, there are drawbacks to floppy disks: (1) the camera must be big enough to accommodate the floppy disk, and (2) a floppy disk holds less than 1.5 MB of data, much less than flash memory cards.

If you wish to use removable storage media with your floppy drive, you can purchase a FlashPath adapter. The adapter is shaped like a floppy disk and inserts into the standard drive slot found on almost all computers. You can then insert the media card into the FlashPath and begin downloading images. You won't need a cable connection to utilize the FlashPath adapter, but you will need driver software. FlashPath adapters are available for Toshiba's SmartMedia.

PC Card Adapters

You'll typically find a PC card port on notebook PCs, PowerBooks, and some handheld devices. If your computer supports Type II cards, you can purchase a PC card adapter for either CompactFlash or SmartMedia. Then it's a simple process of inserting your flash memory card into the adapter and plugging the adapter into your PC. The great thing about using a PC card adapter is that it's immediately ready to use—there's no driver or other software necessary. The downloading process is really fast: You can copy 8 MB of images in just a few seconds. The PC card appears as a drive on the computer desktop, and you simply drag and drop image files from the PC card to the hard drive.

Memory Card Readers

Memory card readers are available from a number of different manufacturers. They not only help you to transfer digital images from cameras quickly and simply, but they also work with MP3 players, personal digital assistants (PDAs), and the Internet. The readers work with SmartMedia and CompactFlash memory cards, allowing users to copy and move digital files from one device to another. A memory card reader plugs into a serial, parallel, or USB port. Some newer readers also utilize FireWire ports.

FACTS

Memory card readers are great for downloading digital images because you don't have to hook the camera to the computer. By inserting your SmartMedia or CompactFlash card into the reader, you're ready to access image files. Once the memory card is full, you can download it using the reader and keep on taking pictures.

ImageMate Drive

SanMate manufactures the ImageMate Drive, an external CompactFlash drive that allows you to transfer image files from your camera at a rate forty times faster than a serial cable connection. It connects to your computer using either a USB or parallel port. Once you've got it hooked

up, it appears on your desktop as a drive so you can easily drag and drop files from your digicam. It also works for downloading files from handheld computers and the Internet.

Iomega PocketZip Drive

If you're a photographer who likes to travel, you'll probably be interested in Iomega's PocketZip. The compact, rechargeable, handheld drive can read CompactFlash and SmartMedia cards. PocketZip then automatically transfers the images to 100 MB, matchbook-sized disks. Once you're back at home, you simply connect the PocketZip drive to your computer's parallel port for downloading to your hard drive.

Iomega recently introduced the new, 100 MB size disks. Retailing for as little as $10 each, the PocketZip disks provide an economical alternative to 32-MB solid-state memory cards, which sell for about $60 and provide one-third the capacity. If you plan to spend a day shooting photos, you may want to investigate the PocketZip drive.

Wireless Transfers

Wireless is fast becoming the way to go. And now you can transfer your digital images using wireless technology.

Infrared Transfer

You can avoid the hassle of connecting your camera to your computer with cables by using wireless infrared (IrDA). You'll need a digital camera with an IrDA port and a receiving device that also features this technology, such as another digicam, a computer, or a printer.

IrDA wireless transfer utilizes infrared light beams to carry files. This same technology has been used for more than twenty years in television and VCR remote controls. Many devices today feature IrDA ports, including digital cameras, notebook computers, mobile phones, digital pagers, printers, PDAs, organizers, PC Card adapters, and others. Some digicam manufacturers who utilize IrDA technology are Casio, Sharp, Kodak, and Sony. If your computer does not have infrared capability, you can buy an

adapter that plugs into one of its ports and allows it to be used with your IrDA-equipped digicam.

To transfer your image files, just put your camera near your computer or other IrDA-equipped device and begin the transfer process. The downloading speed will be determined by the capabilities of the receiving device's IrDA port.

FlashPoint

How about skipping the step of downloading to your computer altogether? Thanks to an alliance between Motorola and digital software vendor FlashPoint Technology, you can send and receive digital pictures over the Internet using Digita-enabled cameras and Motorola iDEN (Integrated Digital Enhanced Network) cellular phones. The new platform was designed to enable users to quickly and effortlessly share digital photographs.

A photographer using a Digita-enabled camera connected to an iDEN handset, such as the Motorola i1000plus, can capture, send, and receive images wirelessly. The process allows the transmittal of digital images via the Internet to friends, family, and colleagues anywhere in the world.

The FlashPoint/Motorola combination is ideal for anyone wanting to quickly capture images and transmit them immediately. In effect, it allows you to use an Internet-ready Motorola iDEN wireless phone as a modem for your camera. You can post images on any Web site, including your own business or personal site or a photo-sharing site where others may view your pictures. Digita automatically sends an e-mail containing the link to your photos.

So far, FlashPoint has licensed its Digita operating system to Eastman Kodak, Hewlett-Packard, Minolta, and Epson. Current digital cameras utilizing the Digita operating system include the HP PhotoSmart 618, 912, and C500 models; the Kodak DC220, DC260, DC265, and DC290 models; the Minolta EX 1500; and the Pentax EI-200 and EI-2000 models.

Other Types of Transfers

Your digital camera can also be connected to a television, VCR, or printer. Let's examine how you can transfer images to these types of equipment.

Connecting to a Television or VCR

If your digicam has a video-out jack, as many digital cameras do, then you can connect to a TV using standard input or video-in terminals. This type of connection allows you to view your images on your TV or record them on videotape using your VCR.

When you display your images on a TV screen, you can see them a lot more easily and clearly than when you view them on a computer monitor. Because of the bigger screen, small imperfections become more readily discernible. And if you have a group of people who would like to see your images, whether for business purposes or just for fun, this is one way to do it.

By recording your images on video you can create your own slide show, complete with sound if your camera provides the ability to record audio.

Many digicams sold in the United States output video in NTSC format, the format used by TVs in North America. European televisions use the PAL format so you won't be able to display digital images from your camera on European TVs unless your camera has PAL capability. Some newer digicams offer the choice of NTSC or PAL formats. If you travel a lot and want to use the video-out feature in countries outside the United States, this feature is something to keep in mind.

To transfer images between your digital camera and a TV, typically you connect one end of an AV cable to the camera's video-out or AV-out jack and the other to your TV or VCR's video-in jack. If your camera has the ability to record audio, you will use a separate AV plug for the audio signal, inserting it into the audio-in jack.

ALERT

Be aware that your digicam's software must allow you to transfer downloaded images back to the camera or you will lose your images unless you record them on video.

Downloading to a Printer

Your camera may offer you the capability of downloading your images directly to a printer. Of course, you'll need to be sure that your printer can communicate with your camera.

With some cameras and printers, when you choose to download directly to a printer you are foregoing the option of editing your images. You may be able to make a few minor adjustments, such as rotating the image, but you will not be able to make major changes in an image.

One printer that does allow you to manipulate your images before downloading directly from your camera is the Kodak PPM200. Using this printer, you can insert a memory card into a slot on it, then use its picture preview screen to view, crop, and size your images before printing. You also have the option of printing your pictures with frames or without. The Kodak PPM200 works with both CompactFlash and SmartMedia storage devices.

A printer that offers infrared technology, along with a built-in reader for SmartMedia and CompactFlash memory cards, is the HP Photosmart 1218. The color printer allows you to download images directly from your digital camera, PC, Mac, laptop computer, or other digital device. It also provides a USB and parallel port for users who don't have an IrDA-equipped digicam.

There are certain circumstances that make downloading digital images directly to a printer the best alternative. For instance, a teacher may want to use her digicam in the classroom to catch her students in action. If she can quickly print out the stored images, the kids can take pictures home with them the same day. If the need to print digital images quickly is your top priority, then you may want to consider choosing a digicam that provides direct printer output.

CHAPTER 15

Image Compression and File Formats

Compression reduces the size of an image file by either reducing the number of colors in an image or by grouping together a series of pixels of a similar color. Because a compressed file takes up less space, you can fit more image files on your internal flash memory chip, removable storage media, or hard drive when they are compressed.

How Compression Works

The amount of digital images that fit on a memory card varies according to the resolution of each image as it is the resolution that determines the size of each image. For instance, a memory card that holds sixteen low-resolution images might hold just a single high-res image.

Let's take a closer look at how this works. The Kodak DC3800 digicam outputs images with resolutions of either 1,792 x 1,184 or 896 x 592, depending on how compressed the images are. The user chooses one of three image-quality settings to determine the compression ratio.

If you choose the "best" resolution setting, your images will be 1,792 x 1,184, which is roughly 2.1 MB. To determine the size of the image, we multiply that number by three, because every pixel in a color digital image utilizes three bytes of information (one byte for red, one byte for blue, and one byte for green). The result is 6.3 MB. This would lead us to believe that a 16 MB memory card could only store two images from the Kodak DC3800. In reality, it can hold as many as thirty images. What is the secret to squeezing in the extra images? Compression.

Ideally, your digicam will allow you to choose the amount of compression used on a particular image. You can then determine the setting you want to utilize based on the resolution you need for the image. If you need your digital images to be of the very highest quality, select a digicam that has a no-compression or low-compression option.

ESSENTIALS
Experiment with compression levels on your camera and in your image-editing software to see what best meets your individual needs. You may find that when you apply less compression, the quality remains quite high while still saving you time on downloads.

Lossy Versus Lossless Compression

There are two types of compression: lossy and lossless. With lossless compression, no bits of information are permanently lost. Lossless compression works by rearranging redundant pixels but does not delete

any of them. For this reason, lossless compression preserves image quality, but it also results in smaller decreases in file size. Lossless file formats include TIFF, GIF, and BMP.

With lossy compression, some bits of information are permanently eliminated. Lossy compression results in significantly smaller file sizes, but image resolution is also reduced. JPEG is one example of a lossy file format. Another, less popular one, is FlashPix.

File Formats

The term file format refers to a method of storing computer data. There are many different file formats, including proprietary ones used exclusively by a particular camera manufacturer or a particular software manufacturer. Some formats can be used only with Macintosh computers; others can be used only with PCs. The more popular formats are supported by most programs across both platforms. The following is an overview of popular file formats.

JPEG (JPG)

JPEG is the image compression method most widely utilized by digital cameras. JPEG stands for Joint Photographic Experts Group, the people who developed the original code. Because of its ability to reduce file size with a negligible degree of deterioration, JPEG has become the standard for saving and compressing digital images.

JPEG is a very efficient method and preserves colors well. It accommodates both 8-bit grayscale and 24-bit color images. JPEG rearranges or deletes pixels to reduce the size of digital images. The resulting compressed images take up from 2 percent to 50 percent of the space they would have used if they were left as uncompressed images.

As you can see, compressing files to JPEG results in great savings of space on memory cards and hard drives. However, since JPEG is a lossy compression scheme, each time that an image is compressed using JPEG, there is a corresponding decrease in resolution. Every time a photographer edits or resaves a JPEG file, the quality of the image deteriorates. Because of the pixel elimination that happens during JPEG

compression, the decompressed image is not going to be identical to the original.

FACTS

In a nutshell, JPEG uses a lot of compression and JPEG images are good for using on a Web site or with e-mail, while TIFF uses much less compression and TIFF images are best for photos you want to print.

One great advantage of JPEG is you can control the degree of compression. For instance, with some image-editing software programs, such as Photoshop, you can compress JPEG files in a variety of preset levels, ranging from maximum (highest compression) to low (lowest compression), thereby altering the resulting quality of the image. You'll be able to determine how you want to balance file size with image quality.

Using low-compression/higher-quality settings will give you bigger files but better images. Higher-quality images always look better, even at lower resolutions. And since you have more pixels to play with, they provide better results when used with an image-editing software program.

JPEG2000 (JP2)

The Joint Photographic Experts Group and others have developed a new image coding system using state-of-the-art compression techniques. It is called JPEG2000 and was made available in the marketplace in early 2001. JPEG2000 should provide users of digital cameras with a more versatile JPEG file format that uses wavelet technology, a significant advancement in image compression.

With JPEG, compression is performed on 8 x 8 blocks of pixels. When you use the highest level of compression or enlarge a compressed image greatly, the blocks become visible to the human eye. Wavelet technology does not divide images into blocks the way JPEG does; it uses a continuous stream. Therefore, images in the JPEG2000 format suffer less degradation at a higher compression ratio, enabling them to take up less space but provide better resolution.

The new JPEG2000 format based on wavelet technology provides users with certain advantages over the original JPEG standard. JPEG 2000 offers the following:

- Comparable image quality with files that are 25 to 35 percent smaller in size
- Improved image quality at the same file size
- Good image quality even at compression ratios as high as 80:1 and higher
- A single compressed file offers a variety of options, which vary depending on need. Options include image sizes ranging from thumbnail to full size; grayscale to full three-channel color; and low-res images to those identical to the original.

Some of the companies currently marketing products utilizing JPEG2000 are Aware Inc., Imagepower, and Algo Vision.

TIFF (TIF)

TIFF (Tagged Image File Format) allows you to store the highest-quality uncompressed images. It is the most popular lossless compression format. The TIFF format supports 8-bit grayscale and 24-bit color images. In addition, it accommodates 1-bit black and white, 8-bit color, and numerous other color settings. Consider using TIFF if you plan to edit your images repeatedly, use them in a publishing software program, or if you want to produce high contrast photos. TIFF is not a good choice for images that you will be using on Web sites or e-mailing, since it cannot shrink images to their smallest possible size.

When manipulating digital images in an image-editing software program, save them as a TIFF file or the program's proprietary file format to preserve their quality. Once you have finished editing the image, save the image as a JPEG.

EXIF

EXIF stands for Exchangeable Image Format and is a variation of the JPEG format. It was developed by the Japanese Electronics Industry Development Association. Some digital cameras may store images as EXIF in order to record extra information with the file, such as the aperture, shutter speeds, and other camera settings; picture taking conditions; sounds recorded when the image was captured; and more. This extra information is known as metadata. Camera specifications sometimes note this type of format as JPEG (EXIF).

After downloading your images, you will need a special EXIF extractor in order to view the metadata that was captured by your digicam. If your camera did not come with proprietary software allowing you to view the metadata, there are several programs you can buy for this purpose.

GIF

Another lossless compression format, GIF stands for Graphic Interchange Format. GIF was developed in 1987 by CompuServe, who referred to the file format as GIF87. In 1989, the company added new features to GIF, including animation, and it became GIF89a. Today, we don't usually differentiate between the two formats, but if you hear someone refer to GIF89, the image most likely is animated.

FACTS

If your image has less than 256 colors, then there will be no degradation of quality when you choose to save it as a GIF file format. Since the format is not saving color information for unused colors, the file size will be reduced. But if your image contains lots of subtle variation in color, its quality will be greatly decreased.

GIF and JPEG are the two formats most commonly used on the World Wide Web. Most color images and backgrounds on the Web are GIF files. GIF accommodates 8-bit color, giving you the option to have an image display up to 256 colors. This is far fewer than the 16 million colors recognized by JPEG and TIFF. However, you should note that the user

chooses which colors GIF will use, and they can come from any of the 16 million available from the 24-bit color library. An index lists the colors contained in the GIF file. GIF is a good file format for line drawings, text, and graphics.

EPS

EPS stands for Encapsulated PostScript. EPS files incorporate the PostScript language and the original file, so files saved in the EPS format are larger than the original. Adobe created PostScript as a means of communicating to a printer the size of the file, what fonts it uses, and other details so that the printer can output an accurate document. This format is utilized primarily for high-end desktop publishing and graphics output. Because they are cumbersome, EPS files do not work well on the World Wide Web.

PDF

An updated version of the EPS format, PDF (portable document format) also contains information that is helpful to the printer, including descriptions of font, size, and color. The PDF file is not really just one file; it is an entire document that can include images, color, and the like.

A PDF file easily accommodates a large document, making it an excellent method for transmitting data via the Internet, and PDF readers are readily available. Many software companies are distributing their software manuals as PDF files.

FlashPix (FPX)

Another file format is FlashPix, which was developed jointly by Hewlett-Packard, Kodak, Microsoft, and Live Picture in 1995. Its aim is to accelerate the image editing process and to allow a user who does not have a computer with a lot of RAM to easily edit large images.

The FlashPix format uses lossy compression and stores an image plus several lower-resolution versions of that image. Each resolution is divided into square tiles. Applications use only the specific areas of an image for a selected procedure. If only one section needs adjustment, then only

that section of the image is processed. Changes take place faster because only the affected tiles need to be adjusted. In the same way, applications do not have to process a high-res image if only a low-res image is needed. Once the user is done editing and needs a high-res file, the changes that have been made are applied to the image.

FlashPix has certain drawbacks. For one thing, it is not supported by all image-editing and cataloging programs. Another drawback is that it produces files that are larger, and take up more space in memory, than other file formats, such as TIFF. Although it has promise, FlashPix is not yet an established standard.

Native Formats

Many software programs save files to native (proprietary) formats, which are designed to support the program's special features. For instance, PhotoDeluxe uses the PDD format, and Photoshop uses the PSD (Photoshop document) format. Remember that if you want to use your image with a different program, you will need to save it to another format, such as JPEG or TIFF.

Platform-Specific Formats

There are some formats that are not particularly useful for digital photographers, but you should be aware that they exist. One is PICT, which is the native graphics format used by the Macintosh operating system and can only be read by Macintosh programs. Another is BMP, which is a standard bitmap file format designed by Microsoft to handle images in Windows programs. Neither format works well with digital images. It is better to save your images as JPEGs or TIFFs.

Compression (Archive) Formats

If you have many large digital image files to manage, you may want to investigate zip files. Zip files are the most common type of archive format

and are designed to help you distribute and store files. Zip files contain one or more other files, which are usually compressed first. You can easily and quickly group, transport, and copy zip files.

There are other file formats that provide benefits similar to zip files. These include TAR, gzip, ARJ, LZH, and CAB.

There are dozens of compression and archiving utilities available that will allow you to shrink images, making them easier to archive or use on the Web. Below are summaries of several of them. Be aware that if you "zip" your files and send them via e-mail, the receiver must have the proper software to "unzip" them.

WinZip

WinZip is a powerful yet easy-to-use compression utility. The program includes long file name support and tight integration with Windows 95, 98, NT, 2000, and Me. You can drag and drop to or from Windows Explorer, or zip and unzip within Explorer. Popular Internet file formats that it supports include ZIP, TAR, gzip, CAB, UUEncode, Xxencode, BinHex, and MIME. ARJ, LZH, and ARC files are supported via external programs. WinZip will help you access almost all the files you download from the Internet. WinZip has won numerous awards, including the Shareware Industry Award 2000 for Best Overall Utility, the People's Choice Award 2000 for Best Application, the Best Utility MVP Award from *PC Computing* (January 2000), and was voted Download of the Millennium on ZDNet. A free evaluation version of WinZip can be downloaded at their site, *www.winzip.com*.

BitZipper

Another excellent archive utility is BitZipper from Bitberry Software. You can download a free trial version at *www.bitberry.com*. BitZipper is an easily used utility that offers full support for many file formats, including ZIP, CAB, BH, GZ, JAR, LHA, LZH, and TAR. In addition, it offers partial support (view and extract) for ACE, ARC, ARJ, RAR, RGZ, UUE, XXE, Z, and ZOO formats. BitZipper allows you to create, view, and extract from ZIP files, apply password protection, and read and add comments. With the BitZipper Batch Tool, you will be able to extract,

convert, search, and virus scan multiple archives in one operation. BitZipper supports Windows 9x, NT, 2000, and Me. BitZipper has been recognized by ZDNet, Winfiles.com, Yahoo! Internet Life, Yippee Shareware, and others.

FilZip

FilZip is a free ZIP program that lets you zip and unzip compressed archives. It has features such as password protection, multiple-disk archive support, zip file comment support, and self-extracting zips. It supports many archive formats, including ZIP, ACE, ARC, ARJ, CAB, GZ, LAH, JAR, RAR, and TAR. With FilZip, you can create new zip files, edit existing zip files, unzip multiple archives in a single operation, and view and extract individual files from within zip files. A free download is available at *www.filzip.com.*

StuffIt Deluxe

Macintosh users can utilize the StuffIt Deluxe program from Aladdin Systems to compress image files. The program helps you create and send email attachments faster, back up more files as archives, and squeeze more images onto Zip disks, CDs, and other removable media. StuffIt Deluxe works with most file formats, including StuffIt, Zip, Bzip, BinHex, MacBinary, Uuencode, gzip, Tape Archive Format, ARC, Compact Pro, DiskDoubler, LHA, RAR, MIME, Z, AppleLink, Private File, and more. Perhaps the most popular compression utility for the Mac, StuffIt Deluxe has been recognized by CNET, MacFixIt, Applelinks.com, and others. The program costs $80 and is available from Aladdin Systems at *www.aladdinsys.com.*

CHAPTER 16

Storing Your Digital Images

If you take a lot of pictures, sooner or later you are going to want to create a storage system that allows you to easily access your images. The goal is to create a storage system that allows for easy retrieval of your images. The advent of the megapixel digicam has resulted in the ability to capture higher resolution images that provide greater detail. The downside? These images require much more storage space than earlier, low-res images.

Understanding Computer Memory

There are several different ways to approach storing your digital images. Storage options run from hard drives to CDs and DVDs to memory cards used in your digicam. (You can find more on removable memory in Chapter 6.) With a little planning, you will be able to utilize one or more of the powerful and flexible computer-based storage and management tools available today.

Taking a look inside your computer will give you a better idea of how data is stored.

- Data stored temporarily in your computer is stored in RAM (random-access memory).
- There are two types of RAM: cache and system RAM.
- RAM is considered to be "volatile" because it stores data and allows access to it as long as an electric current is maintained. Once the power is turned off, everything stored in RAM is lost.
- There are two types of cache: Level I is small and is located in the processor itself. It stores data that is needed quickly. Level II cache is larger and originally was an external memory, but increasingly it is being placed directly into the CPU core. Level II cache stores data that is needed less quickly.
- System RAM holds information that is critical to your applications and operating systems. As you add more applications to your computer, you will be using up more RAM.
- A PC should have at least 128 MB of RAM in order to run Windows 98, ME, NT, or 2000 without difficulty.
- You'll know that your computer is low on RAM if you hear your hard drive spinning while you edit large files or switch between applications.

Saving Your Images

The first step toward storing your digital images is to choose how you will save them.

Choosing a File Format

As discussed in Chapter 15, a file format can be compressed or uncompressed. Uncompressed file formats take up more storage space but offer you the maximum amount of image-forming information. Compressed file formats sometimes delete information in order to reduce the file and conserve storage space.

Many digital imaging experts recommend initially saving your digital files as TIFF files. These act in the same way that negatives do in a 35mm system. By saving your images as TIFF files, you will preserve their image quality. Then you can make duplicate files and save them as compressed files, such as JPEG, to use for e-mailing, on Web sites, or for printing.

Storage Devices

There are two main types of storage technologies: magnetic and optical. Magnetic media include floppy disks and hard drives. Optical media include CD-ROM.

Magnetic media are inexpensive and quick and easy to use. But magnetic media are not archival; the information contained on magnetic media will degrade over time. They are also more adversely affected by the environment than optical media are.

Optical media drives are more expensive, but they are designed to provide archival storage capabilities. In fact, Kodak's premium CDs are designed to last more than eighty years. Recently, however, some concerns have arisen about the viability of CDs as a long-term storage device. An article in the *Wall Street Journal* reported that CDs could prove to have problems, saying, "Discs have turned out to be surprisingly vulnerable to fingerprints, heat, even something called laser rot."

ISSENTIALS

The type of storage device you choose for your images will depend somewhat on how you plan to use them. Do you want to transport them to a digital lab to have prints made? Or are you hoping your images will be around as long as you will?

Magnetic Media

Most people are familiar with magnetic media. Below we'll look at the common types of magnetic media that photographers use for the storage of digital images.

Hard Drives

The hard drive is the internal memory of your computer, which acts as a filing cabinet where you store files. You can choose to store all of your files on your hard drive, or use removable media in addition to or in place of your hard drive. Even if you use your hard drive as your primary place of storage, you will want to back up your files in case your hard drive ever fails.

Hard drives are not costly. To determine the size of the hard drive you will need, you'll have to consider your storage needs and habits. If you like to keep everything on your computer for quick access, you'll probably want to buy the biggest hard drive you can afford.

If you've filled up your computer's hard drive and want to purchase an external one to hold all your images, consider the Que! M2 FireWire drive from QPS. With a 10 GB hard drive enclosed in translucent plastic, the Que! M2 is small enough to fit in your pocket but still offers you speedy transfers of 16.6 Mbps. The Que! M2 comes with a suction cup and belt clip so you can affix it to any smooth surface or clip it to your belt. It's possible to connect up to five drives by stacking and interlocking them using the QPS patented built-in FireWire connectors located on the top and bottom of each drive. Or you can use the optional bay rack mount accessory kit to connect up to ten M2s. If your digicam is FireWire-equipped, you'll have no problem hooking it up to the Que! M2. Find out more at *www.qps-inc.com*.

Floppy Disks

Just about everyone is familiar with the ubiquitous floppy disk. Floppy disks provide an easy method of transporting files as virtually all computers have floppy disk drives. They are inexpensive and readily available. However, they provide limited storage space. Your images will

need to be low-res or highly compressed if you plan to store them on a floppy disk.

Sony manufactures a line of digital cameras, the Mavica, that are floppy-based.

Optical Media

There are several types of optical media that digital photographers can utilize. Below we'll examine what benefits they provide for the digital photographer.

CD-R and CD-RW

One storage solution is to use CDs with a CD-Recordable (CD-R) or CD-Rewritable (CD-RW) drive. CDs (and other removable media) will protect you against a faulty drive and provide you with an ideal means of backing up your hard drive. Using CDs, you can easily expand your storage system. As your needs increase, you simply purchase more CDs. They provide lots of storage space, since one CD-R can hold up to 650 MB of images. And they are economical, since each CD-R costs less than one dollar. Another important benefit of CDs is that their technology is likely to be around for the long haul.

Most computers come with a CD-ROM drive, which lets you read CDs. In order to write files to CDs, you will need to purchase a writable CD drive, which allows you to both write and read data.

There are two different types of writable CDs. CD-R disks allow you to record on them only once, but it is impossible to overwrite your original file, which can be an advantage. A CD-RW disk can be used again, but you must erase all data before recording new data to it. Keep in mind that if you decide to use a rewritable CD drive, you'll need special software to write to ("burn") CD-RW disks.

An easy way to get your images written to a CD is to have your image-processing service do it for you. Many services will give you a hard copy of thumbnails showing each of your images, along with software that lets you view your images. If you want to have your images printed, this service can be completed at the same time.

FACTS

Take these steps to ensure that your CDs last a good long time.

- Buy a high-end CD, not a bargain brand that can be made with inferior coatings.
- Keep your CDs in their jewel cases. If you do use plastic sleeves for storage, be sure they contain no PVC.
- Never leave writable CDs in direct sunlight.
- Do not flex a CD.
- If you clean your CD, use products meant for cleaning photo lenses.
- Never write on a CD or apply adhesive labels. If you've already labeled your CDs, do not try to take off the labels.
- Try to keep your CDs at low humidity and at temperatures below 77 degrees F.

Super Floppies/Zip Drives

Super floppies are just a bit bigger than regular floppy disks, but they hold considerably more data. Iomega makes the Zip drive, a popular super floppy available in 100 MB and 250 MB versions. The Iomega Zip supports many operating systems and interfaces, including Microsoft Windows 95, Windows 98, Windows NT, Windows 3.x, and Macintosh. Zip drives are available as both external and internal drives. Using a Zip disk is like using a preformatted floppy disk. They are enclosed and almost impossible to scratch.

Iomega also makes the Jaz, a 2 GB external drive. The Jaz is fast, with transfer rates up to 8 MB per second. Using one 2 GB Jaz disk, you can transport files, store 2,000 photos (640 x 480 pixels) or twenty to forty minutes of compressed video, or run individual applications.

Cutting-Edge Storage Technologies

Advances in digital photography are not limited to cameras. New storage options are continually being introduced. The following provides an overview of some of the latest storage technologies.

Peerless Storage System

In mid-2001, Iomega introduced the multigigabyte Peerless storage system. The Peerless system provides extremely fast transfer rates of up to 15 MB per second. The removable storage media will be available in 5 GB, 10 GB, and 20 GB configurations. Peerless works with both Macs and PCs, using FireWire, USB, and SCSI connections.

DVDs

The DVD (digital versatile disk) is a high-capacity optical media. Some technology experts believe that DVDs will replace VHS tapes for videos and may likely replace CD-ROM and laserdiscs as well. However, before that can happen, it appears that DVD standards must be developed and utilized throughout the industry.

A DVD is a disk equivalent in size to a CD. Like a CD, it stores data in small spiral indentations and is read by a laser beam. The difference between the CD and DVD is that a DVD is read by a laser beam of a shorter wavelength than the CD so a DVD can utilize smaller indentations and, therefore, provide increased storage capacity. Today's DVD can store up to 17 GB of data on a 5" disk.

A DVD-ROM is a read-only DVD. It utilizes two layers. The outer layers can hold 4.7 GB, while the underlying layer can hold 3.8 GB. A two-sided disk accommodates 17 GB of storage space. A DVD-R is a writable DVD that can be written to just once, similar to a CD-R. DVD-RAM is a readable and writable disk, which holds either 3.6 GB or 4.7 GB of files. A special cartridge holds the disks, which are extremely sensitive to contaminants. Because of the cartridge, a DVD-RAM cannot be utilized with a standard DVD player.

ESSENTIALS Another option is to store your images online. There are many Web sites that now offer digital archival storage. For more on online storage alternatives, see Chapter 22.

Image Browsing and Management Utilities

Whether you are storing your digital images on your hard drive or on removable media, you will need to design a data management system that makes it easy to locate your pictures.

There are dozens of software programs designed to help you manage your image files. Using one of these software programs, you can create your own searchable database, create a slide show, and view thumbnails of images. Also look for features such as multiple-image retrieval, drag-and-drop arranging, and batching capabilities.

When working with your digital images and other media files, if you find yourself doing the same tasks again and again, you may want to employ image tools that provide "batching" capabilities. They'll apply frequently executed operations to a list of files so you don't have to do the same task on individual files. Here are just a few of the many programs that provide batching:

- ACDSee works with both Macs and PCs. For more details, visit their Web site: *www.acdsystems.com.*
- CompuPic is a digital file manager and viewer that works with PCs, Macintosh, and Unix. Available from Photodex Corporation: *www.photodex.com.*
- IrfanView is a very fast freeware 32-bit graphic viewer for Windows 9x, Windows NT, and Windows 2000.

Sanyo has developed a high-capacity storage and playback device known as the Digital Image Album. The component allows you to watch digital camera images and videos on your TV or through your VCR. You can transfer images and videos from CompactFlash, SmartMedia, and IBM Microdrive media to a standard 650 MB CD-R. The Digital Image Album

comes with a slide show feature with sound and edit functions. It also offers multivoltage capability with auto adjust.

ACDSee

ACDSee from ACD Systems offers an extremely fast way to view and process digital images. It acts as a high-speed picture viewer and browser, file manager, and digital-image sharing tool and is compatible with both Macs and PCs. With ACDSee software, you can preview more than forty different types of file formats, including BMP, TIFF, JPEG, PIC, WAV, and MPEG, among others. Use it to perform batch file functions and convert images into ten different formats, including BMP, JPEG, TARGA, and TIFF.

The program offers image enhancement functions such as red-eye reduction, crop, and color balance. ACDSee also works with MPEGs, QuickTime, and MP3s. A free trial version is available for downloading at *www.acdsystems.com.*

The CameraMate from Microtech International is a palm-size digital media reader that was designed with the needs of the digital photographer in mind. Using its USB cable, you can use the CameraMate to transfer your digital images to your PC or Mac at rates of up to 1.2 MB per second—up to thirty times faster than with a serial cable download. You can also utilize it to transfer data from a notebook or palmtop computer to your desktop computer. The CameraMate supports CompactFlash, SmartMedia, and IBM Microdrive cards. Included in the CameraMate package is software designed for editing images, creating a Web site, and designing a slide show. If you own more than one digital camera and use several different types of storage media, the CameraMate may be prove to be a godsend.

FACTS

Extensis Portfolio 5 Desktop Edition helps you effortlessly catalog and retrieve digital files, including photos, clip art, movie files, audio, and more. Use it for previewing images, digital watermarking, customizable thumbnails, and slide shows. Extensis Portfolio supports both Macintosh and PC platforms. For more information, visit *www.extensis.com.*

Image AXS Professional

ImageAXS Professional 4.1 from ScanSoft (*www.scansoft.com*) is another good program for organizing and easily retrieving all your digital images and multimedia files, including photos, scanned images, downloaded images, movies, sounds, and more. ImageAXS Professional was designed to be a visual database for professional users, such as photographers, Web designers, graphic artists, and stock photo collectors. But even if you're not a professional photographer, if you have lots of images to catalog and want to be able to find them fast and easily, this is a program to consider.

Using ImageAXS Professional, you can publish catalogs to the Web or share images and text in self-extracting executable files via diskettes and e-mail. The program accepts all the popular digital file formats, including JPEG, GIF, TIFF, BMP, EPS, RAW, PCX, DIB, PICT, Photoshop, PhotoCD, QuickTime, AVI, WAV, and more.

Iomega markets the FotoShow Digital Image Center, which is a version of its 250 MB Zip drive that turns your television into a digital image-viewing center. Utilizing FotoShow and Zip disks, SmartMedia, CompactFlash, or the IBM Microdrive, you can view, edit, and share digital images. You can view images at full-screen or create a continuous slide show. There's a built-in image editor that allows you to perform basic editing tasks such as red-eye reduction, cropping, rotating, and other enhancements. The FotoShow also helps you organize your digital images into albums and folders and add captions. The FotoShow Digital Image Center is compatible with both Macs and PCs. There are a few options for hooking it up to your TV, including composition (RC), S-video, and RF (coaxial).

SuperJPG

SuperJPG from Midnight Blue is an Explorer-style image file manager and viewer designed for use with photos. It helps you organize your image files with fast thumbnail loading and complete drag-and-drop support. The program helps you effortlessly manage a large image file database. You can sort, organize, categorize, catalog, view, browse, crop, and print your digital photo collection with ease. The program also offers

image-editing features, allowing you to crop, resize, adjust color, sharpen, flip and rotate, and remove red eye. SuperJPG supports JPG, GIF, TIFF, PNG, BMP, PCX, and PSD file formats and Windows 95, Windows 98, Windows NT, and Windows 2000. You can download a free trial version of SuperJPG at *www.midnightblue.com.*

IrfanView

IrfanView is a very fast freeware 32-bit graphic viewer for Windows 9x, Windows NT, and Windows 2000. With IrfanView, you can view directories, create slide shows, convert files in batches, and edit images with a variety of effects. You can select, crop, and cut in zoom mode, and set the compression level when you save PNG files. IrfanView provides thumbnail views, drag-and-drop support, and allows you to save images up to 4,096 x 4,096. The program supports all major graphics formats, including BMP, GIF, JPEG, PNG, and TIFF. It also supports Paint Shop Pro 7 files. IrfanView can be downloaded free of charge from *http://stud1.tuwien.ac.at, www.pcworld.com,* or *www.zdnet.com.*

The LifeWorks Photo Album from Iomega lets you use Zip disks to share, organize, and print your digital images. The software uses Active Disk Technology so it runs directly from the Zip disk, allowing you to carry your digital images anywhere and share them using any Zip drive–enabled computer. The program's slide show feature lets you create a photo slide show that you can play automatically whenever the Zip disk is inserted. Printing is easier, too, since the program helps you organize several photos and print them on a single page, saving you paper and money. The LifeWorks Photo Album is compatible with all e-mail programs, which makes it easy to send a photo directly from the application.

What's in a Name?

We all know what software is, right? Well, sort of. Software is a general term used for programs designed to perform specific tasks within a

computer. But there are different classes of software you should know about. Here's an overview:

- *Firmware:* Firmware is not really software; it is data programmed into the circuitry of some hardware components of your computer. Firmware contains programming code that communicates to the equipment how it should operate. On the other hand, software is stored in read/write memory and can be easily altered.
- *Freeware:* Freeware is software that is available for download and unlimited use and is totally free to the user. Freeware includes utilities, desktop pictures, and fonts.
- *Postcardware:* The developer of postcardware allows you to use the software without paying a fee but requests that you send him a postcard so he can get feedback and judge the popularity of the product.
- *Shareware:* Shareware refers to an application or utility that you can try out for free. Sometimes it is a fully featured product, and other times it lacks some of the features of the commercial version. If you like it and want to continue to use it, you'll have to register the software and pony up a small fee to the program's author.
- *Vaporware:* Vaporware is software that is announced a long time before it is ready for sale. Sometimes problems arise during development, and it never reaches the marketplace at all.

CHAPTER 17
Scanners

A scanner "digitizes" photographs, allowing you to make changes and print out your photos or post them online. Today, historians use scanners to rescue old negatives and prints. Botanists scan seeds and pressed flowers. Even zoologists scan fish and insects to record scale and color patterns. In this chapter we will discuss the functions of scanners in digital photography and what to look for when you are purchasing these devices.

What Is a Scanner and Why Do I Need One?

A scanner is a device that takes a picture of a page. In more technical terms, a scanner is an array of photosensitive silicon cells that measure the light reflected off—or transmitted through—the original. These measurements are then mapped onto levels (for example, 256 levels per primary color for a 24-bit scanner) by an analog-to-digital converter and stored as binary digits that you can view and manipulate with your computer. Basically, what the scanner is doing is turning the components of a slide, negative, or print into digital data. Now that we've cleared up what a scanner is, the question remains: Do you really need one?

That's a good question. About twenty years ago, there weren't too many people who could afford to have a scanner hooked up to their computer. Ten years ago, scanners had come down in price substantially, but they still cost as much as most automobiles. Today, flatbed scanners are affordable and are becoming a standard peripheral for many computer users. Although you don't need one, you'll find that a scanner will allow you to do a lot of wonderful things at an affordable price.

What kinds of things can scanners do? As mentioned above, scanners allow you to take existing photographs and digitize them. Once digitized, your photographs can be permanently archived on a disk. Scanners offer substantially higher resolution than digital cameras, so you can create much higher image quality and enlarge pictures that might otherwise look grainy. And scanners allow you to import photographs into your computer and edit them using special image-editing software. (See Chapter 21 for more details on image-editing software.)

ESSENTIALS

You can have fun scanning three-dimensional objects with your scanner. Because your scanner will place a slight shadow on one side of the object, you'll want to do a little experimenting. Scan the object, and if you don't like the effect you've achieved, reposition it on the glass platen and try again.

If you have a home office, scanners can also perform some additional functions. A scanner can act as a color copier; just insert the original in

the scanner, press the function button, and the copy can be printed on your color printer. If your computer has a built-in modem, you can scan documents, newspaper clippings, or layouts and send them to any fax machine in the world. You can also "photograph" three-dimensional objects on a scanner and print or store the images.

Flatbed Scanners

If you are new to the world of digital photography, chances are that you will probably want to purchase a flatbed scanner, the most popular model of desktop scanner. A flatbed scanner takes its name from the flat, glass platen (or bed) where you place the object to be scanned. It is very versatile and can be used to scan flat materials such as photographs and printed pages.

There are three basic levels of flatbed scanners you can buy. Entry-level scanners feature a scanning area of 8½" x 11" and cost under $100. They generally feature a horizontal resolution of 300 dpi and 30- or 36-bit color depth; though the bulk of the products available use charge-coupled device (CCD) sensors, the smallest and lightest flatbed units typically use a CMOS image sensor (CIS). Most scanners in this price range come with very little software.

Midlevel scanners feature an 11" x 17" scanning area, and their cost ranges from $100 to $275. Optical resolution on these models ranges from 400 to 600 dpi and color depth is 30 to 36 bits. They usually come with image-editing and optical character recognition (OCR) software.

Higher-level flatbed scanners cost between $250 and $800. These scanners feature a minimum 600 dpi optical horizontal resolution, 30- or 36-bit color, and high-quality bundled software such as Adobe Photoshop LE.

FACTS

"Dots per inch" refers to the resolution of an image. This number tells you how much information is contained in a linear inch of an image. In general, the higher the resolution, the higher the quality of the image.

You want to purchase a scanner with an optical scanning resolution of at least 600 dpi (dots per inch) so that you can scan detailed images and line art from photographs or other printed originals.

Film Scanners

A transparency or film scanner allows you to scan everything from a 35mm slide to a 4" x 5" transparency. These scanners are more expensive than flatbed scanners, but they are excellent for people who want to scan a lot of transparencies because they are the only scanner that will produce quality transparency scans. However, if you only occasionally scan transparencies, a flatbed scanner with a transparency adapter is sufficient.

Film scanners generally feature an optical resolution of 1,200 dpi or higher. In fact, most affordable transparency scanners scan images at 2,700 dpi. That's because the higher resolution is needed to compensate for the small size of the item being scanned.

For film scanners, a more important measure is optical density (OD). OD measures the breadth of the tonal range—or brightness values—that a scanner can capture. Slides, film, negatives, and transparencies have a broader tonal range than printed photographs. Because OD is directly related to bit depth, you want a scanner with a bit depth of 30 or higher. Although there is no direct correlation, a 36-bit scanner generally has a higher OD than a 24-bit scanner, provided all other things are equal.

The Acer ScanWit 2740 Film Scanner removes dust and scratches from images while you are scanning them. Using Applied Science Fiction's Digital ICE technology, this scanner also features 2,700 dpi optical resolution and a dynamic range of 3.2. It has a list price of $599. For more information, go to *www.acerperipherals.com.*

The Polaroid SprintSCAN 4000 is a 35 mm film scanner that is Windows and Macintosh compatible. It features 4,000 x 4,000 dpi optical resolution, 3.4 density range, and 36-bit color. Its high resolution allows users to work with smaller portions of an image and still maintain recognizable detail. It features a scan time of less than one minute per slide and has a SCSI-2 interface. The Polaroid SprintScan 4000 retails for $1,369.95.

The new Nikon LS-400 Film Scanner delivers 130 MB, 48-bit color scans and a dynamic range of 4.2. This scanner also features Applied Science Fiction's Digital ICE scratch and dust removal technology, as well as Digital ROC and digital GEM to help restore faded colors and make scans less grainy. An auto slide feeder handles up to fifty slides and a series of adapters for slide mounts. Nikon Scan 3 and Altamira Genuine Fractals 2.0 software come bundled with this scanner. For additional information, go to *www.nikonusa.com.*

Combination Scanners

As you might have guessed, combination or multiformat scanners scan film and slides as well as flat printed materials. Until fairly recently, combination scanners did not do a good job scanning film and slides. Now there are a few combination scanners on the market that will allow you to produce good film and slide scans, as well as high-quality scans from the flatbed part of the scanner.

ESSENTIALS

You can expect to pay quite a bit more for combination scanners because of their dual purpose. At the present time, a high-end combination scanner is selling in the $750 to $800 range.

The CanoScan D660U is a new flatbed scanner with a built-in 35mm film adapter in the lid for scanning negatives and slides on the flatbed glass. It doesn't offer the resolution or the sharpness that you'll find with a dedicated film scanner, but it costs about one-tenth the price. It's a great choice for scanning images for use on the Web or for e-mailing images to friends. It features a 600 x 1,200 dpi CCD with 42-bit color, and it recognizes more than a trillion colors. It can also handle 8½" x 11" prints. The CanoScan D660U uses USB to connect with both Mac and Windows systems. It lists for $149. For additional information, visit *www.usa.canon.com.*

Drum Scanners

A professional wouldn't use anything but a drum scanner for producing color separations. While other scanners use CCD technology (see Chapter 5 for an explanation of CCD technology), drum scanners use Photo Multiplier Tube (PMT) technology for greater color accuracy. PMT detects light and splits it into three beams, passes it through red, green, and blue filters, then converts the light into an electrical signal. Drum scanners also offer features that you won't see on ordinary desktop scanners, such as direct conversion to CMYK, batch scanning, auto sharpening, and huge image areas. The biggest difference between drum scanners and other models is their speed. Since the process of converting an image to CMYK is automatic, drum scanners can produce considerably more scans per hour than desktop models. The disadvantage of drum scanners is that some have price tags that run into the six-figure range. Although drum scanners are too expensive for most people, some professional printers will scan photographs using a drum scanner on a per-project basis.

Images are created on professional printing presses and many consumer printers using four colors of ink: cyan, magenta, yellow, and black (CMYK). The K is used for black so as not to be confused with blue. The black is necessary so that the black portions of an image come out black and not a shade of gray.

Be aware that some inkjet printers only use three colors: cyan, magenta, and yellow. Color is severely jeopardized on these printers; you won't get the same rich blacks that you get on a four-color printer.

Handheld Scanners

Handheld scanners cost about a third to a quarter of the price of a flatbed scanner, and they are very portable. You can plug them directly into a computer's printer port, so they can be easily shared by different workstations. Many people like to use them with their laptop computers.

Handheld scanners do have some disadvantages over flatbed scanners: They are less accurate, and they have weaker light sources, so they sometimes produce uneven scans. They are also dependent on the steadiness of your hand or the surface you are standing on. (Many hand scanners offer an alignment template to help you with more accurate scanning.)

There are some high-end hand scanners that offer 400 dpi resolution and 24-bit color, which allow you to achieve high-quality results. However, because their focus is on portability, their scan head is only 4" x 5". This means that you have to make multiple passes to scan any images that are larger than 4" x 5". What you'll have to do with a larger image is to stitch the parts of it together using software. This can be very tedious and time-consuming. Despite their disadvantages, handheld scanners are very popular because they are so portable and can produce quick and easy low-cost scans.

Small-Footprint Scanners

You can now find quite a few small-footprint scanners for under $150. Some of them take advantage of CMOS image sensor (CIS) technology, which allows the manufacturer to do away with the complex systems of lenses and mirrors required by a CCD-based model. Though CIS scan quality isn't yet up to that of CCDs, these scanners are smaller, lighter, and more durable than their CCD-based counterparts, which make them ideal for taking on the road or fitting into cramped spaces such as dorm rooms.

The UMAX Astra 3400 is an excellent low-priced scanner that can be used on Windows or Macintosh computers. It features 600 x 1,200 dpi optical resolution, 9,600 x 9,600 dpi interpolated resolution, and 42-bit color. The maximum scan size is 8.5" x 11.7", and it comes with a transparency adapter that allows for 4" x 5" scanning. This scanner comes with SCSI-2 and USB interfaces and retails for $99.00.

Are More Bits Necessarily Better?

An important feature of scanners is their bit depth. Keep in mind that when it comes to bits, more is better. Bit depth doesn't refer to the actual number of colors the scanner can capture, but rather the number of levels it can enumerate. In other words, just because a scanner has the capacity to assign one of 16.8 million values to a color (24-bit) doesn't mean that the sensor can distinguish between two close shades of gray or blue. That's why more bits will generally give you better image reproduction, even though your printer can't print and your screen can't display more than 16.8 million colors.

The minimum color depth you should consider for scanning photos and documents is 24 bits (8 bits per color or gray shade). Even the best 24-bit scanners suffer from noise, which usually results in a maximum of 6 usable bits per color rather than 8 bits. That's only about 262,144 colors, which falls short of the dynamic range of a typical photograph. In addition, those bits will be clustered around the midtones of the image, which means you'll lose detail in shadows and highlights. The images should be adequate for printouts on older, lower-quality printers, as well as Web graphics and document management tasks.

ESSENTIALS

If you're scanning slides, negatives, or transparencies, which have a broader tonal range than printed photographs, 30 bits is the absolute minimum you should consider.

Be careful not to confuse common printing rules of thumb with scanner specifications. For instance, just because your high-end inkjet printer can only reproduce 24 bits of color data doesn't mean you won't get better print output from a 36-bit scan than you would from a 24-bit scan. In theory, a higher bit depth should always be better than a lower. Unfortunately, some flatbed scanner vendors are not clear or consistent when they define bit depth. For instance, some manufacturers use a 24-bit CCD and combine it with a 10-bit rather than a standard 8-bit ADC to stretch the output range of the colors into the shadows and highlights. This doesn't add any information, but it can potentially make the existing image data look

a little better. So, in this case, a very good 24-bit scanner can still give you better images than a mediocre 30-bit one.

Which Scanner Is Right for You?

The good news is that there are many affordable scanners on the market today. The bad news is that it can be confusing to determine which one is right for you. Here are a few points that might help you to clarify what model is best for you.

Price

How much do you want to spend on your scanner? As we mentioned earlier, you can pay up to $100,000 for a top-quality scanner, but the ones that you will be looking at will probably range in price from $80 to $2,500.

Purpose

What do you want to scan? Flat things like magazine clippings, photographs, pages of books? Slides or negatives? A combination of both? The answer to this question will determine what type of scanner you should purchase.

Resolution, Color Depth, and Density Range

These three factors will determine the quality of your scanned images. Optical resolution determines how sharp your image will be. This, in turn, determines how large your image can become, because low-resolution images will become grainy when they are enlarged. A good rule of thumb is to choose a scanner with a minimum of 600 dpi. Make sure that you are looking at the optical resolution rating and not the interpolated dpi rating, which is the resolution that can be achieved with the help of software.

Although an optical resolution of 600 dpi is sufficient for most people, you will want to invest in a scanner that offers higher optical resolution if you will be producing a lot of large images. When comparing resolution specs, you need to watch for two measures. The optical resolution of the scanner's CCD (a row of sensors that moves vertically down the scan

bed) determines how much real information the scanner captures. In contrast, the maximum interpolated resolution is what the scanner can achieve by using various optical enhancements and firmware algorithms to "fill in the blanks" between actual pixels. If you need more data—to pick up finer details in line art, complex edges in images, or fine print—then you need to go for higher optical resolution. If you simply want more dots—to scale the size upward so it will print at the appropriate size—you can settle for a high interpolated resolution.

For most tasks, a scanner with an optical resolution of 300 dpi will be sufficient. This is also true for low-res proofs and placing the image on a printed page, capturing images and putting them on a Web page, and printing text. Choosing a scanner with a minimum dpi of 600 will allow you to scan detailed images and line art from photos or other printed originals.

> **ALERT**
>
> Be careful not to confuse specifications for scanners and printers. They are not the same. (If it were that simple, you wouldn't need this book.) Even though your printer may require no more than 150 dpi, you would rarely want to scan an image at that resolution.

One of the reasons you need to scan at a higher resolution than you print is that editing the photo in your computer causes the image to degrade. Whenever possible, scan the image at a higher resolution than is necessary, and your results will be better.

And if you can afford a high-resolution scanner, it is a good investment. Even when they are scanning images at a lower resolution, higher-resolution scanners always print images that are sharper and have more detail. So a 150-dpi image scanned on a 600-dpi scanner is going to have more detail than a 150-dpi image scanned on a 300-dpi scanner.

If bigger is better when it comes to resolution, the same must be true for color depth, right? Not so. Color depth is an important factor in image quality, but things are not so clear-cut in this area. For example, some 24-bit scanners produce lower quality scans than some inexpensive 6-bit scanners. So while color depth is something to keep in mind when

shopping for a scanner, it's not as important or as reliable a measure as optical resolution or density range.

Optical density range is defined as a measurement of the breadth of the tonal range—or brightness value—that a scanner can capture. This is directly related to optical resolution. Density range is the most important value for film scanners and professional scanners, but many consumer-level scanners do not offer density value ratings. For this reason, OD is the best way to differentiate between a good graphics scanner and a consumer-level device. If the scanner lists its OD rating, it's probably a higher-quality model. The average flatbed scanner provides an OD of between 2.8 and 3.0; this is fine for scanning most photographs. Slides and transparencies require at least 3.2 OD for a decent scan, and negatives require 3.4 OD or more.

CIS Versus CCD

For a long time, the only desktop scanners available were CCD-based scanners. Then a less expensive competitor—CIS (which stands for both contact image sensor and CMOS image sensor)—came along. Both are made of silicon, and both use on-chip filters to separate light into red, green, and blue. A CCD-based scanner requires an analog-to-digital converter (ADC) to translate the sensor data into binary information, while a CIS sensor has built-in logic to perform this task.

The advantage of owning a CIS-based scanner is that it requires fewer components than a CCD-based scanner. This means that it takes up less space, uses less power, and costs less to manufacture. But there is a trade-off: The on-chip ADC logic takes up space that might otherwise be devoted to light sensing, so current CIS sensors tend to have a smaller dynamic range than CCDs. In addition, because CIS scanners are relatively new, manufacturers don't have as much experience at fine-tuning the noise reduction and filtering algorithms as they do for CCD scanners.

Scan Speed

Scan speed means just what you think it does—the amount of time that it takes to scan a single page at a specific resolution. Depending on whether you will be scanning a lot of images, and especially a lot of large images, speed may or may not be important to you. Scan speeds

are also affected by your computer interface and, to a lesser extent, by your scanning software.

Scanner Interface

Interface refers to the connection between your scanner and your computer. A SCSI interface is generally fastest, followed by USB and then parallel interfaces. If you plan to use your scanner with several personal computers, USB might be your best choice because USB interfaces are easier to install than SCSI interfaces. (See Chapter 14 for more on interfaces.)

Many low-cost scanners operate via a parallel connection with a pass-through connector for a printer, primarily because this is an inexpensive implementation for the manufacturer and every PC has a parallel port. On the downside, however, parallel scanners can be slow, and external parallel-based Zip drives can't use the pass-through connector. USB-compliant devices, the logical successor to parallels' market position, have made great inroads as more systems ship with USB ports. If you've got the choice, opt for USB over a parallel connection for greater reliability and configuration flexibility.

In general, any scanner with an optical resolution of more than 600 dpi and a color depth of 36 bits or more will ship with a SCSI connector, which can handle high-bandwidth applications such as graphics designed for print and high-volume document management.

If you find a low-priced scanner with less impressive specs that has a SCSI interface, chances are it's an old model. You are better off choosing a scanner that connects via parallel or USB. Note that SCSI scanners usually include their own controller cards, but these adapters aren't good choices for other devices.

Scanner Software

The software that you use with your scanner can make a big difference in image quality and the speed with which you can scan. With some software, you can scan an image with a single click of a button. Other software packages require a two-step process: You must look at a preview

of the image after it is scanned, and then wait again while the final image is made. Some software allows you to optimize the image, whereas other packages offer you little control. Chapter 21 looks at popular image-editing software.

When you scan a page, you end up with a file that consists of a bunch of dots. To turn this file into text you can edit, you have to run it through optical character recognition (OCR) software to "translate" it. Most scanners come bundled with limited editions of OCR packages.

Image-editing software lets you manipulate the tones and colors of an image to make it display or print better. It also gives you filters to apply special effects.

Extras

Some scanners offer special features that you might find valuable. For example, some Nikon scanners enable batch scans and come with software that automatically removes dust and scratches. Some scanners come with transparency adapters, and some have automatic document feeders. Others come with a bundle of software that you might find attractive.

A transparency adapter is sometimes packaged as a scanner extra, but in most cases you'll have to purchase one separately. To scan negatives, slides, and transparencies, you need to place the original between the light source and the sensor array so that the light passes through them before hitting the sensor. However, typical flatbed scanners place the light source and sensor array on the same side, to catch the light as it reflects off the original. You need a transparency adapter (also called TPA or TPU)—a backlight that replaces the scanner cover—to handle these kinds of originals. Not all scanners support a TPA, so ask before you buy if you think you'll want one. They tend to cost between $100 and $350.

An automatic document feeder (ADF) is a good investment if you are going to be doing volume scanning. They cost between $150 and $350.

There are so many factors you'll want to take into consideration when you decide which scanner to purchase. You can look at the different brands and models at a national retail chain (CompUSA, Office Depot), at a computer store, or by visiting the manufacturers' Web sites listed in Appendix B. The ZDNet Web site *(www.zdnet.com)* provides additional

information about scanners and allows you to search by manufacturer, merchant, computer type, interface, and price.

Handy Tools

After you purchase your scanner, you'll want to keep a few basic tools on hand. These include a can of compressed air, glass cleaner, a lens brush, black paper, a spare scanner bulb, screwdrivers, and black paper masks for ¼" and 4" x 5" transparencies and negatives. You can get rid of dirt and dust spots on photographs after you scan them into your computer, but it's so much easier to keep your photos and scanner as clean as possible. The cleaner you keep your scanner, the less work you'll have later.

Where Do Your Scans Go?

Once you scan your images, you'll have to decide what to do with them. The format you use to save your image will depend on how you want to use it. Some popular image file formats include:

- Native tongue format
- GIF (Graphics Interchange Format)
- JPEG (Joint Photographic Experts Group)
- TIFF (Tagged Image File Format)

The first format is the native tongue format. For example, Adobe Photoshop saves in Photoshop format. The other three formats are shared formats, which can be read by a number of applications. Each of them has a different purpose. GIF and JPEG formats are best for Internet images. They have the right resolution for Web pages or e-mail, and they don't use up a lot of disk space. JPEG is great for photographs, and GIF is best for artwork and detailed images. TIFF format is best for sharing images with other applications. Even word processing or spreadsheet programs can understand what a TIFF file is. The downside to TIFF files is that they are huge and not well suited to the Internet. For more on file formats, see Chapter 15.

Tips for Good Scanning

Here are a few techniques that will help you to create better images with your scanner.

- *Practice, practice, practice!* Don't be discouraged if your initial scans aren't great. Scanning is an art, and the more you practice with different images using your particular scanner and computer, the better you'll get at it.
- *Choose your best photos.* Although there are a lot of things you can do to correct an image in your computer, it is always better to pay attention to things like proper exposure when you are taking your pictures. It's also a good idea to keep your scanner as clean as possible so you don't have to remove the spots in your computer.
- *Pay attention to image placement.* With a little practice, you'll learn how to correctly place images on your scanner. Rotating your image later using software degrades it, so learning to place things properly on your scanner is important.
- *Set your resolution.* Choosing the correct resolution is challenging, and not all scanner drivers do it the same way. A good rule of thumb is to always go slightly higher in dpi than what you'll need. However, going too large results in huge files that take up a lot of memory and require more computer time to work with. Depending on your scanner, you will be looking at one of the following measurements when you are setting your resolution for scanning:
 - Output resolution: If your scanner driver uses output resolution as a measurement, set it to 240 to 300 dpi and the final print size to the largest print you are likely to make. For example, your choice might be an 8" x 10" print at 300 dpi.
 - File size: Choose a 5 MB file for an excellent 4" x 6" print, 10 MB for a 5" x 7", and 20 MB for an 8" x 10".
 - Input resolution: If your scanner driver uses input resolution, you'll have to do some calculating. For an inkjet print, you might choose 300 dpi as your output resolution and 8" x 10" as your final print size. You can then multiply 8 x 300 to get an input resolution of 2,400 dpi.

CHAPTER 18

Printers

While you may enjoy viewing your digital images on a computer monitor, at some point you'll probably want to see a hard copy of what you've produced. Therefore, you'll want to purchase a printer that can supply you with good quality prints of your photographs. Conventional pictures printed in a darkroom are called photographs, but prints of digitized photos are generally known as "photorealistic" prints. As printers become better, the difference between the two is lessening. However, the difference in color between photographs and photorealistic prints is substantial.

The Printing Process

Photographs are continuous tone prints that contain an infinite variation of tones, colors, and hues. If you looked through a loupe (a small magnifying glass used to examine photographs) to examine a photograph, you wouldn't see any white space or dot patterns. Digital prints, on the other hand, can generate 24-bit color, which means that they can reproduce 16.7 million colors. Although that sounds like a lot, it really isn't that many when you realize the billions of color variations the human eye can distinguish. And because of the way digital printers represent color, most can only print a fraction of these 16 million colors. Printers also do not print color continuously; instead, they lay color on a print dot by dot. Thousands of dots are placed on a page per second, but they are still individual dots. If the resolution of the print is too low or the printer can't generate images with tight dot patterns, the quality of the print will suffer.

Color printers for home or small business use generally range in price from $100 to $500. Printers in the middle of this range offer high print quality. If you spend more, you'll gain faster output speed and additional features like the ability to print directly from your camera's memory card or dual paper trays. The following represent the different types of printers and the advantages and disadvantages of each.

Inkjet Printers

Inkjet printers work by forcing little drops of ink through nozzles onto the paper. Consumer inkjet printers have been around for many years, but they initially produced images of poor quality. Today's inkjet printers produce excellent photorealistic prints. They are designed for home or small business use, and they range in price from $100 to $500. With inkjet printers, you can output pictures on plain paper or thicker, glossy photographic-type paper stock. If you use a glossy stock, the inkjet printer will pump out more ink onto it than it will on a plain piece of paper, so your images will be sharper. The best inkjet printers are those that use more than the standard CMYK colors. Inkjet printers that use a five-color cartridge with cyan, magenta, yellow, light cyan, and light magenta can emulate

subtleties of skin tones. The color inkjet printer has become the standard output device for many digital photographers.

What are the disadvantages of inkjet printers? Images can sometimes look a little fuzzy because ink droplets have a tendency to spread out when they hit the paper. This phenomenon, whereby colors bleed into each other, is known as dot gain. In response to this problem, some printer manufacturers are now including dot gain compensation controls on their inkjet printers. The wet ink that is forced onto the paper can also cause paper to warp slightly, and prints can smear if you don't allow them to dry properly. You can lessen these problems by only using specially coated inkjet paper in your printer. The newer model of inkjet printers feature less color bleeding and paper warping. However, the image on an inkjet print will still be destroyed if it gets wet.

With a list price of $129, the Canon S450 Bubble Jet Printer is one of the least expensive color inkjet printers you can buy. It features 1,440 x 720 dpi resolution, and it has a color ink cartridge that is composed of three separate and replaceable cyan, magenta, and yellow ink tanks. The advantage to this system is that if one color becomes depleted, that is the only one that needs to be replaced. The Canon S450 comes with both USB and parallel ports and can be used with Windows 95/98, NT4, 2000, or Me, as well as Macintosh OS 8.1 or higher. This printer comes bundled with a lot of utility software, including Canon Photo, OfficeReady CC, CreataCard, PrintMasterSE, and TextBridge Pro. For additional information, see *www.ccsi.canon.com*.

Dye Sublimation Printers

For many years, dye sublimation printers have been heralded as the top-of-the range output device for digital printing. Dye subs (for short) transfer images to paper using a plastic film or ribbon that's coated with color dyes. During the printing process, heating elements move across the film, causing the dye to fuse to the paper. The printers work by fusing dye onto the specially manufactured transfer paper, making a separate pass through the printer for each color.

The advantages of dye sub printers are that they produce a high-quality, continuous-tone image with little or no evidence of pixelization. Dye sublimation printers are either three-color (cyan, magenta, and yellow), or four-color (cyan, magenta, yellow, and black).

Some printer manufacturers (such as Alps Electric) have developed printers that enable you to print in either dye sub mode or another "everyday" print mode.

Despite their advantages, there are several disadvantages to dye sub printers. First, the ones that are available for the consumer market only produce snapshot-sized prints, so you can't use them to output letters, invoices, and other full-page text documents. Second, the cost of consumables, particularly of the dye ribbon, is relatively high. Print paper for dye sub printers is also more expensive than photographic paper of equivalent size. (Cost, including the cost of paper and dye film/ribbon cartridges, is about $1 per print.) Finally, questions have arisen about the stability of dyes over time, especially when prints come in contact with certain protective sleeves.

Thermo-Autochrome Printers

A handful of printers use thermal wax to heat pigment-carrying wax from a print ribbon. They are faster than dye sublimation printers because they use sticks of wax or ribbons of dye rather than ink cartridges. The technique is similar to that seen on fax machines that print on thermal paper. The major disadvantages of thermo-autochrome or thermal wax printers are that they reproduce color using a halftoning process and that they can only use specially manufactured paper.

Solid Inkjet Printers

Solid inkjet printers use sticks of crayon-like ink that are heated and dropped onto the paper. These printers were the first on the market

with the ability to print on many different types of paper. The fact that many different types of paper can be used in these printers is still one of their major advantages. The disadvantage of solid inkjet printers is that they are not as photorealistic as standard inkjets and they do not print text detail well.

Color Laser Printers

Color laser printers use a technology similar to photocopiers; a laser beam produces electrical charges on a drum inside the printer. The drum then rolls ink onto the paper, and heat is applied, which permanently affixes the toner to the page. Laser printers are also more expensive than most printers, as high as $1,000. However, although upfront costs are higher, money can be saved in the long run on consumables such as toner, ink, and paper. These printers are best for networked groups of people who need high-speed quality output.

The Epson Stylus Photo 870 is a photo-quality 8.5" x 11" format printer. It features a resolution of 1,440 x 720 dpi. It has a six-color ink system and a USB interface, with drivers for Mac OS 8.5 or later, Windows 98, and Windows 2000. Adobe PhotoDeluxe image-editing software and Sierra Imaging Image Expert, a general-purpose program for viewing, organizing, editing, and printing images, are bundled with the printer. The printer lists for $249.

FACTS

The Canon BJC-50 is a battery-powered, compact, bubble-jet photorealistic color printer that weighs only 2.1 pounds. It comes with a little case, and it's great to use if you're traveling with your digicam and your laptop computer.

Making Your Choice

After you review all of your options, the final decision about what printer to buy will be based on your own personal needs and preferences. Do you want a printer that you can use directly with your camera, or do you

plan on manipulating most of your photos on your computer? Is text quality important to you, or are you mainly concerned with photographic quality? Is speed important? How important is price? The answers to these questions will determine what printer is the best choice for you.

Types of Printing

Host-Based Printing

All the computation that turns pixels into prints is actually done inside your computer, not in your printer. With a host-based printer, your computer is tied up while you're printing, so you won't be able to do anything else while you print. Other host-based printers allow you to perform additional tasks, but your computer runs much more slowly. You can generally save money by purchasing a host-based printer.

Computer-Free Printing

Some printers allow you to print images directly from your digital camera's memory card or other storage device. Other printers provide you with the option of cabling your camera to your printer for direct image download. Digital print order format (DPOF) allows you to select images you want to print through your camera's user interface. The camera records your instructions and passes them onto the printer, and you can transfer images between the two devices. The downside of this technology is that you can't edit images on your computer.

The Kodak Personal Picture Maker 200 from Lexmark is a computerless printer. It features a 1.8" LCD monitor, and CompactFlash and SmartMedia are included. Using the Picture Preview Screen, images can be edited with features such as rotate, crop, change brightness, and auto-enhance, to name a few. The Kodak Personal Picture Maker 200 can print on several paper sizes, including 8½" x 11" and postcards. The printer lists for $249.

Postscript Printing

Postscript printing allows you to print illustrations created on a program like Adobe Illustrator and saved in EPS (encapsulated PostScript) format. Some printers have PostScript support built in, while others can be made compatible with the use of software.

Printers and Resolution

The standard for resolution today is 600 x 600 dpi (or the equivalent 720 x 720 for some inkjet printers), but you can find both higher and lower resolution. In general, you'll want to avoid lower resolutions unless you get an exceptionally low price and never use anything but 10- or 12-point text. Don't insist on 1,200 dpi unless you need high-quality photographic output. Make sure you find out both the vertical and horizontal resolution for any printer you're considering, and keep in mind that many inkjets have different resolutions for color and monochrome.

Resolution isn't the only factor that determines the output quality of your photographic prints. You also need to know whether the printer offers resolution enhancement and if so what kind. Edge enhancement typically varies the size or position of dots on edges of lines, text, and solid blocks. Because this feature smoothes edges, it can produce an apparent resolution nearly double the dpi rating. However, it won't improve continuous-tone images like photos. For photos, you can get very different output quality at any given resolution, depending on how the printer creates shades of gray and shades of colors.

ESSENTIALS

The best way to find out how well a printer handles photos is to look at a sample output. If you can't see samples before buying, make sure you can return the printer if you don't like the results.

Photo Printing

If you need to print photos at the highest possible quality, consider an inkjet specifically designed for photos. These printers typically offer six ink colors rather than the usual four. The additional two colors improve photo quality in two ways: They increase the range of colors the printers can print, and they decrease the number of individual dots the printers need to create most colors.

Lowering the number of dots is important because it reduces the likelihood of showing noticeable "dithering" patterns. Because six-color printers can print any individual dot in more possible colors than four-color printers, they don't need as many dots to fake other colors. Fewer dots mean smaller, less visible patterns of dots.

Interface

The conventional choice for connecting to a stand-alone system is a parallel port, which is generally still the best choice. USB ports are an attractive alternative for quick and easy connections, particularly if you may have to switch the printer between desktop and notebook systems on a regular basis. Of course, before you choose USB, be sure you have a USB port on your computer and that your operating system supports it.

> Keep in mind also that as you add more USB devices to a USB chain, the performance of each device can suffer because they all share the same connection. If you're putting the printer on a network, you'll get the best performance with a network connection.

Most printers separate the cost of the network interface from that of the printer because there are so many choices. Just don't forget to factor the price of your particular interface into your budget.

Cartridge/Toner Life

Take a look at both the price of an ink or toner cartridge for any given printer and the number of pages it will print. An inexpensive

cartridge that prints relatively few pages may actually be much more costly than a more expensive cartridge that prints more pages. Higher-capacity cartridges also mean you won't have to change them as often, which can be particularly important for a network printer in an office that prints a large number of pages.

QUESTIONS?

What warranty is best for me?
Read your warranty carefully. A three-year warranty might appear to be more attractive than a one-year warranty, but the one-year plan might cover parts and labor and the three-year plan might not. Find out who pays for shipping on major repairs and whether you can receive a loaner if your scanner or printer is being repaired.

Using the Right Type of Paper

When it comes to printing photographic quality prints, choosing the right paper is very important. The four basic types of paper are:

- *Copier paper:* Plain paper or copier paper is the least desirable type of paper for printing photographic images. This paper is okay for printing text, but you'll get a smeary image if you use this paper for printing photos. Because it is less expensive than other papers, it is often a good choice for printing drafts.
- *Inkjet paper:* Special inkjet paper is best for printing photographic images. Inkjet paper absorbs ink well and creates a crisp image.
- *Photographic paper:* Special photographic paper comes in various sizes and stocks, and it is the best choice for printing photographic images. It absorbs ink very well, but it is also quite expensive—about one dollar per sheet. To save money, print a few drafts on plain paper before you print a final copy on photographic paper.
- *Other papers:* You can find all types of specialty papers to use for producing stickers, color transparencies, iron-on transfers, decals, bookmarks, and the like. These can be a lot of fun to work with and can be purchased almost anywhere.

How Long Can I Expect My Prints to Last?

You've decided that a digital camera and inkjet printer might be the best way to get your photographic prints. But how long will the prints last? It is actually light that kills the color in prints, and ultraviolet light is the worst. The magenta and purple color dyes in inkjet prints fade the quickest. Bright magenta often turns red or brown fairly quickly if it is exposed to sunlight. The new Epson printers use a dye-based ink system that is predicted to last three to four times longer if the image is printed on Epson paper. In fact, Epson claims that their new inks on their heavyweight matte paper will last for twenty-five years. Another way to make your prints last longer is to protect them under UV absorbing glass, which you can find in frame shops. It is estimated that a print that is protected in a low ultraviolet environment could last thirty years or more. And although it's true that the images you print today aren't going to be as colorful ten years from now, the same can be said about traditional photographs.

CHAPTER 19

Improving Your Digital Pictures

lthough there is no way to avoid ending up with a few disappointing pictures, there are techniques you can use to minimize the number of bad photos you accumulate. And an exciting aspect of digital photography is that you can use image-editing software to improve, and use, those less-than-stellar images.

Ways to Improve Your Digital Images While Shooting

Today's high-tech digital cameras make it easy for almost anyone to create good photos. With the additional advantage of image-editing software, your satisfaction is practically assured. However, there are some actions you can take while shooting that will improve your images and reduce the need for editing.

Take Time to Compose Your Shot

Like traditional analog photography, good digital photographs rely on certain basic things such as good composition. Many of the techniques of film photography apply to digital photography as well. Strive to get the best possible shot; don't expect to correct all your "mistakes" later with image-editing software.

Get Close

Most photos miss the mark because the photographer did not get close enough to his subject. Your objective should be to fill the frame. This will result in photos that are better composed and provide more visual information to work with when you edit your images with your computer.

Walk nearer to your subject, or zoom in for tight framing. A closer shot creates a greater sense of intimacy. When shooting vertical images-people, buildings, trees—turn the camera for a vertical orientation and avoid empty space at the edges of the frame.

Keep It Simple

Avoid clutter in your photos. To do so, change the angle of view or move closer to your subject. Aim for one strong focal point in your composition. Rely more on close-ups and simple compositions, and you will be pleased with the improvements in your photographs.

Experiment with Lighting

Try shooting at different times of day to see the effects on your subjects. Just be sure you are never shooting directly into the sun.

Plan Ahead for Action Shots

One drawback to digital cameras is shutter lag. On a film camera, you press the shutter button and the camera snaps the photo almost immediately, usually within a few tenths of a second. On a digital camera, the delay after you press the shutter button (shutter lag) can last as long as a full second. This lag is the result of the time used by the digicam to focus on the subject, calculate exposure, and adjust for proper color balance.

One way to avoid shutter lag is to prefocus the camera. If you can determine a spot where the action is apt to take place, such as the area around the goal at the end of a soccer field, you can prefocus on that area and wait for the action to occur. On most digital cameras, if you press the shutter button halfway, the camera will begin focusing and adjusting for the proper exposure. Then when you snap the photo, the shutter lag is reduced to only two or three tenths of a second.

ESSENTIALS

If your camera is equipped with a high-speed continuous shooting mode, you can utilize it to quickly snap several shots in a row. But remember that in high-speed mode some cameras capture very low-res images. Check your camera's manual for more information.

Avoid Stiff Portraits

When taking snapshots of a group of people, you'll get better results if they are involved in an activity or interacting with each other. Allow people to sit or lean against something so they will feel, and look, more relaxed. Be sure you are not catching them squinting into the sun.

Creating Your Digital Darkroom

One of the noteworthy advantages of digital photography is the ability of any photographer to create his or her own darkroom with a computer and image-editing software. Although the term digital darkroom is a bit of a misnomer, the benefits of using an image editor are very real. An image editor provides the user with the ability to correct color, crop, duplicate, and retouch images. You can reduce red eye, adjust contrast, resize objects, make a photo collage, control perspective, distort the photo for a special effect, and add text. The darkroom was once the province of the professional photographer, but now almost anyone can use a digital camera, scanner, and image-editing software on their home computer to produce high-quality images.

You will need a digital camera or a scanner in order to capture digital images. (Scanners are discussed in more detail in Chapter 17.) You will need a computer and an image-editing program in order to manipulate your images.

You can use the image-editing software that came bundled with your camera or scanner to begin your journey into digital editing. Using the software that came with your camera, you should be able to transfer your images to the computer and view thumbnails of your images. The scanning software may allow you to carry out some basic manipulating and enhancing actions. You probably will be able to correct the color, contrast, and brightness, among other things.

Often the software that accompanies the digital camera or scanner is not the full version of the commercial product. Once you've become accustomed to using your software, you'll be able to decide if you need to purchase a program that gives you more options.

Choosing an Image Editor

You can produce some fantastic results when you edit your digital images, but much depends on choosing the right software. There are numerous image-editing software programs on the market, ranging in price from

under $50 to well over $500. How do you sort through all that's offered to find the one that's best for you?

When should you purchase image-editing software?
All digital cameras and scanners come packaged with image-editing software. You'll want to start editing your pictures with the software that came with your equipment. Once you have used it for a while and gotten the hang of the techniques it offers, you'll have a better idea of what to look for when you trade up to a more advanced program.

The Right Tools

If you are really serious about wanting to manipulate your digital images, you will need certain editing tools to be able to produce the best results. For maximum control and superior results, here are a few tools that you should look for when purchasing your image-editing software:

Precise Selecting Tools

Some programs come with simple rectangular and elliptical lasso tools that are used to select rectangular and elliptical areas of an image for editing. If you are interested in doing more sophisticated image editing, you'll need more sophisticated selecting tools. Look for a custom lasso tool so that you can select any area, regardless of its shape. Color-based selecting tools are even better.

Layers

When combining images to form photo collages, you will have much more control of the program if each object is assigned to its own layer. Independent objects can be repositioned or deleted without adversely affecting the rest of the image. For example, if you want to utilize a background of brightly colored autumnal trees and place a person in the foreground, layering will allow you to do this. Adjustment layers let you apply color and make other corrections to an image without changing the original content.

Soft Edge

A soft edge makes the transition between a selection and another area less noticeable. When you paste an element into another image, the lines of demarcation become less apparent and one seamlessly blends into another.

Rubber Stamp or Clone Tool

The ability to copy objects is absolutely essential when editing an image. This tool will be described in more detail below.

Red-Eye Reduction

Red-eye reduction is a popular tool, since most folks at one time or another end up with images that feature eyes of an unnatural color. The red-eye reduction tool is sometimes difficult to use. Be sure the image editor you're purchasing lets you effortlessly adjust the size and type of color you're applying to correct red eye.

Ease of Navigation

Besides the tools described above, it is important that your image editor be easy to use. Some inexpensive software programs are loaded with wizards, which take you step-by-step through the editing process. Although wizards can be useful, they also can impede navigation. For instance, a tool that you might want to use may not be shown in some windows since the wizard has "simplified" the process and eliminated it.

ESSENTIALS

When it comes to file formats, the more your software program can support, the better off you'll be. Some of the most common file formats include JPEG, GIF, TIFF, BMP, EPS, and PICT. See Chapter 15 for more information on file formats.

More expensive programs, such as Photoshop, offer less onscreen help but more flexibility, allowing you to choose tools at will so you can make a wide range of manual edits. However, you don't have to invest $600 in Photoshop to get the flexibility you need. Some less expensive

programs, such as PhotoImpact, manage to be easy-to-navigate while foregoing the use of limiting wizards.

Web Integration

If you plan to use your digital images on the World Wide Web, you should be sure that your image-editing software will make it easy for you to do so. Some programs effectively help you send photos via e-mail, add images to a Web page, post your images to a Web site where others can view them, and transfer your images to online printing services.

It pays to do some research and compare several software programs before purchasing one. We'll take a closer look at some popular image-editing software programs in Chapter 21.

Overview of Imaging Tools

After you've set up your digital darkroom, you will probably be eager to start having fun editing your images. But before you jump in, carefully review the user's guides that came with your hardware and software.

You will find that your software program offers quite a wide array of image manipulation tools. Take some time to learn about the uses of each tool. Here is an overview of tools that typically are found in image editors. Different programs have different tools, though there is quite a bit of overlap among programs. Tools with similar functions often have different names.

- *Airbrush:* Sprays color ("paint") onto the image
- *Blur/sharpen/smudge:* Lets you blur or sharpen certain areas of an image
- *Burn/dodge/sponge:* Lightens or darkens an area of the image
- *Eraser:* Eliminates any unwanted area
- *Eyedroppers:* Allows you to sample and duplicate a color from an image
- *Gradient:* Creates a smooth transition from one color to another
- *Hand:* Moves the image around the screen
- *History brush:* Allows you to undo certain areas

- *Lasso:* Selects an area of the image
- *Magic wand:* Allows you to select pixels based on similar colors
- *Marquee/crop:* Allows you to select rectangular and elliptical areas for cropping
- *Measure:* A ruler that measures the image
- *Move:* Allows you to move selected areas and layers
- *Paint bucket:* Lets you fill specific areas of an image with a particular color
- *Paintbrush:* Allows you to color your image; has a softer edge than the pencil tool
- *Pencil:* Allows you to hand draw or color; has a harder edge than the paintbrush tool
- *Rubber stamp/cloning tool:* Allows you to copy, or clone, parts of an image
- *Type:* Lets you add text to the image
- *Zoom:* Magnifies the image for easier retouching

Image-Editing Tips

No matter what image editor you are using, you will get the most from your software with the least amount of frustration if you adhere to the following pointers.

Duplicate Your Image

Make at least one copy of your original image, and preserve the original in the same way you would protect a negative from a 35mm camera. Edit the copy. This way, if you end up with results that are unsatisfactory and unsalvageable, you can simply go back and make a new copy of your original and begin again. Because some software programs don't offer multiple undo features, once you have made and saved changes you may not be able to return to your original image.

Always save at least one copy of your original digital image before beginning to work your editing magic on it. Better yet, save two copies. That way if you end up hating what you've done with your image-editing software, you'll always have the option of starting over with a fresh original.

Start with a Quick Fix

Begin by choosing the quick fix or instant fix option. With repeated use, you'll learn whether or not this option tends to make images look better or worse. (The quick fix won't always improve your digital images.) Hopefully, your quick fix option will correct the most obvious problems for you, saving you editing time and effort. Then you can use your editing time to make more precise changes in contrast, color, and the like, as needed.

Remember the Cloning Tool

Users often overlook the cloning tool, yet it can prove to be one of the most powerful tools your image editor offers you. Rid your image of unwanted elements by simply painting over them using the cloning tool. It is also helpful for matching colors.

Try a Soft Touch

Your image editor's softening tools can help you blend separate images together. Sharpening images can sometimes result in an artificial look. For a more natural image, the softening tools can be very helpful.

Editing Hints for Better Images

Image-editing software is a real boon for the photographer. Now it's a cinch to get creative with your digital photos and produce some astonishing effects. Just remember a few key points:

- Read the user's guide that came with your image-editing software, then be prepared to do a bit of experimenting in order to fully grasp how the program's tools work.

- Just because you can change something doesn't mean you should. Don't manipulate your image too much or it can end up being too much of a good thing. For best results change only a few key elements. A light touch is best.
- Remember that a low-res image cannot be enlarged without some loss of quality.
- Read up on digital imagery and its manipulation to find out how particular effects are accomplished. Visit your local library or bookstore for books and magazines, or search the World Wide Web for how-to articles on digital photography.

The Power of Editing Tools

Just as photographers have long used the darkroom to control the final processing of film, your image editor allows you to manipulate your digital image, controlling the final output. A software program saves you the hours you would have spent in a traditional darkroom and offers many other advantages as well. You can correct your image by adjusting and improving the color, composition, and brightness. You can resize your photo, apply special effects, even turn it into a painting. Professional-level software programs offer literally thousands of different options for the digital photographer seeking to creatively manipulate an image. Other simpler programs focus on ease of use, allowing you to jump right into a project without having to develop the knowledge and technique of a graphics professional.

In Chapter 21 we will examine in detail specific image-editing software programs of various levels and price points. For now, let's explore some of the tools image-editors commonly provide and the resulting techniques you can utilize to improve images.

Correcting Your Digital Images

You can make an endless number of improvements to your digital photos using an image editor. Here are just a few common problems and the techniques you can use to solve them.

Changing Format

Some subjects lend themselves to vertical orientation; others look better when taken in the horizontal format. In general, people and buildings tend to look better when taken in the vertical format. Landscapes and groups of people work well with the horizontal format.

FACTS

Because landscapes are often shot in horizontal format, such orientation is sometimes referred to as "landscape." And as portraits are often shot in a vertical format, such orientation is sometimes referred to as "portrait."

If you find you've taken a photo of a building in the horizontal format and you'd like to change it to vertical, you can select the area you want to work with and then crop away the rest. Using this approach, it becomes easy to salvage an image by changing its format.

Correcting Color

Your digital camera likely has a color balance setting that helps you make adjustments for colors that are too warm or too cool. In the same way, image-editing software also utilizes color balance for better pictures.

Another way you can adjust color in your image is by changing the saturation. Doing so allows you to boost colors or make them more subdued.

Correcting Converging Verticals

The problem of converging verticals frequently happens when the photographer uses a wide-angle lens and looks up to shoot a building. In the resulting photo, it looks as if the building is tipping backwards. With a film camera, there is no easy fix for this problem. But digital image editors can do the job in short order.

To fix the problem of converging verticals, the top of the original image is stretched until all vertical lines appear upright, then the image is cropped to fit inside a rectangle. There are other minor adjustments that might need

to be made, but they can be accomplished quite quickly. By correcting converging verticals, you'll be left with a more realistic image of a building— one that is firmly planted on the ground.

Combining Images

Haven't you ever wished you could take the best parts of two (or more) pictures and merge them? Now you can. Simply use your editing program to copy the element you want to use as a substitute and save it at the same resolution as the base image you're using. Shape it to fit, place it into position, then blend it so that it appears as if it had always been there.

Combining images works particularly well with pictures of people. For instance, let's say you want to capture a picture of your friend, Maria, talking with her son, Joseph. You've got one shot where Maria looks great, but Joseph has his eyes closed. In the second photo Joseph has a sunny smile, but Maria is looking away from the camera. Simply take the smiling Joseph and add it to the shot where Maria is facing the camera, and you've got a winning photo.

Improving Sharpness

Because of the technology used to capture them, digital images have a tendency to appear fuzzy. Usually the problem is easily corrected by using the automatic sharpening mode. However, sometimes a picture will need extra help.

To add crispness, begin by applying the unsharp masking technique to enhance contrast. Then use the sharpening tool to bring the image into focus. Just be careful not to get carried away with sharpening or your image could end up looking unnatural. As with other image-editing tools, a light hand usually provides the best results.

Getting Rid of Red Eye

Red eyes typically happen in low-light situations. The pupils dilate to let in light, and when the flash fires, it reflects off the blood vessels at the back of the eye. The result: The subject's eyes appear bright red. Some software programs feature an easy-to-use red-eye reduction mode. If your

program doesn't offer an automatic red-eye reduction option, you can enlarge the image and paint over the red with the desired eye color.

Refining the Background

As we discussed in Chapters 11 and 12, our eyes automatically screen out a lot of the clutter that surrounds us in our everyday lives. That's why when we're busy taking pictures in the field we don't always realize what the background will look like in the finished photo. By using software to change the background of a picture, we can transform it from tiresome to spectacular.

This is another process that requires scrupulous attention to detail as you cut out your image, clean it up, save it, and add it to the background of your choice. You may want to start collecting interesting backgrounds especially for use as the need arises. Some software programs provide a variety of backgrounds to help you get your image bank started.

Another way to approach changing a background is to isolate the main element in your picture, keeping it sharp while you blur the background. If advantageous, you can even move your subject's position in the frame, perhaps putting more emphasis on the foreground.

Shooting Images with a Specific Purpose in Mind

As you become more adept with your image editor, you will want to experiment with different techniques. One good habit to get into is to keep an eye out for interesting backgrounds that can be used later to enhance shots where the subject is interesting but the background is cluttered or bland. Images having interesting views of the sky, a row of trees, or skylines are all possible backgrounds. If you enjoy creating collages, always keep an eye open for subjects that could be utilized as elements for compositing. One of the interesting aspects of digital photography is the ability to combine photos. By compiling an image bank, you'll be assured of always having plenty of material to draw on.

CHAPTER 20

Getting Creative with Digital Images

I n this chapter we'll take a look at the effects you can create using image editors, plus other imaginative ways to have fun with your digital images. We'll discuss darkroom techniques you can do right on your computer, such as embossing, burning, cropping, duotones, flipping, and many others. Then we'll look into how to get camera-like results from your software. The range of artistic and special effects available grows every day. There seems to be no end to the possibilities that await you in your digital darkroom.

Replacing the Traditional Darkroom

In the digital world, certain tasks previously undertaken in the darkroom using chemicals are now executed with a computer and software. Here are some of the most common tasks you can perform with your image editor.

- **Brightness**—Allows you to lighten or darken your image without affecting the color balance or overall contrast.
- **Burning/Dodging/Sponging**—Dodging lightens an image, burning darkens it, and sponging increases or decreases the saturation of colors. All of these techniques took the traditional film photographer hours of work in the darkroom. With an image editor, you can lighten or darken your photo far more quickly and simply.
- **Color Correction**—Using an image editor, you can make fine adjustments to the hue, saturation, color balance, and brightness of your image. You can even substitute one color for another wherever the color being changed appears.
- **Contrast Range**—You can choose to include more or less detail in your image by adjusting the difference between the lightest and darkest parts of an image (contrast range). By manipulating the contrast range and brightness, you can often salvage an overexposed or underexposed image.
- **Cropping**—Even simple image editors allow you to change the shape or printing size of your image.
- **Duotones**—Duotones are created in a traditional darkroom by tinting a black-and-white photograph. The gray area in the photo turns a particular tint, such as sepia, while black stays black and white remains white.
- **Hand Coloring**—Before the introduction of color film, hand coloring was a popular way to add color to a black-and-white print. Today, modern image-editing software allows you to "hand color" your photo using painting tools.
- **Inverting**—The invert command lets you instantly turn a positive image into a negative image or vice versa.

- **Lithographic Effects**—Lithographic film produces extremely high-contrast photographs, reducing monochromatic images to pure black and white. Now, instead of creating these results in the darkroom, you can use an image editor to readily produce dramatic images of high contrast.
- **Masking**—The masking tool preserves areas of an image, in the same way a drop cloth protects your furniture while you're painting a room. Masking permits you to apply an effect to one specific part of an image or to vary the strength of an effect within an image.
- **Posterization**—In a traditional darkroom, a posterized image was created by replacing shading and gradations of tone with marked changes in color. It was accomplished through an elaborate process using multiple negatives printed at varied exposures and contrasts.
- **Reticulation**—When processing 35mm film incorrectly, an effect called reticulation sometimes occurs. Reticulation results in a photo that appears very grainy. Using an image editor, you can deliberately achieve a similar effect with your digital images.
- **Retouching**—With an image editor, you can retouch any digital image using a variety of tools and techniques. Retouching allows you to remove dust, scratches, and blemishes, and it is a common feature of image-editing software programs.
- **Solarization**—In the traditional darkroom, solarization is the term used to describe the reversed tones of a photographic image that result from prolonged exposure to an extremely bright light. What once took hours of experimentation in the darkroom to produce can now be created using the curves feature in an image-editing software program.

FACTS

Solarization, also known as the Sabbatier effect, is the term used to describe the reversed tones of a photographic image. Sabbatier discovered in the nineteenth century that photosensitive materials exposed to a bright light for prolonged periods caused some of the tones to reverse.

Camera-like Results

Image-editing software is not a replacement for a good photographer. However, it can provide some effects that in the past were attained only when a photographer employed certain techniques while shooting.

Blur/Focus

A photographer manipulates the shutter speed and aperture while shooting in order to create a desired effect in a photograph. Sometimes he or she will deliberately produce a blurry image to suggest a particular mood. Other times, he or she will choose to have a photo sharply focused. You can get similar results using your image editor. For instance, you can decide to blur the whole image or just a specific area of it.

Software programs offer different types of blur, including random, which creates a general fuzziness, and motion, which is similar to the effect achieved when panning a camera. You can also specify the degree to which you want the image blurred.

Filters

In film photography, a filter is attached over the camera's lens in order to alter the light before it reaches the film. In digital photography, the term "filter" refers to an effect achieved by an image editor on a digital image. Digital filters change the effects on your images but frequently in a different manner from traditional photographic filters. Filters may come with your software program or as plug-ins. (We will talk more about filters throughout this chapter.)

There are two general types of filters: those that improve the quality of images, and those that allow you to be creative and add special effects. Below we will explore some of the creative effects you can apply using software.

Artistic Effects

There are many artistic effects that you can achieve using your image editor. Image-editing software programs commonly allow the user to choose "painting" tools, such as a pointed or flat brush tip, an airbrush, or spray paint. You also may be given your choice of media, from pencil and ink to crayons, chalk, and pastels. But some of the most interesting effects are achieved through the use of special filters. You can try your hand with different filters and achieve masterly results without having to take expensive and time-consuming art classes. Below are five special filters and the results they'll provide.

- *Contouring filter:* Contour drawing refers to drawing just the outline (contour) of a subject. When you apply contouring to your digital images, the results will vary widely depending on the photos you're using.
- *Mosaic/tile filter:* The mosaic filter enlarges the size of the pixels in your digital image so that they resemble tiles in a mosaic, creating an image that is somewhat abstract but still discernible. The user can adjust the size of the pixels to vary the effect.
- *Oil painting/palette knife filter:* The palette knife filter gives your photo the look of an oil painting. You can significantly change the effect by selecting a different "brushstroke size."
- *Pointillist filter:* If you have always admired the work of the famous French artist, Georges Seurat, who rendered pictures by painting a series of small dots of paint, you may enjoy using a filter that will cause your digital image to mimic an impressionistic pointillist painting. More sophisticated programs allow you to decide the size and color of the dots and how they will be dispersed. This filter requires a bit of experimentation in order to achieve the best results.
- *Watercolor filter:* If you'd prefer an image that mimics a watercolor, choose the watercolor filter. It works especially well with subjects from nature. Use it sparingly for an ethereal feeling.

Collage/Montage/Composite

Using photographic software, it's fun to mix images to create unique effects. Whether you call it a collage, montage, or composite, a collection of different photos grouped together to form one image can be a visually appealing way to tell a story. As part of your collage you can include artwork and text, as well as your photos.

A collage is not an easy project to execute; it requires far more than simply assembling miscellaneous images. To create a collage that works, you'll need a good eye for composition, some practice using your software program, and, most importantly, an engaging concept. The images in a collage should have a thread or theme that connects them so that they work together to convey one particular idea or impression.

High-end programs permit you to assign weights to the various images in your collage so that certain objects appear more prominent while others seem to recede. You can also choose the transparency of various objects and the extent to which the edges of photos blend together.

ESSENTIALS

Don't overlook the value of using stock photography in combination with your digital images. Let's say you want to create a collage, and in your mind you are picturing a beautiful sunflower in front of a red barn. With stock photography, you can search for just the image you need.

Special Effects

Besides the effects achievable with image-editing software that we've discussed so far, there are myriad other possibilities. Read on to learn more about the amazing results you can achieve with a little imagination and your own digital images.

Distortion/Warping

Some image-editing software programs allow you to distort and stretch an image for unusual effects. A program may offer you the ability to

choose the shape and axes of the distortion, the rate of distortion, and the precise area of the image that will be distorted. There are several types of distortion:

- *Linear:* Using a linear distortion, your image is stretched on the horizontal axis, the vertical axis, or on a diagonal.
- *Pinch:* Also known as thinning or imploding, this technique "pinches" the image inward.
- *Spherical:* Also referred to as fat effects or exploding, spherical distortion "puffs" out the photo at whatever point the user specifies, following a circular pattern. This effect is similar to that provided by a fish-eye lens on a film camera.
- *Stretch or goo:* Some programs allow you to simply click on an area of your image and drag the mouse to give the appearance of stretching the image. It is almost as if you are working with an image made of Silly Putty or rubber.

Adding Text

The ability to add text to an image may seem like a feature that would appeal only to those using image editors for professional uses, such as composing advertisements or catalogs. But you may find that a word or two can make a nice addition to your digital picture. The text tool makes it simple to add type. Consider using it to designate the place shown in a travel photo, to reveal the name of the subject captured in your portrait, or as an added element in a collage.

From Color to Monochromatic

With film cameras, you must decide before shooting whether you want your pictures to be black-and-white or color. One of the great advantages of digital photography is the freedom it offers in this area. After capturing your digital image in color, you can always decide to change it to monochromatic by copying it and saving it as a monochrome image. The same effect can be achieved on a photographic print that you've scanned and downloaded to your computer.

Infrared Effects

Film photographers obtain unexpected results with infrared film. Infrared film is sensitive to both the light humans can see and some of the longer length infrared radiation that we cannot see with the naked eye. It takes time, experimentation, and considerable effort to use infrared film effectively. **FIGURE 20-1** shows an infrared photograph taken with a film camera.

FIGURE 20-1:
The photo of the trees shown here is an example of an infrared photograph taken with a film camera using an image editor.

Photo by Philip Thornberry

A similar result can be obtained with your digital photos and an image editor. If you choose your subject carefully, you can manipulate the hue and saturation to achieve results not unlike infrared photos.

Patterns

In Chapter 11 we talked about capturing patterns while shooting. Another way to have fun with patterns is to create them using your computer. Find an element of your image that is appealing to you, then experiment with creative ways of duplicating and using it. For best results, you need to pay

particular attention to detail when combining the repeated elements so that they blend perfectly together.

Reflections/Mirror Images

One way to use patterns imaginatively is to create images that contain mirror images, or reflections. Begin with an image that is strong enough to stand alone and still be effective. Then experiment with duplicating it by copying it onto its own layer and flipping it. Combining the two images results in a mirror image. You can also get creative with this technique by mixing several images at once to form repeating patterns or multiple reflections.

FACTS

The glowing edges filter is used to transform your image into a tracery of neon-like lines by defining the edges in your photo and reversing their tones and colors.

Ripple Filter

Imagine tossing a stone into a still body of water and watching ripples appear on the water's surface. In the same way that ripples become visible in water, distorting the reflections on the water's surface, the ripple filter produces a distorting effect on your image. There are a number of controls you can use to cause a range of effects, from slight rippling to maximum distortion. When using the ripple filter, you will need to choose your subject wisely in order to obtain satisfactory results.

Twirl Filter

When you're looking for a different way to distort an image and create a unique effect, apply the twirl filter. It will twist your image around its center either clockwise or counterclockwise depending on which you specify. You also control the degree to which your image is "twirled." The final result: an interesting spiral distortion of your original photo.

Silhouetting/Vignetting

It used to be that negatives were actually painted to create a white silhouette, or border, around the edges of the picture. Many software programs allow you to apply this masking function to your digital images, imparting a vintage look. The technique works best on simple images, especially portraits. Consider scanning an old-time photo, then adding both sepia tones and a vignette effect to recreate the charm of a bygone era.

Having Fun with Your Photos

Photography has always been a creative medium, but digital technology provides even more opportunities for you to unleash the power of your imagination. Consider these possibilities, then see what fun things you can do with your digital images.

It's easy to execute photo projects using ClickArt 300,000 Premier Image Pak from Broderbund. Create posters, stationery, invitations, greeting cards, banners, pamphlets, letterhead, newsletters, brochures, school projects, Web pages, and lots of other items using the program's step-by-step instructions. The package includes 160,000 high-quality images and graphics, 50,000 photos, and 20,000 illustrations, 60,000 Web graphics, 7,000 sounds, and 2,500 fonts so you're sure to have all the tools you need. For more information, visit *www.learningco.com.*

Getting Kids into the Act

Kids will love playing around with digital images just as much as you do. In fact, since kids tend to be less inhibited, especially when working with computers, they may have more fun with photographic software than you do.

There are special photography software programs designed just for kids. If you have an easy-to-use general consumer image editor, your older children will probably be able to use it to produce some exciting results once they've had a little practice.

Students can incorporate digital images into their reports, term papers, special projects, and other school assignments. If you don't have an

image editor or layout program at home, a word processor should be enough to produce what's needed. Photos and text can be combined in the program, and by varying the font and point size of the text, the student can produce some eye-catching results.

If you have little ones between the ages of six and ten, Looney Tunes PhotoFun software can keep them busy for hours with projects ranging from making cards and buttons to using their own images in ready-made scenes. They're sure to love the Looney Tunes characters that walk them through each activity. The program, which is manufactured by MGI Software, retails for about $30. More details can be found at *www.mgiphotofun.com.*

Adding a Border or Frame

Today's kids bring home some fantastic school pictures, but now you don't have to rely on a professional photographer to get outstanding pictures of the children in your life. With your digital camera and the right software, you can create your own jazzy pictures. One trick you'll be able to take advantage of is the inclusion of a border or frame directly in the image. You can pick a frame that looks like real wood, one that seems like it's been drawn with a crayon, a stained-glass design, or choose from a wide variety of other patterns and colors to complement or contrast with your photo. When framing kids' photos, why not let them have a say in choosing the frame? And don't forget to print out extras because the grandparents are going to want copies.

Turning Digital Images into Gifts

Your digital images don't have to remain photos. There are software programs on the market that make it easy to create novelty items and gifts that incorporate your images. Photos are no longer simply for use in holiday cards. With the increased popularity of digital photography, images can now be incorporated into any number of items, including:

- Calendars and buttons
- T-shirts
- Gift wrap
- Picture cubes
- Stationery, cards, and stickers

If you do decide to try your hand at turning your photos into gift wrap and you're using an inkjet printer, you might want to pick up some fixative at an art supply store. It will keep your design from smearing or rubbing off.

Digital Photographs: Other Good Uses
Putting Digital Images to Work

If you're a small business owner or self-employed entrepreneur, a digital camera can be a wise investment, and it's probably tax deductible. Digital images can be put to good use at work. For instance, you can add interest to your newsletter whether your target audience is your own staff, prospective clients, or current customers. Using a digital camera, you can snap pictures of office parties, the annual company picnic, or new employees, then incorporate your snapshots in the next employee newsletter. If you have an in-house creative department, your staff can manipulate the images for a wide variety of uses. Product shots can be incorporated into newsletters, product sell sheets, slide show presentations, and more.

Some businesses, in particular, can really benefit from going digital. Real-estate agents can employ pictures of homes to motivate potential buyers. A photo of a home is the perfect addition to a sell sheet distributed at an open house.

An insurance agent can use a digital camera to snap a picture of a damaged auto or building, then e-mail the image to others for a quick way to share information pertaining to a claim.

Anyone working in communications, whether it's a public relations specialist, freelance writer, or news reporter, can benefit from having a digital camera handy to capture an important moment in time.

Digital images can be a powerful way to tell a story about a company, product, person, or event. People love pictures, and digital images can really spice up your business communications.

PhotoParade Maker 3.0 makes it easy to enjoy your digital images every day. This software package allows you to turn your favorite photos

into a screen saver or wallpaper for your computer, or create a photo slide show that you can e-mail to family and friends. PhotoParade Maker comes bundled with an assortment of themes to complement your photos. A free downloadable PhotoParade Player means anyone can view your PhotoParade. See *www.photoparade.com* for more details.

If you're a Palm Pilot user, take advantage of the freeware programs that turn your Palm into a photo album. PhotoAlbum 3 freeware is available for downloading at *www.photoalb.zip*. Using PhotoAlbum 3, you can turn your Palm Pilot into a photo album, displaying black-and-white images as either high contrast (black-and-white) or grayscale. For users of Microsoft Windows 3.x, 95, and 98, PhotoAlbum Studio version 3.23 is available at *www.microsoft.com*. The freeware utility lets you create your own Palm Pilot photo albums from your BMP files.

Using Digital Images at School, Civic Organizations, and More

Teachers and others who work in schools will find endless opportunities to use digital snapshots. One mother of four related to me that her child's teacher used digital pictures to create a newsletter that was sent home with the kids on the second day of the new school year. The newsletter featured the headline "They're Back!" and showed a picture of the class taken on the first day of the new term.

FACTS

If you're interested in turning your digital images into a slide show, a freeware program called MySlideshow can help you do that. It's available for downloading at *www.mclarentech.homestead.com.*

She also reported that the weekly and monthly newsletters her children bring home from school have gotten a lot more interesting since teachers began adding pictures to them. For example, when a special guest comes to the classroom, the newsletter describes the event and shows a photo of the guest interacting with students. This gives parents a bird's-eye view into their kids' classrooms.

Students working on school yearbooks and newspapers are embracing digital photography as a means of catching the action wherever and whenever it happens—at sporting events, in the classroom, on field trips, and at dances. Students use graphic design software programs to manipulate their images and combine them with text for top-notch results.

Scout leaders and others who work with kids in volunteer capacities can achieve similar results with a computer and a digital camera or scanner. Bulletins, flyers, and invitations can display photos of the children in action and show off some of the projects they're working on. Even announcements of upcoming fund-raising events, such as bake sales, can entice participation by displaying pictures of the baked goods or other goodies that will be offered.

CHAPTER 21

Image-Editing Software

As the popularity of digital photography skyrockets, the number of available software programs is also growing at a fast clip. Because image editors allow consumers to turn their computers into digital darkrooms, even amateur photographers are experiencing the joy that comes from working with digital images themselves. You can use your image-editing software to touch up pictures, but you can go far beyond simply eliminating red eye and cropping photos.

Overview of Image-Editing Programs

The most powerful program on the market is Adobe's Photoshop. Adobe calls Photoshop the world standard image editor, and everyone else seems to agree. Graphics professionals know the power of Photoshop because they use it on a daily basis. But if you're an amateur photographer, jumping into Photoshop as your first image editor is like jumping into a Maserati when all you really need is a good economy car to take you around town.

Remember that as you spend more money, you will get a more sophisticated program with additional bells and whistles. To utilize a sophisticated program like Photoshop will require additional time spent learning how it operates. You may even have to invest money in a class or workshop to get the hang of using it.

Magic Series's MagicJpgHtmlPager enables you to create an online photo album, and since it's shareware you can try it without paying a cent. It's easy to make digital photo albums for the Web or CD-Rs, since the program takes you step-by-step through the creation process. To download the shareware, go to *www.magicseries.com.*

On the other hand, an inexpensive image editor costing less than $100 can often deliver enough options to satisfy the beginning digital photographer. Later in this chapter we'll explore some of the popular software programs out there, ranging from the pricey, top-of-the-line Photoshop to effective programs with price tags under $100.

Questions to Ask When Choosing Consumer-Level Software

Before you go software shopping, take some time to consider your needs. When choosing image-editing software, ask yourself the following questions to help you decide which one is right for you:

- How will you use the software program? Because technology changes so fast and software programs are constantly being upgraded, think in

terms of your short-term needs. Do you want to create pictures for use on a Web site? E-mail photos to friends? Print images that are good enough to be considered fine art?

- How easy is it to use? The program should be intuitive and easy to operate. If not, you will spend more time learning how to use it.
- What are the program's capabilities? Can it do what you need it to do?
- How much does the program cost? To save money, consider buying through a mail-order or Internet retailer. They can offer reduced prices, because once you've purchased the product you'll be turning to the manufacturer for support services. If your local computer retailer offers used equipment, you may find a bargain on the software program you're seeking. Finally, remember that freeware and shareware image-editing programs can be excellent, so don't overlook them.
- What platform is it compatible with? Some software programs are only available for a specific platform (Mac or PC). Pay attention to the system requirements. Some packages list both minimum and recommended system requirements. Remember that if your system has only the minimum requirements, you may run into difficulties when manipulating large image files. You may need to upgrade your computer's memory or even trade up to a more powerful system.
- What file formats does the program support? Most image editors handle the popular image file formats, like TIFF, JPEG, and BMP. Not all programs work with Kodak's Photo CD. To be certain that the program you're considering can support the file formats of your choice, read the package specifications carefully or check out the manufacturer's Web site for complete details.
- Does the program include templates to help you get up to speed quickly?
- Does the software program accept Photoshop-compatible plug-ins? Plug-ins allow you to customize an image editor. If your program supports plug-ins, you'll benefit from more options.

If at all possible, you should try the program before you buy it. This becomes easier to do as more and more manufacturers are offering trial or demo versions of software. Many demo programs come packaged with magazines and books. Contact the software's manufacturer or visit their

Web site to learn more about demos and trial versions. (See Appendix B for a list of manufacturer Web sites.)

QUESTIONS?

Can I try out software programs before I buy?
Many software manufacturers provide free trial versions. You can often download the program from their site and try it out at home before you buy. Keep in mind that the demo versions of some of the more sophisticated programs can take up a lot of memory. You might want to go with a shareware program.

Advanced Image-Editing Software Programs

Let's look at some high-end image editors, beginning with the top of the line, Photoshop.

Adobe Photoshop 6.0

- The king of image-editing programs
- Available for Windows or Macintosh

 System requirements—Windows:

- Intel Pentium processor
- Microsoft Windows 98, Windows 98 Second Edition, Windows Millennium Edition (Me), Windows 2000, or Windows NT 4.0 with Service Pack 4, 5, or 6a
- 64 MB of RAM
- 125 MB of available hard disk space
- Color monitor with 256-color (8-bit) or greater video card
- Monitor resolution of 800 x 600 or greater
- CD-ROM drive

System requirements—Macintosh:

- PowerPC processor
- Mac OS software version 8.5, 8.6, or 9.0
- 64 MB of available RAM (with virtual memory on)
- 125 MB of available hard disk space
- Color monitor with 256-color (8-bit) or greater video card
- Monitor resolution of 800 x 600 or greater
- CD-ROM drive

Named Best Image Manipulation/Enhancement Software of 2000 by *digitalimagingmag.com,* Adobe Photoshop 6.0 represents a major upgrade to the reigning king of image-editing programs. With an estimated street price of $609, it is also the most expensive image-manipulation software program around.

If you're using Photoshop, you'll get very little handholding. That's because this is a program designed for professionals. If you are a serious photographer, you may want to consider investing the time, money, and effort it will take to learn how to master Photoshop. (It's good to note, however, that the 6.0 edition of Photoshop has been enhanced to make it somewhat easier for novices to comprehend.)

ESSENTIALS

If you're a Photoshop user, check out Kai's Power Tips & Tricks on *www.pixelfoundry.com/tips.* These nuggets of information are not to be missed!

The latest version of Photoshop has dozens of new features, and many are particularly beneficial to the digital photographer. For instance, when you're cropping an image, you'll appreciate being able to dim the areas of the image that you're about to crop off so that you can have a better idea of how your final image will appear. Other updates include enhanced layer controls, great typographic control, additional tools for publishing to the Web, and a more user-friendly interface.

If you're an amateur digital photographer who looks to do only occasional retouching of images, you may not need—or want—all the power that Photoshop delivers. Check out some of the less complicated programs discussed later in this chapter.

No matter how long you work with Photoshop, it seems there are always new ways to use this multidimensional program. One good resource to help you plumb its depths is Deepspaceweb *(www.deepspaceweb.com)*. The Photo FX section will be of particular interest to digital photographers; it provides tips and tricks for achieving special effects with digital images. With a click of your mouse, you can learn how to give your photo a vintage look, create a vignette, and more. Novice Photoshop users can find help in the beginner's section, while the Interfaces section provides instructions on achieving the look of wires, screws, and more unusual elements.

For more details on Photoshop, visit the manufacturer's Web site at *www.adobe.com*.

Users of Adobe Photoshop, Corel PHOTO-PAINT, and other software products can benefit from a trip to Unleash.com. This site is loaded with tips, tricks, and tutorials to help you find your way around many software programs.

Corel PHOTO-PAINT 9

- A powerful image-editing and painting program costing hundreds of dollars less than Photoshop
- Available only for Windows

System requirements:

- Intel Pentium processor
- Microsoft Windows 95, Windows 98, or Windows NT 4.0
- 32 MB of RAM (64 MB recommended)

- 100 MB of available hard disk space
- SVGA monitor
- 2x CD-ROM drive

If you approach digital photography in the same way a painter approaches a blank canvas, you should consider Corel PHOTO-PAINT 9. This powerful software program provides precise editing capabilities, plus the creative tools you need to produce masterpieces. Because PHOTO-PAINT 9 is loaded with features and tools, you can quickly produce excellent results. PHOTO-PAINT 9 includes a media asset-management tool, a font-management tool, 1,500 photos, 1,200 clip-art images, 1,500 floating objects, and 800 fonts.

PHOTO-PAINT makes it simple to add special effects to your photos. With more than 100 effects filters, including artistic brushes and texture-based effects, plus multiple onscreen color palettes, it's easy to turn your digital images into breathtaking works of art. The program's touch-up tools allow you to effortlessly manipulate your images. Choose from sharpen, blend, dodge/burn, tint, sponge, contrast, brightness, hue, smear, smudge, and more. PHOTO-PAINT also offers users twenty-eight paint modes for superior touch-up capabilities.

PHOTO-PAINT retails for a suggested price of $349. More details about the program can be found on the manufacturer's Web site, *www.corel.com*. Corel also offers the PHOTO-PAINT 9 Digital Camera Edition. See the section "Beginner Programs" later in this chapter for more details.

Intermediate Programs

If you're not a professional photographer or graphic artist, your needs will probably be satisfied with a less sophisticated image-editing program than Adobe Photoshop or Corel PHOTO-PAINT. In fact, having to learn how to operate all the bells and whistles of a top-of-the-line image editor can be frustrating for someone who really doesn't need that much power. Many experts recommend starting with a simpler program, then moving up as your needs change and your skills grow.

Below are descriptions of several intermediate-level software programs that are popular with digital photographers. Each one retails for about $100.

Ulead PhotoImpact Version 6

- An image-editing program with superior features at a reasonable price
- Available only for Windows

System requirements:

- Intel Pentium processor
- Microsoft Windows 95, Windows 98, Windows NT4.0 SPE (or above), or Windows 2000
- 64 MB of RAM
- 240 MB of available hard disk space
- CD-ROM Drive
- True Color or High Color display and monitor
- Mouse or WinTab Compatible pressure-sensitive graphics tablet (optional)

Ulead PhotoImpact 6 is an advanced image editor with a host of features found in top-of-the-line Adobe Photoshop—at about one-sixth the cost. Digital photographers will find that PhotoImpact 6 is an elaborate, powerful software program that offers an array of imaging and painting tools.

PhotoImpact offers the user plenty of control while manipulating images. Besides many standard image-editing tools, PhotoImpact includes exceptional capabilities and tools, such as spin buttons, a colorizing pen, a color replacement pen, object erasers, a Bezier selection tool, the ability to record macros, and multiple undo. The paint eraser tool makes it simple to remove pixels using brush strokes. Or to remove pixels of a similar color, choose the magic eraser.

For those new to the world of digital photography and editing, mastering the wealth of features offered by PhotoImpact 6 can be a bit of a challenge. But it you're looking for a program whose value will continue to grow with time, PhotoImpact is a good choice. PhotoImpact's

suggested price is $99.95. You can download a free, thirty-day trial version of PhotoImpact from Ulead's Web site *(www.ulead.com)*.

Adobe Photoshop Elements

- Digital photographers, this Adobe's for you—the power of Photoshop for less than $100
- Available for Windows or Macintosh

System requirements—Windows:

- Intel Pentium processor
- Microsoft Windows 98, Windows 98 Second Edition, Windows Millennium Edition, Windows 2000, or Windows NT 4.0 with Service Pack 4, 5, or 6a
- 64 MB of RAM
- 150 MB of available hard disk space
- Color monitor with 256-color (8-bit) or greater video card
- Monitor resolution of 800 x 600 or greater
- CD-ROM drive

System requirements—Macintosh:

- PowerPC processor
- Mac OS software version 8.6, 9.0, 9.0.4, or 9.1
- 64 MB of available RAM (with virtual memory on)
- 150 MB of available hard disk space
- Color monitor with 256-color (8-bit) or greater video card
- Monitor resolution of 800 x 600 or greater
- CD-ROM drive

Released in the spring of 2001, Photoshop Elements is the latest edition to Adobe's lineup of graphics software, replacing Photoshop LE. Designed with digital photographers in mind, Photoshop Elements brings you the power of Photoshop at a fraction of the price. And it won't take you weeks of experimenting and training to learn how to operate this

midlevel package. With the assistance of Photoshop Elements, you can capture, edit, e-mail, and print images—even post them on a Web site.

You can't work in CMYK mode in Photoshop Elements; however, you do have the option of opening such files and converting them to RGB. Photoshop Elements does allow you to work with EPS files.

Photoshop Elements retails for $99. Go to *www.adobe.com* for more information about this product.

Jasc Software's Paint Shop Pro 7

- A powerful, affordable image editor
- Available only for Windows

System requirements:

- Intel Pentium processor
- Microsoft Windows 95, Windows 98, Windows Me, Windows 2000, and Windows NT 4.0
- 64 MB RAM
- 75 MB of available hard disk space
- Color monitor with 256-color (8-bit)
- Monitor resolution of 800 x 600 or greater
- CD-ROM drive

With 20 million users, you know Paint Shop Pro must be doing something right. This image-editing software is an affordable means of enhancing your digital images. You can easily retouch images using its automatic photo-enhancement features. Whether you're creating a print or Web graphic project, Paint Shop Pro has something to offer you. Choose from the program's seventy-five special effects. As part of the package, you'll also get Animation Shop 3 so you can create your own animations.

Paint Shop Pro 7 supports almost fifty file formats. The customizable autosave helps to protect important projects. Paint Shop Pro 7 has a

suggested retail price of $109 boxed; $99 for the download. Find out more at *www.jasc.com.*

Beginner Programs

There are many beginning photo-editing programs that work well with digital images. You don't need a big budget to start having fun with your images, as the programs listed here show. Even many of the less expensive image editors now pack quite a punch, and you'll be able to take advantage of lots of editing tools and filters.

Microsoft Picture It! Photo Premium Edition 2001

- An easy-to-use editing program with plenty of digital photo tools and filters, plus an extensive image library
- Available only for Windows

 System requirements:

- Intel Pentium processor
- Microsoft Windows 95, Windows 98, Windows Me, and Windows 2000
- 32 MB of RAM minimum (64 MB recommended) for Windows 95 and Windows 98; 64 MB of RAM recommended for Windows Me and Windows 2000
- 190 MB of available hard disk space recommended. Microsoft Internet Explorer 5.5 software required and included. Up to an additional 80 MB of hard disk space may be required for Internet Explorer upgrade.
- Super VGA monitor
- Quad speed or faster CD-ROM drive

This popular photo-editing program has been enhanced with an accessible interface that captures the feel of a Web site. You operate the Picture It! program using both Web site-like rollover buttons and hyperlinks and standard dialog boxes and menus. Step-by-step instructions and pop-up tutorials guide the user through Picture It!, making it simple for novices to operate.

For amateur digital photographers who are grappling with the best way to store their digital images, the Picture It! Program offers a Gallery feature that provides helpful cataloging functions. You can organize files by customizing categories and applying keywords.

Picture It! works well with Web-based projects and tasks, including sending photos via e-mail, ordering reprints from online processing sites, and adding photos to Web sites. The suggested retail price for Picture It! is $54.95. Learn more at the Microsoft Web site *(www.microsoft.com)*.

Corel PHOTO-PAINT 9 Digital Camera Edition for Win98/95/NT

- A scaled-down version of PHOTO-PAINT designed especially for the digicam user
- Available only for Windows

System requirements:

- Intel Pentium processor
- Microsoft Windows 95, Windows 98, or Windows NT 4.0
- 32 MB RAM (64 MB recommended)
- 100 MB of available hard disk space
- SVGA monitor
- 2x CD-ROM drive

The award-winning PHOTO-PAINT 9 technology is available in Corel's PHOTO-PAINT 9 Digital Camera Edition, a version meant just for digital photographers. Like its big brother, PHOTO-PAINT 9, the digital camera version includes an ixla digital camera interface that works with more than 120 different models of digital camera. No digital camera? Corel's PHOTO-PAINT 9 Digital Camera Edition can be utilized with images from scanners, CDs, or the Web.

The program's suggested retail price is $59. For more information, visit the Corel Web site *(www.corel.com)*.

MGI PhotoSuite 4 Platinum Edition

- Simple yet powerful photo software that makes it easy to edit, enhance, organize, and share digital images
- Available only for Windows

System requirements:

- Intel Pentium processor (Pentium 166 MMX minimum; Pentium II-266 MHz recommended)
- Microsoft Windows 95, Windows 98, Windows Me, Windows NT 4.0 (SP3 or higher), Windows 2000
- Internet Explorer 5 (required and included)
- 32 MB of RAM recommended
- 200 MB of available hard disk space, plus 65 MB space for Internet Explorer and DirectX
- SVGA Video Card
- Color monitor with 24-bit True Color (2 MB video RAM)
- Monitor resolution of 800 x 600 or greater

The PhotoSuite line of products from MGI Software has been recognized with more than seventy-five awards. The latest version, PhotoSuite 4, permits the digital photographer to transfer images from many popular models of digital cameras, a hard drive, CD-ROM, floppy disk, or the Web. You can also use a standard TWAIN connection.

Even though PhotoSuite is a program that is loaded with features, it's easy for beginners to navigate, thanks to the easy-to-follow, step-by-step guides that show you just how to go about completing projects.

With a suggested price tag of $49.95, PhotoSuite 4 Platinum Edition's many features make it a real bargain. Log onto MGI's Web site *(www.mgisoft.com)* for more details.

ArcSoft's PhotoStudio 2000

- A powerful photo-editing application with an extensive collection of editing and retouching tools
- Available for Windows or Macintosh

System requirements—Windows:

- Intel Pentium processor
- Microsoft Windows 95, Windows 98, Windows Millennium Edition, Windows 2000, or Windows NT
- 32 MB RAM
- 50 MB of available hard disk space
- Color monitor with 16-bit color or higher
- CD-ROM drive

System requirements—Macintosh:

- PowerPC processor
- Mac OS software version 8.5, 8.6, 9.0, or 9.1
- 64 MB of available RAM (32 MB with virtual memory)
- 50 MB of available hard disk space
- Color monitor with 16-bit color or higher
- CD-ROM drive

PhotoStudio offers both Mac and Windows users a robust editing program at a very reasonable price. Take advantage of its large collection of features and special effects to retouch and enhance your digital images. Besides offering limitless levels of modification, PhotoStudio includes many features found in high-end programs, such as batch processing, image management, multiple undo, and macros. Transfer images to PhotoStudio from your digital camera or scanner, a disk drive, or your desktop.

PhotoStudio 2000 carries a list price of $39.99. A thirty-day free trial download is available at the manufacturer's Web site *(www.arcsoft.com)* and at *www.photoisland.com.*

CHAPTER 22
Using the Web

The beauty of digital images is that they are easily transported and shared via the Internet. Now, within minutes of shooting your photos, you can get them online and share them with dozens, or even hundreds, of people. You can attach your digital photos or digital video clips to e-mail and share your images with anyone who has Internet access. When you're e-mailing digital photos, it's a good idea to size them at 4" x 6" and 75 dpi.

Taking Your Images Online

A friend recently told me the story of how digital photography played a part in announcing her nephew's birth. Within an hour or so after he arrived, the proud father had snapped a picture of the new baby and e-mailed it to faraway relatives and friends. Not only could they get a firsthand look at the newest member of the family and feel part of the happy occasion, but they also could turn around and show off little Alexander by forwarding his digital picture to others.

This is just one example of how digital photography can offer benefits that film photography cannot match. In the past, the only immediate gratification one could hope for came from using Polaroid cameras and film. Using the same example of a baby's arrival, you could snap a Polaroid at the hospital and it pass around, but how could you share it with loved ones in other parts of the world? Chances are, you would have had to rely on mail, which would mean a delay of at least a few days. In the twenty-first century, photo sharing is a whole new ballgame thanks to the ever increasing popularity of digital photography, coupled with the technology of the Internet. Now people all over the globe can communicate and share pictures in moments.

E-mailing Photos

If you love sharing photos, you may want to take advantage of the Internet to create your own personal Web site where others can view your photo collection.

There are two ways to e-mail digital images: as attachments to your e-mail, or included in the body of the e-mail. Let's take a look at both options.

With many e-mail program, such as those that utilize Outlook Express, e-mailing a digital image takes just four simple steps.

When sending your digital photo as an attachment, follow these steps:

1. Open your e-mail program
2. Choose New Mail (or similar)

3. Choose Insert>File
4. Select the image file you wish to send

When sending your digital photo in the body of an e-mail message, follow these steps:

1. Open your e-mail program
2. Choose New Mail (or similar)
3. Choose Insert>Picture
4. Select the image file you wish to send

Using the software that came with your digital camera to e-mail your photos can be the simplest method of all.

1. Select an image
2. Choose Send To>Mail Recipient
3. Your e-mail application launches automatically and attaches the digital image file
4. Enter your message, then send it

Taking Your Photos Online

To take your photo album online, follow these steps:

1. Use your digicam to snap pictures, or scan prints, then upload the images to your computer
2. Using your image-editing program, reduce their size and resolution so they will load more quickly
3. Using photo album software, organize the images in one folder
4. Add captions to each picture
5. Upload your photo album to the Web, following the instructions that came with your album software
6. To make sure the upload was successful, double-check all links and images

Developing a Family or Genealogy Web Site

Individuals interested in genealogy are finding a digital camera comes in handy for preserving photos of ancestors, information on headstones, and other items of interest, including family heirlooms such as quilts, marriage certificates, Bible records, and the like. When traveling through the United States or other countries, an amateur genealogist can use a digicam to record photos of ancestral homes and other places of interest. The photos captured during genealogical searches can be shared via e-mail or posted on a site created just for that purpose.

Even those who are not researching their family histories may decide to create a family-oriented Web site. A Web site incorporating your digital pictures can be a good way to share information and family news with relatives across the globe. For instance, instead of mailing your yearly newsletter with your holiday cards, you could post it online and update it regularly to let visitors know all the latest news from your house. Digital photography makes it easy to show off the kids' latest school pictures or the happy couple's wedding portrait.

ESSENTIALS

Andy Warhol once said that everyone will have fifteen minutes of fame. Every day, iWannaBeFamous *(www.iwannabefamous.com)* puts the spotlight on a person or group and makes them a star for the day by posting their photo on their Web site.

In conjunction with your family site, you might want to go offline to make a family tree collage using the collage tool in your image editor. Or you can gather digital images of your family, print them on high-quality paper, and create a family tree by attaching them to poster board.

Developing an Online Portfolio

Artists, writers, and photographers have long known the value of sharing samples of their work. Now, by creating a Web site and capturing his or her work digitally, an individual can create an online portfolio that is accessible to anyone with an Internet connection. Digital images can

be uploaded, works of art such as drawings and paintings can be photographed with a digital camera, and printed samples can be scanned or photographed. By using an online portfolio to market your work, your services instantly become available to people you might otherwise never have met.

Using Online Photo Albums

One way to share photos is to take them online. Later in this chapter, we'll explore some of the many sites that allow you to save your photos to their Web site server, which you access via the Internet. Many offer printing services and online photo albums. Usually albums can be made public or private. And frequently there's an easy way to send out e-mail messages inviting others to view your photos online.

FACTS

Worldisround.com was designed for those who love to share their travel shots. You can upload your images, write travel articles and include corresponding images, give advice about taking photos, and share your work with other travel enthusiasts.

Online Resources

A simple search on the Internet will reveal an ever-expanding variety of sites that help you display and improve your images. The following are just a sample of the types of sites you can use.

Producing Digital Slide Shows

No longer strictly the domain of professionals, slide shows are an excellent way to showcase your digital images. Using specially designed software, you can create your own slide show and run it on your computer when you want to view your photos or share them with others or use it as a continuous screen saver.

In the business world, a slide show highlighting your latest product or service can be used in the field as a sales tool for prospective customers

or as a training tool for sales representatives and others. Digital photography makes it possible to snap a picture and incorporate it into your slide show within a matter of minutes.

When preparing images for a slide show, remember that digital slide show programs use a 720 x 480 format. You'll probably want to use your image-editing software to crop and resize your images to fit this format. For fast processing, use an uncompressed format such as TIFF.

Turning Photos into Paintings

Do you remember the paint-by-number kits that were so popular a few decades ago? Today's high-tech answer to painting by number can be found at *www.photodoodle.com*. Log onto the site, upload one of your digital images in JPEG or TIFF, and for $24.95 they'll send you a kit that helps you turn your photo into a masterpiece in no time. You'll receive an 8" x 10" paint-by-numbers canvas, thirty-two paints, and two premium paintbrushes delivered to any destination in the United States.

If you'd like to paint an image just for fun—and at no charge—you can use your own digital photo or one from the site's gallery. Simply "paint" it online, or send it off in an e-mail for a friend to paint and enjoy.

Club Photo also offers a paint-by-number kit. See the "Online Photo Processing Sites" section for more information about Club Photo, or visit *www.clubphoto.com*.

Transforming T-shirts Online

Maybe you've got an exceptional photo that you'd like to turn into a T-shirt, either for yourself or for a friend. Although you can buy various software programs that allow you to make wearable art from photos (see Chapter 20 for more details), you also can go online for this service. Upload your favorite photo at AShirtOfYourOwn.com *(www.ashirtofyourown.com)*. Then spice it up with text or one of their decorative frames. The standard price for one T-shirt is $19.95. But volume discounts and group rates are also available, so if you are part of a sports team or other group you might want to consider getting your team shirts online.

When a new baby arrives, everyone wants to share the good news. It's easy to do—and costs nothing—with BabyAnnounce.com *(www.babyannounce.com).* Fill out the online form, and BabyAnnounce.com will list your announcement online and send twelve e-mail messages to your family and friends.

Online Photo Processing Sites

There are many Web sites that offer photo processing services. Most also have online photo album capabilities. Some allow you to edit your digital images right on the site. You can even turn your images into e-cards, printed greeting cards, calendars, and other gifts.

Here are some of the most popular sites for photo processing, sharing, and related activities.

Club Photo

For photographers who haven't made the switch to a digital camera but would like to share photos via the Internet, Club Photo *(www.clubphoto.com)* offers a solution. Send them your 35mm or APS film or disposable camera in a prepaid mailer, and they will post your photos on their site, usually within one day of receiving your film, and e-mail you when they're ready for viewing. You simply choose the ones you want, and delete the duds. Club Photo offers high-quality prints and enlargements, which are processed in three to five days. Images also can be put on a compact disc.

It's easy to create a digital photo album at Club Photo and send out e-mail invitations with a link to your album if you'd like to invite others to view it. You can password-protect an album or allow it to be accessed by anyone entering your e-mail address. Add an album or photo to the site's Gallery, and it becomes viewable by anyone who visits the site.

Club Photo lets you share photos directly from your Palm OS device using their Album To Go feature. You'll be able to transfer images from

your computer or Club Photo online album to your Palm OS device, then view them individually or as a slide show.

The Club Photo site offers a wide assortment of gift items that can be adorned with your photos. Transform your favorite digital images into T-shirts, aprons, mugs, stamps, mouse pads, puzzles, memo cubes, stuffed animals, checks, and more. Or place one on any number of different edible items, from cookies and candy to Rice Krispie Bars—even frosting! Gold and silver jewelry also can be adorned with your photos. For a decorative effect, you can have your favorite image turned into a work of art on stretched canvas, or have an artist create a hand-drawn sketch based on your photo.

Kodak PhotoNet Online

Kodak's PhotoNet *(www.photonet.com)* is similar to Club Photo, since it offers film processing and online album services. But with PhotoNet, you have the choice of mailing in your film and viewing the images online, taking your film to one of 40,000 participating retailers and picking up your prints when they're ready, or uploading images directly from your digital camera.

Once you've previewed your photos at PhotoNet, you can enhance your images online with the editing tools, including cropping, rotating, resizing, and sharpening. When you've got your images looking good, you simply upload them to your computer then access them later to enhance documents and Web pages, complement your auction site listing, or create screen savers. The site offers personalized gift items featuring your photos, including mugs, T-shirts, mouse pads, and more.

Shutterfly

The services offered by Shutterfly *(www.shutterfly.com)* benefit both digital camera users and film photographers. Membership is free. Once you sign up, you're eligible for fifteen free 4" x 6" prints. Digital camera users upload their images to the site from their computers using Shutterfly's free software, SmartUpload. If you don't have image-editing software at home, you can go online to crop, remove red-eye, adjust colors, sharpen focus, and add decorative borders.

Photographers using 35mm or APS film or single-use cameras send film for processing in prepaid mailers. In approximately five to seven days after processing, an e-mail is sent to announce that images are ready for viewing on the site.

Pictures can be shared via e-mail or with online albums. Prints, which can be ordered by the photographer or site visitors, are available in a variety of sizes including wallet size, 5" x 7", and 8" x 10". Special effects can be added to prints, including sepia tones, black-and-white, and soft focus. There's even a feature that lets you add a personal message on the back of your prints.

If you're looking for unique invitations or note cards, the site includes a feature that lets you transform your photos into greeting cards, which are printed on 5" x 7" card stock with a high-quality gloss finish. Shutterfly will even mail the cards for you if you wish.

If you'd like to purchase a frame for your printed photo, you can try it before buying it using the interactive frame store.

PhotoAccess

PhotoAccess *(www.photoaccess.com)* is designed solely for the digital photographer. Become a member of PhotoAccess and you'll get twenty free prints, plus unlimited online storage space in your personal digital albums. Using the site's PhotoStreamer application with your Mac or PC, you can upload digital images to the site and manage the photos in your personal album. Your Web album is mirrored on your home computer, which means you can make changes on your desktop album and they'll be automatically reflected on your Web-based album. Execute tasks such as adding or deleting photos, rearranging the photos in an album, or change sharing options.

Choose your favorite images and have them made into prints or slides, which will be sent to you in the mail, a process that takes about five to seven days. Photo-decorated gift possibilities from PhotoAccess include mugs, mouse pads, tote bags, baseballs and softballs with holders, greeting cards, T-shirts, hats, aprons, and more.

Ofoto

Ofoto *(www.ofoto.com)* offers services for both digital and film photographers. Upon joining Ofoto, you automatically receive twenty-five free prints. Create albums or slide shows with captions, add borders to images, get prints and enlargements made, purchase frames and photo holders, or transform your images into greeting cards.

Edit and upload digital images to online albums using OfotoNow 2.0 Upload Assistant, which supports both Windows and Macintosh. Ofoto was rated number one for quality in a study of five online photo venders undertaken by the InfoTrends Research Group in April 2000. Ofoto offers users a thirty-day, money-back guarantee if you are not satisfied with their prints.

Dale iPrints

Dale iPrints *(www.daleiprints.com)* is the online arm of Dale Laboratories, a photo lab that's been around for more than thirty years. The site was designed to provide digital photographers with high-quality print photos. Printed on nonfading Kodak photographic paper, Dale promises that their iPrints will look good for years to come.

Images are uploaded from your hard drive, digital camera, CD, or diskette to what Dale calls online "shoeboxes." Then users can view images one by one in a slide show, or all at once via a thumbnail index. You can zoom in or out, rotate images, or add captions to your photos. Order prints and they'll be sent to you via first-class mail.

The MyPostcardsNow section of the site lets you turn photos into electronic postcards, including a personal message and digital "stickers." Or you can organize your images in an online photo album with MyAlbumsNow. Dress up your album using decorative themes and digital stickers.

To share your photos with others, you have two options: e-mail individual photos, or send your friends and relatives a direct link to your entire online photo gallery where they can see all of your pictures at once. An online address book keeps track of everyone's e-mail addresses.

FACTS

You don't have to be someone's mom to take advantage of the Mom's Life Web site *(www.momslife.com)*. The Mom's Life Digital Postcard section makes it simple for anyone to send an e-postcard customized with a digital image.

EZ Prints

Digital photographers looking for an online service that offers prints in a range of sizes should check out EZ Prints *(www.ezprints.com)*. Upload digital images from your camera or send them to EZ Prints on a CD-ROM or Zip disk for processing, then take your choice of glossy or matte prints ranging in sizes from 3½" x 5" to 20" x 24". The site also offers panoramic pictures printed on 6- or 12-inch-tall paper. Lengths start at one foot and increase in 6" increments to a maximum of 24 feet. Other items displaying images that can be ordered online include calendars, greeting cards, mouse pads, mugs, T-shirts, puzzles, coasters, luggage tags, desk clocks, refrigerator magnets, key tags, and ceramic tiles.

DigiPrint Store.com

DigiPrint Store *(www.digiprintstore.com)* is a site for photographers using digital cameras, or film cameras and scanners, to produce digital images. By creating an account and uploading your digital images, DigiPrint Store can be used to turn them into prints, greeting cards, and gifts. The gifts run from the usual mugs, mouse pads, calendars, and T-shirts to less commonly available items, such as coasters, clocks, magnets, and key chains.

DigiPrint Store offers an array of print sizes, from wallet to panoramic. All are available in a choice of glossy or matte finishes. DigiPrint prints your images on Kodak Digital III professional photographic paper, which they state has an archival quality of fifty years or more.

If you have a need for large quantities of a single image, check out DigiPrint Store's quantity discounts. When you order twenty-five prints of the same image, you will receive a discount of 5 percent. Order fifty prints and save 10 percent.

Another nice benefit of DigiPrint Store is their ability to ship to destinations outside the United States. Few other online photo processing sites that we encountered offered this service. Even if you live in the United States, you may have relatives and friends in other countries who would be interested in ordering prints of your images directly from the site.

eframes.com

As its name suggests, eframes.com *(www.eframes.com)* is a site that lets you add frames to your digital images. But you can do a whole lot more than that. Once you've uploaded your digital photos into an online album, you'll be able to edit them using PictureIQ technology. Zoom, crop, adjust contrast and brightness, or add special effects, such as black and white. When you've got your images looking good, you can choose to share them with others. Simply send out a link to your album via e-mail, and your recipients will be able to view your album and order prints online.

You can order frames at eframes.com, with or without prints. If you do want to order a frame to go with a printed image, you can select a frame and preview the image in it to see how they will look together. There are dozens of frames here to choose from—everything from classic to contemporary to whimsical designs. If your framed photo is a gift, eframes.com will wrap it, add your personal message, and ship it on to the recipient.

PhotoWorks

Send PhotoWorks *(www.photoworks.com)* your 35mm film, APS film, or single-use camera, or upload images from your digital camera, scanner, or a CD, and you're ready to take advantage of the site's services. Using PhotoWorks.com, you can send photo e-mails, view online albums, or order prints and gifts.

The site scans your images and places them in your online album. To allow others to see your photos, you simply send them an e-mail containing a link to your photo(s) on the site. You can decide to share a single image or your entire PhotoWorks album.

When you order high-resolution Pictures on Disk, or select the "Upgrade to High-Resolution Scans" option when ordering, you can purchase near photographic quality prints in sizes up to 8" x 12". If not, you can order only 3" x 5" and 4" x 6" prints.

Gifts that can be enhanced with your images include mugs, playing cards, calendars, ceramic plates, aprons, teddy bears, clocks, mouse pads, puzzles, coasters, baseballs, tote bags, and more.

Snapfish

Snapfish *(www.snapfish.com)* is designed to help film photographers make the transition to the digital world. In addition, digicam photographers can utilize Snapfish to organize and share images or have them made into prints. The site states that all processing is done by "District Photo, the nation's largest mail order photo finishing lab, with more than 50 years of experience in the market."

Snapfish operates a little differently from other photo processing sites. If you're sending your film to be processed, you won't be able to view your pictures online until after they've been developed as prints. That means you can't pick and choose which photos you want to have printed. However, Snapfish does offer good prices for print and enlargement processing. For $3.98 ($1.99 processing fee, plus $1.99 shipping and handling), Snapfish develops your film, mails you a full set of prints on Kodak paper, and places your photos into an online album. At the time we visited the site, Snapfish had sweetened the deal by offering to process the first three rolls free of charge.

Digital photographers simply upload their images to the site using Snapfish's drag-and-drop tool, organize them in an online album, and add titles and captions, if desired. Others can be invited to view your photos online. If you'd like to get prints, Snapfish will send them to your home or directly to your loved ones. At the time of publication, Snapfish was offering fifteen free prints with the digital photographer's first upload.

In addition, like the majority of other photo Web sites, Snapfish offers gift items imprinted with your favorite photos.

Kodak Picture Center

Kodak *(www.kodak.com)* is certainly a well-known brand in the world of photography. Their online site offers a variety of services and information.

Follow the link labeled Print@Kodak to access their printing services in cyberspace. Digital photographers can upload their JPEG images using Kodak's software. (There is no film processing available at the site.) All photos are printed on premium Kodak DuraLife photographic paper.

The site offers several photo gift items: mugs, T-shirts, sweatshirts, mouse pads, and jigsaw puzzles. You'll also be able to purchase unique Picture Pages—photo album pages onto which you print your photos and then put into a photo album binder. Turn your photo into a digital postcard, and send it off via e-mail. To have your images turned into printed greeting cards, follow the link to Kodak's online card store.

PhotoIsland.com

PhotoIsland.com *(www.photoisland.com)* was created by ArcSoft, a manufacturer of digital imaging and video software and hardware. The site offers PhotoIsland members free thirty-day trial downloads and discounts on some of their popular consumer products, including PhotoStudio 2000.

Other features that PhotoIsland offer include the ability to store your images, create online albums that you can invite others to view, participate in contests and exhibitions, and store and link your images for auction sites.

The Photo Workshop section of the site allows you to enhance your photos with a variety of effects and techniques. For instance, with iWarp you can twist or stretch your image to create all kinds of strange effects, while iMorph lets you combine two images into one bizarre picture. Use iEffects to edit and retouch your images. The iFantasy templates offer a myriad of choices for producing wacky images, including animal, sports, nostalgia, and trading card options. Add the finishing touch of a colorful border to your image with the iFrame tool.

Once you've created your digital masterpiece, you can e-mail it as a multimedia postcard, accompanied with sound and a unique photo "stamp." Or turn it into a customized gift, such as a teddy bear, T-shirt, or mug.

Finding Kindred Spirits Online

Photographers of all stripes typically enjoy sharing their photos and their photographic experiences with others. Now the Internet opens the door to worldwide communication among digital photographers and anyone interested in all types of photography. Let's take a look at some of the Web sites that promote the sharing of ideas and images.

Digital Fridge

Digital Fridge *(www.digitalfridge.com)* is a site that provides amateur digital photographers with a place to display their digital images and digital videos. Each gallery of photos or videos (homepage) is known as a fridge. Exhibiting images or videos on the Digital Fridge is completely free.

If you are using a film camera, you'll have to get your images scanned first in order to be able to utilize the site's fridges for displaying your photos.

Users can choose either personal fridges or public fridges to display their work. By adding your images to a personal fridge, you preserve your privacy. To share your photos, you send out e-mail invitations with links to your online gallery.

The public fridges can be viewed by anyone. There are more than twelve categories of public fridges, ranging from animation and comedy to pets and sports. You can perform a keyword search to find a specific type of image.

ESSENTIALS

If you own a dog, cat, bird, or other pet, chances are you love to show off your special friend. iVillage's Pet section *(www.ivillage.com/pets)* includes a Pet Photo Gallery that makes it easy to do.

We particularly liked the Editor's Choice area, which helped us quickly identify high-quality photos. In fact, we were so impressed by one Digital Fridge photographer's work that we've included some of his images in this book.

Each fridge identifies the photographer's name and e-mail address. Visitors to the site can add their comments next to an image they've

viewed or e-mail the exhibitor directly. This is an effective way to promote communication between visitors and exhibitors.

Digital Fridge has partnered with eframes and iPrint so that site users can have their images applied to personalized gifts or made into prints.

Nikon Centre

One of the most inspiring sites for amateur photographers comes from the well-known photographic equipment manufacturer, Nikon *(www.nikon.net)*. Follow the link to the Nikon Centre. Here you'll find a collection of online galleries and articles highlighting the work of nature, travel, commercial, underwater, wedding, sports, and portrait photographers.

Start with Legends Behind the Lens, their monthly showcase of the world's greatest photographers. Here you can read about the personal experiences of photographers whose works appears in publications such as *National Geographic, Time, Life, Audubon, Smithsonian,* and other leading magazines. In their own words, they tell about their experiences and the things that motivate, inspire, and teach them to take better and better photographs. The On the Road Again section follows photographers as they undertake assignments and projects. The Articles section includes a look at some of the best photos as chosen in recent photography contests. Once you're feeling inspired, turn to the photography school and workshop listings for hundreds of places worldwide where you can improve your own photography skills.

GatherRound.com

GatherRound.com *(www.gatheround.com)* is a free photo-sharing site created by Intel Corporation. Join GatherRound.com, and you'll receive these benefits:

- Your own password-protected album for sharing photos on the Web,
- The GatherRound Picture Organizer-free software that lets you organize and edit pictures before uploading them to the site,
- A monthly newsletter filled with news and special offers, and

- 360-degree photo panoramas you create using a series of your own images

Post photos to your album, then communicate with visitors in the Album Talk section. Send an animated photo e-mail, or buy items for displaying your favorite pictures, such as mugs, mouse pads, T-shirts, and puzzles.

Agfaphoto.com

Agfa, a Belgium-based manufacturer of hardware, software, and digital imaging products, features three different galleries on their Web site *(www.agfaphoto.com)*. The first is Agfa Surfers' Photo Gallery. Anyone can submit images for inclusion in the Surfers' Gallery. Site visitors vote for the Picture of the Month. The second gallery is the Agfa Professional Portfolio, which includes both images and information about the photographers. The third gallery is the SCALA Gallery, a collection of photos taken with Agfa's SCALA 200 film.

Digital Art Gallery

Visit the Digital Art Gallery *(www.willmaster.com/gallery)* to view digitally enhanced photographs and electronically generated images. This beautifully designed site offers some unique images. We appreciated seeing the before and after photo shots—they really conveyed the extent to which digital images can be enhanced through manipulation.

Photography Organizations

There are countless photography clubs and organizations, both online and offline. The following represents just a small sampling of groups that have a Web presence.

The Amateur Photographers Association

Started in 1997 by Anne Covino while she was a student at Syracuse University in New York, the Amateur Photographers Association

(http://apa.topcities.com/main.html) has grown to include about 800 members. At the time we visited the site, it was offering free membership to anyone with an interest in amateur photography. The site features an online gallery with exhibits that change monthly, plus articles, stories, and links to photography-related sites.

Women in Photography International

The mission of Women in Photography International *(www.womeninphotography.org)*, an educational nonprofit organization, is "to promote the visibility of women working in the photographic art. . . ." Their Web site is designed to "serve the needs of photographers, photo educators, photography students, gallery owners, and photographic organizations around the world." Women in Photography presents exhibitions, educational programs, juried competitions, lecture programs, workshops and conferences, and awards and scholarships. Their quarterly e-zine, f2, contains interviews, member profiles, portfolios, book reviews, gallery listings, and product information.

Northern California Council of Camera Clubs

The Northern California Council of Camera Clubs *(www.nc4.org)* provides information on many camera clubs located in Northern California, making it easy for those who live in the region to find a group in their area. Learn about photography-related events at the site and through the free e-mail newsletter. If you're planning a trip to San Francisco, you may want to check out the link to a guide of San Francisco galleries to see what exhibits are planned.

New England Camera Club Council

The New England Camera Club Council *(www.neccc.org)*, a nonprofit organization, has almost ninety member camera clubs in New England (Maine, New Hampshire, Massachusetts, Connecticut, Vermont, and Rhode Island). Each July, NECCC sponsors one of the largest photography conferences in the United States. Designed for both amateur and

professional photographers, the 2000 conference drew more than 1,300 attendees from the United States and other countries.

Storing Images Online

One of the downsides to digital photography is the need to manage and store digital images. If you pursue digital photography with any regularity, you will soon develop a large collection of pictures. Then the question becomes, How will you store all of them? We discussed some storage options in Chapter 16, but in this chapter we will take a look at online storage alternatives. This list is just a sampling of the many online storage services that are available to digital photographers.

Xdrive

Xdrive *(www.xdrive.com)* is an online information storage and management provider. Digital photographers will want to investigate Xdrive Express, a free service offering up to 100 MB of online storage space. Xdrive offers users a desktop application that functions like other drives on a PC. Using Windows Explorer, you can see and access your online Xdrive files and folders at any time. Xdrive also provides file access and management services for Palm VII and WAP phone wireless applications.

i-drive

Another online storage provider, i-drive *(www.idrive.com)* provides free personal space on the Web to more than 5 million registered users. Using i-drive, you can gather, store, and share rich-media files, such as digital images, MP3s, games, and HTML pages. With i-drive you'll get 50 MB of online disk space for your desktop files, plus unlimited space for any content or file you collect from the Web. You can access i-drive from any Internet-enabled device, such as a PC or any WAP, i-mode, or Palm device.

One feature of i-drive that digital photographers will appreciate is the ability to create and share online photo albums. With i-drive you can build an online photo album using your own digital photos, then, if desired,

add images you've collected on the Web. It's easy to share them with others, who simply follow a link to your i-drive album.

This online storage provider also offers Filo, freeware that lets you save Web pages, images, files, and links directly to your i-drive. For instance, if you come across an online magazine article that you want to save, instead of simply bookmarking the site, you can save the entire page and store it in your i-drive. Then you will always be able to find it whenever you want to reread it or e-mail it to a friend, unlike bookmarked pages that can disappear. You can access your i-drive from any computer with an Internet connection. You can choose to keep your files private, or add them to a shared folder for other site visitors to view.

BigVAULT

BigVAULT *(www.bigvault.com)* offers Web-based storage in the form of a digital safe deposit vault. The Web site provides a user with a multilevel, password-protected storage area on the Internet where images, videos, data files, software, documents, and music can be stored and backed up. If you would like others to have access to your vault, you can take advantage of the site's DateTimeLock function. Using this feature, you can assign visitor passwords and establish "date/time" rights for these passwords. This way, others can access certain files indefinitely or for specified time periods. You can also create files within files and establish passwords for each subvault and even for individual files.

There is no software needed to store images at BigVAULT, but you will need to become a member, which costs $36 per year and gives you 100 MB of storage space.

APPENDIX A
Glossary

AC adapter. A device that lets you plug a digital camera into an electrical outlet. This option is particularly useful when your batteries run out.

alkaline. A primary battery (nonrechargeable) often used in electronics requiring heavy currents for long periods of time.

angle of view. The maximum horizontal angle seen by the lens that can be recorded on the film from edge to edge.

aperture. The opening that controls the amount of light that passes through the lens; also known as the diaphragm. The size of the aperture is measured in f-stops, which control the length of time the shutter stays open and the depth of field.

aperture priority. This mode allows the photographer to choose the aperture (controlling depth of field) while the camera sets the best matching shutter speed for desirable exposure results.

ATA. Refers to AT Attachment standards. ATA was designed as a standard interface for storage devices such as disk drives and flash memory cards for the mobile computer market. An ATA-compatible card was guaranteed to work with any system supporting ATA, including digital cameras. An ATA-compatible card also should work with all major operating systems, including DOS, Windows, and Mac OS.

auto flash. A camera having an auto flash feature gauges the available light and fires the flash if needed.

autofocus. Automatically adjusts the focus depending on the distance of the subject from the camera.

backlighting. Backlighting occurs when you are photographing subjects with a bright area behind them, casting them in a shadow.

balance. An even arrangement of elements in a photo.

battery charger. Replaces the charge in rechargeable batteries so that they are useable again.

bit-mapping. To create an image, a computer divides the screen or printed area into a grid of pixels. Then it uses the values stored in the digital photograph to specify the brightness and color of each pixel in the grid. This process is called bit-mapping, and the resulting digital images are called bit-maps.

bottom-weighted metering. This exposure mode measures light throughout the scene but gives greater importance to the bottom of the image area.

bounce lighting. Bounce lighting refers to the technique of allowing light to bounce off the background and onto your subject, rather than aiming your light source directly at your subject.

brightness. A measurement of the light in an image; used by scanners and software.

burst mode. Some cameras offer a burst mode, which lets the photographer take photo after photo while holding down the shutter button.

camera obscura. The forerunner of today's camera, created from a darkened room or box with an opening that lets in light. The term is taken from the Latin words for "dark room."

center-weighted metering. This exposure mode measures light throughout the scene but gives greater importance (weight) to the center quarter of the image area, assuming that that is where the primary subject is located.

channel. An isolated part of the information that makes up a digital image.

charge cycle. A sequence where a charged battery is discharged and recharged.

cloning. A tool or process in an image editing application that allows the user to "paint" one section of an image onto another.

CMYK. Acronym for cyan, magenta, yellow, and black (K represents black to prevent confusion with blue). These are the printer colors used to create color prints. Most color printers, including laser, inkjet, dye sublimation, thermal, and crayon, use these as their printer colors.

color balance. The process by which most digital cameras automatically adjust for the correct color temperature; also white balance. Color balancing determines what combination of red, green, and blue light the camera should perceive as pure white under the current lighting conditions. From there, the camera determines how all other colors can be accurately represented.

color correction. Adjusting an image to make the colors truer.

color depth. The term used to refer to the number of colors in an image. It is also called pixel depth or bit depth.

combination scanner. A combination or multi-format scanner that scans film and slides as well as flat, printed materials.

composition. The arrangement of elements and their relationship to the background of an image.

compression. A technique used to reduce the size of an image file. It works either by reducing the number of colors in an image, or by grouping together a series of pixels of a similar color.

condition. A process that utilizes a series of heavy discharges and recharges on a battery to assure optimum performance.

continuous mode. Allows you to snap an entire sequence of photos.

crop. Resizing an image so that parts of it are deleted.

curves. An adjustment command that allows the user to fine-tune brightness levels. Brightness values are shown along a curve. The user can raise or lower points on the curve to change the overall brightness of the image.

cycle life. The number of cycles under specified conditions that are available from a secondary battery before it fails to meet specified performance criteria.

daguerreotype. An early form of photography using a chemical process developed by Louis Daguerre.

date/time indicator. A feature of some digital cameras, the date/time indicator gives a permanent record of when the shot was taken. Some are displayed in the image area, while others are hidden in the image file and can only be seen when using software.

depth of field. The measure of the area of a photograph that is in focus.

dot gain. A disadvantage of inkjet printers, dot gain occurs when ink droplets spread out when they hit the paper, causing colors to bleed into each other and images to look a little fuzzy.

download. To transfer a file from a camera to a computer or from one computer to another.

dropouts. *See* **hot spots**.

drum scanner. Uses PMT rather than CCD technology, providing greater color accuracy. A professional wouldn't use anything but a drum scanner for producing color separations.

dye sublimation printer. For many years, dye sublimation printers have been heralded as the top-of-the range output device for digital printing. Dye subs (for short) transfer images to paper using a plastic film or ribbon that's coated with color dyes. During the printing process, heating elements move across the film, causing the dye to fuse to the paper. The printers work by fusing dye onto the specially manufactured transfer paper, making a separate pass through the printer for each color.

EPS. Stands for Encapsulated PostScript. EPS files incorporate the PostScript language and the original file, so files saved in the EPS format are larger than the original. Adobe created PostScript as a means of communicating to a printer the size of the file, what fonts it uses, and other details so that the printer can output an accurate document.

EXIF. Stands for Exchangeable Image Format and is a variation of the JPEG format. It was developed by the Japanese Electronics Industry Development Association.

exposure compensation. Allows the photographer to increase or decrease the exposure from what the autoexposure setting typically delivers.

fill. Lets you pour a color, effect, or texture into a closed space within an image.

fill flash. The fill flash mode allows you to add light to an image without affecting the exposure settings.

film scanner. A transparency or film scanner allows you to scan everything from a 35mm slide to a 4" x 5" transparency. These scanners are more expensive than flatbed scanners, but they are excellent for people who want to scan a lot of transparencies because they are the only scanner that will produce quality transparency scans.

filter. An effect, such as emboss, stretch or warp, that modifies an image.

FireWire. A high-speed, high-performance serial bus. FireWire was introduced by Apple Computer in their Power Macs, but today it is used throughout the electronics industry. (FireWire is the name patented by Apple, but it is also referred to as IEEE 1394 and i.LINK.)

fixed focus. A lens with a focus that cannot be changed. Rather, the lens depends on the use of depth of field to produce sharp images.

fixed storage. Memory that cannot be increased or decreased. Once you've filled up the camera's memory, you cannot continue shooting until you've downloaded your images to a computer. Also called onboard storage.

flash. The flash provides additional lighting to the scene being photographed.

FlashPath. A type of adapter that allows you to use removable storage media with your floppy driver. It is shaped like a floppy disk and inserts into the standard drive slot found on almost all computers. You can then insert the media card into the FlashPath and begin downloading images.

FlashPix. A lossy file format that is less popular than JPEG.

flatbed scanner. A scanning device that takes its name from the flat, glass platen (or bed) where you place the object to be scanned. It is very versatile and can be used to scan flat materials such as photographs and printed pages.

focal length. On film cameras, the focal length is the measurement of the distance between the center of the lens and the film. On a digital camera, the focal length measures the distance between the lens and the image sensor. In both cases, focal length is measured in millimeters.

focus lock. Allows the photographer to center the subject in the frame, lock the focus, then reframe and take the shot. When taking a shot of a scene with many elements, this can be a useful feature because it allows you to specify which object you want to be in focus.

GIF. Another lossless compression format, GIF stands for Graphic Interchange Format.

grayscale. Refers to all shades of gray, ranging from black to white.

handheld scanner. Less expensive than a flatbed scanner and very portable, a handheld scanner is plugged directly into a computer's printer port, making it easily shared by different workstations. Often used with laptop computers.

heliography. A process developed by Joseph Niepce that is regarded as having produced the first permanent photographic image.

hot spots. Also known as dropouts, these occur when light bounces off a reflective surface and creates areas in your image that have no detail; they look like white blobs on your picture.

hot swappable. Allows you to plug or unplug the camera from the USB port without turning off your computer or camera.

image sensors. Light-sensitive computer chips that record the image captured by a digital camera. They serve the same purpose as film in a 35mm camera.

inkjet printer. An inkjet printer works by forcing little drops of ink through nozzles onto the paper. Consumer inkjet printers have been around for many years, but they initially produced images of poor quality. Today's inkjet printers produce excellent photorealistic prints.

integrated lens. An integrated lens is part of the camera and is not detachable.

interchangeable lens. An interchangeable lens can be detached from the camera and replaced with another lens having the same type of mount.

IrDA. Wireless transfer that utilizes infrared light beams to carry files.

ISO numbers. These numbers are found on film packages and represent its speed, or sensitivity. Image sensors are also rated using ISO numbers, which are meant to be approximately equivalent to film ISOs. The lower the ISO of an image sensor, the more light that is needed for a good exposure.

ISP. Internet service provider; provides you with access to the Internet.

JPEG. An image compression method, most widely utilized by digital cameras. JPEG stands for Joint Photographic Experts Group, the people who developed the original code. Because of its ability to reduce file size with a negligible degree

of deterioration, JPEG has become the standard for saving and compressing digital images.

JPEG2000. A new image-coding system using state-of-the-art compression techniques. JPEG2000 should provide users of digital cameras with a more versatile JPEG file format that uses wavelet technology. It represents a significant advancement in image compression technology.

laser printer. A laser printer uses a technology similar to photocopiers; a laser beam produces electrical charges on a drum inside the printer. The drum then rolls ink onto the paper, and heat is applied, which permanently affixes the toner to the page.

layer. Stacking elements in an image. The layering tool lets you edit elements such as images, graphics, and text separately from each other. You also can change the settings, coloration, effects, and many more variables for each layer.

lens. Optical glass or plastic elements designed to gather and focus rays of light and form an image.

lens cap. A lens cap protects your camera's lens and is especially important for your digicam. Digital cameras are particularly susceptible to scratching and smearing because the cameras are so small that your fingers may wind up on top of the lens.

lens hood. A lens hood, or lens shade, hinders unwanted light from striking the lens. It also affords your lens some protection from knocks and bumps.

light-balancing filter. A filter that compensates for different lighting conditions.

line. Shapes are defined by lines. As we view a photo, our eyes follow its lines. One of the most important uses of line is to lead the viewer to the center of interest in a photograph.

lithium ion (LiIon). One of the newer and more expensive rechargeable battery technologies, LiIon batteries can deliver more capacity than comparably sized NiCd batteries and are one of the lightest rechargeable batteries available today.

macro lens. Allows you to focus while standing very close to your subject in order to take close-up shots.

magnification. Magnification goes hand-in-hand with angle of view. A short lens, with its wide angle of view, requires all the objects in a scene to be reduced in size in order to fit into the image sensor. It has the effect of pushing the subject away from you. Conversely, the long lens, with its corresponding narrow angle of view, will have the effect of pulling objects in a scene close to you, causing them to appear larger.

masking. The masking tool preserves areas of an image. Masking permits you to apply an effect to one specific part of an image or to vary the strength of an effect within an image.

matrix metering. Often the default autoexposure mode on a digital camera, matrix metering, also called multizone metering, works by dividing the frame into a grid, or matrix. Then it analyzes light at different points on the grid and chooses an exposure that best captures both the dark and light sections of the scene.

megapixel. Used to describe the resolution that can be produced by a digital camera's image sensor; indicates that there are millions of pixels in the image.

nickel cadmium (NiCd) battery. NiCd batteries are the most widely used type of rechargeable household battery and are used in small, portable devices such as digicams, radios, laptop computers, and cellular phones. A dependable and popular rechargeable battery, it has a relatively low capacity when compared to other

rechargeable systems. Contains cadmium, which is toxic.

nickel metal hydride (NiMH) battery. Interchangeable with most NiCd batteries, nickel metal hydride (NiMH) batteries generally deliver greater capacity than NiCds. Nickel metal hydride (NiMH) batteries are the most popular batteries for digital camera use because they are rechargeable, nontoxic, and relatively inexpensive.

night flash. Night flash, or night portrait mode, combines a flash exposure with a longer capture speed. This mode is ideal for shooting room lights or an evening sky with a brightly lit subject.

noise. Small imperfections that can ruin a perfectly good photograph. Noise comes from the light sensors in your digicam, resulting in an image that appears grainy or snowy, similar to a snowy image on your TV screen or a grainy film photograph. Noise tends to appear when a photographer chooses an ISO rating that is too high or when using image-editing software to correct an underexposed area.

parallel port. Parallel ports are normally used for printers and certain kinds of external storage devices, and they carry 8 bits of data at a time. Many card readers plug into a parallel port.

path. A path shows the area where an effect will be applied in an image-editing application. It is shown as a border around an object.

pattern. The repetition of lines, shapes, or colors. Patterns have strong visual impact, and even the suggestion of a pattern in a photo can catch the viewer's eye.

PC Cards. Also called PCMCIA (Personal Computer Memory Card International Association) cards; a type of removable memory card.

PDF. An updated version of the EPS format, PDF (portable document format) also contains information that is helpful to the printer, including descriptions of font, size, and color.

photography. The process of recording an image on a sensitive material. The term was coined by Sir John Herschel in 1839 from the Greek words for light (*photos*) and drawing (*graphein*).

photorealistic print. A print made from a digitized photo, as opposed to a "photograph," which is a conventional picture printed in a darkroom.

pixel. The basic element of resolution. Derived from "picture element" or "picture cell."

plug-in. Software that expands an established software program by providing an added feature. With plug-ins, you'll gain more features for your software without having to spend a lot on upgrading. Free plug-ins on CD-ROMs sometimes accompany magazines.

polarizing filter. Removes glare caused by reflected light and tends to improve color saturation.

previsualization. The ability to imagine while shooting how the resulting photo will look.

primary battery. A battery that is not intended to be recharged and is discarded when it has delivered all of its electrical energy.

rechargeable battery. A battery that can be recharged and used again and again.

red eye. The red-eye effect occurs when a flash is reflected in the subject's eyes.

resampling. A process that deletes or blends pixels in order to reduce an image's resolution without changing its width and height. Resampling can help reduce the size of files used on a Web site so that they download faster.

resolution. A measure of the amount of detail that an image possesses.

RGB. Red, green, and blue; the primary colors for transmitted light. Your computer monitor, TV, and digital camera display their pixels based on values of red, green, and blue. When mixed together, red, green, and blue create white light.

rule of thirds. A formula for achieving balance, which requires that the photographer mentally divide an image into thirds, both horizontally and vertically. For instance, subjects are placed near one of the four intersections to provide immediate off-center emphasis or placed at diagonally opposed intersections to create a balanced composition.

saturation. The intensity of a color. Image-editing software allows the user to boost or reduce saturation as needed.

SCSI. Stands for Small Computer System Interface; transfers data at a rate of from 40 Mbps (megabits per second) to 640 Mbps, making it up to fifty times faster than a USB connection. Historically used by Macintosh computers, SCSI is fast, but it has certain drawbacks.

secondary battery. A battery that can be recharged and reused many times (rechargeable battery).

selection. The specified section of an image to which an effect will be applied.

self-timer. A mechanism that delays the shutter release for about ten seconds, allowing you to jump into a picture before the shutter releases. This is a useful feature when you want to take a self-portrait or include yourself in a group shot.

serial port. Generally used for connecting analog modems so that the user can access the Internet. Some digicams still use serial ports to connect to a computer. A serial cable transmits information one bit of data at a time, which makes for a very slow process.

shape. The first thing our eyes distinguish when looking at a photograph.

shutter priority. This mode allows the photographer to choose the shutter speed, and the camera sets the best matching aperture.

slave unit. A slave unit is a small, battery-operated flash unit with built-in photo eyes. The slave unit fires a flash when it senses another flash of light.

slow-sync flash. Some cameras offer a slow-sync flash, which increases the exposure time beyond the normal flash. This mode helps illuminate background shadows that normal flash mode misses. The slow-synchronized mode works by allowing the shutter to remain open longer than normal so that the background appears lighter.

SLR. Single-lens reflex; a type of camera that uses one lens for both shooting and viewing. Allows the photographer to see exactly what the camera sees.

small-footprint scanner. A smaller, lighter, and more durable scanner than the CCD-based counterparts; ideal for taking on the road or fitting into cramped spaces such as dorm rooms.

solid inkjet printer. A solid inkjet printer uses sticks of crayon-like ink that are heated and dropped onto the paper.

spot metering. This exposure mode measures the light only at the center of the image.

spot reading. A technique for combating backlighting, spot reading enables the photographer to take a reading in a smaller area, such as the shaded area of your subject. Once your spot reading is complete, the camera automatically opens the aperture, creating an image that is properly exposed.

SRAM. Static RAM technology that holds data without electric current. Flash memory cards use SRAM.

texture. Adds a sense of realism to a photo and appeals to the viewer's sense of touch.

thermo-autochrome printer. Uses thermal wax to heat pigment-carrying wax from a print ribbon. Thermo-autochrome printers are faster than dye sublimation printers because they use sticks of wax or ribbons of dye rather than ink cartridges. The technique is similar to that seen on fax machines that print on thermal paper.

TIFF. An acronym for Tagged Image File Format, this format allows you to store the highest-quality uncompressed images. It is the most popular lossless compression format.

tolerance. A setting that determines how discriminating a selection tool will be in matching the criteria you specify.

tools. Raster tools modify individual pixels; vector tools modify the entire image.

transparency. An effect that changes the opacity of an element so that underlying elements can show through.

unsharp masking. A sharpening filter frequently used to regain sharpness lost in the scanning process.

upload. To transfer a file from a computer to a camera.

URL. Uniform resource locator; the "address" or location of a Web site or other Internet service.

USB. Universal serial bus; a type of connection found on newer computers. Downloading via the USB is a much faster and easier way to transfer your images than using a serial cable. USB can transfer images at up to 12 Mbps, which is about fifty times as fast as the fastest serial connection. Besides saving you time when you download, another great advantage to using a USB camera is it's *hot swappable*. Hot swappable is just a fancy way of saying that you don't have to turn off the computer or the camera when you plug or unplug the camera from the USB port. With USB, you can "daisy chain" up to 127 devices on a single USB port, which makes it easy for you to custom-build a system. You can use USB with CD-ROM drives, hard drives, and video equipment.

UV filter. A UV (ultraviolet) filter removes ultraviolet light, which commonly shows up in the background of distant shots as a bluish haze.

vector images. Shapes defined using the mathematical principle of vectors. Digital drawings are vector images. Some software programs let the user draw well-defined vector images of various shapes.

white balance. *See* **color balance**.

zoom lens. A zoom lens has a variable focal length, meaning it allows you to adjust the focal length over a variety of ranges.

APPENDIX B
Resources

Where to Buy a Digicam Online

There are many Web sites selling cameras of all kinds. Here are overviews of ten popular Internet retailers of digital cameras and accessories:

ACE Index (*www.acecam.com*)

If you're looking for a camera in one of thirty-six countries, including the United States, Australia, and Canada, Ace will help put the right equipment in your hands. The extensive portal has links to thousands of camera stores worldwide, plus mail-order dealers, and suppliers of digital, darkroom, lab, lighting, and studio equipment. Search alphabetical store listings, or order directly from the factories. You'll also find a directory of photo labs, plus Ace Camera, an online international photography magazine with informative features on products and techniques. Look for good savings in the Hot Deals section.

Adorama (*www.adorama.com*)

This uncluttered site features a wide assortment of photography products, plus telescopes and other items. Specify price range, manufacturer, lenses or other features, or just click Search and get the complete inventory for each product. An advanced search lets you select from one of numerous manufacturers. Prices are quite competitive, and most items have brief descriptions. Check the Specials section for some very good deals, or trade in your old camera at the Used Equipment section. Adorama also rents equipment.

B&H Photo & Video (*www.bhphotovideo.com*)

This long-established photography emporium based in New York City offers more than 130,000 items from their easy-to-navigate homepage. From state-of-the-art digital equipment to 35mm SLRs to disposable cameras, B&H has it all. The products in their massive inventory are well-categorized, and each comes with complete specifications, warranty information, features,

and appropriate accessories. Their digital photography department includes cameras and accessories, printers, scanners, and more. Serious photographers will find lighting and studio equipment. Purchasing is easy, and you can log in to track orders. A comprehensive Customer Service section covers returns, repairs, and the like.

Camera World (*www.cameraworld.com*)

As all-inclusive as a site can get, you'll find more than just a world of cameras here. Camcorders, accessories, scanners, copiers, binoculars, and electronics are included in the long list of searchable goods. Browse more than 100 brands, or read extensive details on products and consumer reviews. A glossary of terms will help you understand the latest features, and the Order Wizard will ensure that you buy the equipment that best suits your needs.

Norman Camera & Video (*www.normancamera.com*)

At Norman Camera & Video, the name of the game is customer service. The bricks-and-mortar store has been located in Kalamazoo, Michigan, for more than forty years. One key to their longevity is undoubtedly their staff of friendly, knowledgeable salespeople who will go out of their way to help you find the digicam that best suits your needs. Now you can shop online from anywhere in the world and take advantage of their expertise. The digital camera department includes models from Canon, Fuji, Kodak, Minolta, Olympus, Nikon, Samsung, and Sony, plus card readers, carrying cases, flashes and accessories, batteries, chargers, and more. Returns and exchanges may be made in ten days with prior authorization.

Photo Alley (*www.photoalley.com*)

Digital and SLR cameras, camcorders, flashes, lenses, tripods, binoculars, telescopes, and a bevy of accessories are available from this online photography center. Find a detailed overview of each product, plus in-stock availability. Photo Alley also offers plenty of photography insight. The Digital Resource Center provides basic online lessons and tips, plus product reviews and a digital gallery. Check Photo Feedback for opinions from fellow customers, visit Photo Forums, or drop by the Learning

Center for a wide range of articles from the experts. You'll also find a gift center and a helpful glossary of photography terms.

Precision Camera (*www.precision-camera.com*)

This popular Austin, Texas–based store has a digital department with digicams from more than a dozen manufacturers, plus accessories, printers, and scanners. Extensive product listings include summaries, features, and all the specs you could want. Find plenty of photo services featuring a wide range of digital imaging options, including prints, slides, and scanning. Or browse a gallery of work from Texas-based photographers. Purchasing takes a bit of time, but online safety is guaranteed.

Ritz Camera (*www.ritzcamera.com*)

No sales tax, free shipping on orders over $50, and an extensive selection of top brand-name products make Ritz a popular choice among shutterbugs. From children's cameras to advanced photo systems, you'll get detailed product information and good discounts on all the merchandise Ritz offers. Digital cameras include models from Nikon, Fujifilm, Olympus, Canon, and Kodak.

Wolf Camera (*www.wolfcamera.com*)

This sharp-looking site, backed by the twenty-seven-year-old retail chain with 550 stores in thirty states, features a well-stocked inventory of photography equipment and more. The digital camera section offers models from Canon, Fujifilm, Kodak, Nikon, Olympus, and Sony. Note that Sony products must be purchased via a telephone call to Wolf's toll-free number or from one of Wolf's bricks-and-mortar stores.

Other Popular Photography Retailers

- Abe's of Maine
 www.abesofmaine.com
- AnMax
 www.anmax.com
- Best Buy
 www.bestbuy.com
- Camera Sound
 www.camerasound.com
- Camera Zone
 www.thecamerazone.com
- Cameradirect.com
 www.cameradirect.com
- Cameramax.com
 www.cameramax.com
- Casey's Camera
 www.caseyscameras.com
- Circuit City
 www.circuitcity.com
- Classic Connection
 www.classicconnection.com
- CompUSA.com
 www.compusa.com
- Film Shop
 www.filmshop.com

- Focus Camera
 www.focuscamera.com
- Freestyle Camera
 www.freestylecamera.com
- Genesis Camera
 www.genesiscamera.com
- Imageologists
 www.imageologists.com
- KEH
 www.keh.com
- Kirkland Photographic
 www.kirklandphoto.com
- Le Camera
 www.lecamera.com
- Micro Warehouse
 www.microwarehouse.com
- Mid City Camera
 www.midcity.com
- Midwest Photo Exchange
 www.midwestphoto.com
- Penn Camera
 www.penncamera.com
- Richmond Camera
 www.richmondcamera.com

Camera Manufacturer Web Sites

Every major camera manufacturer has a Web site. Although you may not be able to purchase online, you will find lots of information on the various models they offer, including specifications, photos, and press releases.

- Agfa
 www.agfanet.com
- Argus
 www.arguscamera.com
- Bronica
 www.tamron.com
- Canon
 www.canon.com
- Casio
 www.casio.com
- Epson
 www.epson.com
- Fuji
 www.fujifilmcom
- JVC
 www.jvc.com
- Kodak
 www.kodak.com
- Konica
 www.konica.com
- Leica
 www.leica.com
- Minolta
 www.minolta.com

- Nikon
 www.nikon.com
- Olympus
 www.olympus.com
- Panasonic
 www.panasonic.com
- Pentax Corp.
 www.pentax.com
- Polaroid
 www.polaroid.com
- Ricoh
 www.ricoh.com
- Samsung
 www.samsung.com
- Sanyo
 www.sanyodigital.com
- Sharp
 www.sharp.usa.com
- Sony
 www.sony.com
- Vivitar
 www.vivitarcorp.com

Scanner Manufacturer Web Sites

Here are some manufacturer Web sites you'll want to check out to see what types of scanners are available.

- Agfa
 www.agfa.com
- Canon
 www.canon.com
- Epson
 www.epson.com
- Fuji
 www.fujifilm.com
- Hewlett-Packard
 www.hp.com
- Kodak
 www.kodak.com
- Konica
 www.konica.com

- LinoColor
 www.heidelberg.com
- Mustek
 www.mustekdirect.com
- Nikon
 www.nikon.com
- Plustek
 www.plustekusa.com
- Umax
 www.umax.com
- Visioneer
 www.visioneer.com

Plug-ins Enhance Programs

Plug-ins are small software modules that extend the features of a particular software program. Adobe created a popular plug-in standard for Photoshop. But plug-ins can now be used with a variety of other software programs, including the following:

- Apple Computer's PhotoFlash
- Corel's PHOTO-PAINT
- Digital Darkroom
- Enhance
- Macromedia's xRes
- MetaCreations' Painter and Art Dabbler

- MicroFrontier's Color-It!
- Pixel Resource's PixelPaint professional
- Ulead Systems' PhotoImpact

Places to Buy Software Online

If you'd like to shop for computer software online, or if you'd just like to do some research in cyberspace, here are a few sites you won't want to miss.

Beyond.com (*www.beyond.com*)

If you want to go "beyond the software superstore," log onto Beyond.com's software products section. Shop by brand, product category, or keyword. The site also makes it easy to find out the site's top ten bestsellers. Or go to the Hot Sellers section and click on a product category to see which programs other consumers are buying.

Chumbo.com (*www.chumbo.com*)

Chumbo is all about software, with a range of products from graphics/media to games to utilities. The site's advanced search feature makes it easy to fine-tune your search to quickly uncover only the products that meet your specifications. The site includes lists of top sellers and software reviews so you can quickly zoom in on what's hot and what's not.

CompUSA (*www.compusa.com*)

CompUSA is one of the largest computer superstore chains in the United States. Their online superstore offers seven stores (categories) from which to choose, including Auctions, CompUSA Special Order Store, Download Store, the Outlet, and Vendor Showcases. If you know the program you want, the quickest way to find it on the site is with a simple search.

Egghead (*www.egghead.com*)

Egghead's site is made up of online "superstores," selling computer products, electronics, office products, and more. In addition, you'll find bargains galore in the clearance categories where Egghead houses refurbished, closeout, and miscellaneous items with reduced price tags. If you enjoy buying at auction, Egghead's got more than 70,000 auction items for sale twenty-four hours a day. Search Egghead by key word or browse by brand name or product category. The site offers product

reviews, buyers' guides, how-to guides, product recommendations, and other tools to help you become a savvy shopper.

NothingButSoftware (*www.nothingbutsoftware.com*)

As the name implies, this is an online software superstore. You'll find many types of software programs, including graphics, games, tools and utilities, education, and programs designed just for kids. The day we visited, a search of the photo category turned up thirty-six software programs, most of which were priced under $30.

Online Resources for Photographers

If you are interested in digital photography, you can take a trip into cyberspace and find just about anything you might want or need. The chart below provides some starting points for your digital projects and activities.

E-mail an Image as a Digital Postcard

- *www.zing.com*
- *www.shutterfly.com*
- *www.daleiprints.com*
- *www.fotobug.com*
- *www.photoworks.com*
- *www.kodak.com*
- *www.photochannel.com*
- *www.gatherround.com*

Display Images in an Online Photo Album

- *www.zing.com*
- *www.clubphoto.com*
- *www.photonet.com*
- *www.shutterfly.com*
- *www.photoaccess.com*
- *www.ofoto.com*
- *www.daleiprints.com*
- *www.ezprints.com*
- *www.fotobug.com*
- *www.digiprintstore.com*
- *www.eframes.com*
- *www.photoworks.com*
- *www.snapfish.com*
- *www.photochannel.com*
- *www.gatherround.com*

Have Prints Made from Your Digital Images

- *www.clubphoto.com*
- *www.zing.com*
- *www.photonet.com*
- *www.shutterfly.com*
- *www.ezprints.com*
- *www.fotobug.com*
- *www.eframes.com*
- *www.snapfish.com*

- www.photoaccess.com
- www.ofoto.com
- www.daleiprints.com
- www.kodak.com
- www.photochannel.com

Turn Photos into gifts

- www.clubphoto.com
- www.zing.com
- www.photonet.com
- www.photoaccess.com
- www.ezprints.com
- www.fotobug.com
- www.digiprintstore.com
- www.eframes.com
- www.photoworks.com
- www.snapfish.com
- www.kodak.com
- www.gatherround.com

Turn Photos into Paintings

- www.photodoodle.com
- www.clubphoto.com

Turn Photos into Stationery or Cards

- www.zing.com
- www.shutterfly.com
- www.ezprints.com
- www.fotobug.com
- www.digiprint.com
- www.snapfish.com
- www.kodak.com

Turn Photos into Wearable Art

- www.ashirtofyourown.com
- www.clubphoto.com
- www.ezprints.com
- www.digiprintstore.com
- www.photoworks.com
- www.kodak.com
- www.gatherround.com

Turn Photos into Other Works of Art

- www.clubphoto.com

Create an Online Slide Show

- www.zing.com
- www.ofoto.com
- www.daleiprints.com

Exhibit a Digital Image in an Online Gallery

- www.digitalfridge.com
- www.gatherround.com

Sell Your Pictures

- *www.shareyourworld.com*
- *www.viri.com/what.htm*
- *www.photoshot.com*

Find Digital Images for Personal Projects

- *www.shareyourworld.com*
- *www.photostogo.com*
- *www.programfiles.com*
- *www.viri.com/what.htm*
- *www.ecophotography.com*
- *www.christies.com/christiesimages*
- *www.corbis.com*
- *www.comstock.com*
- *www.artres.com*
- *www.mira.com*

Find Digital Images for Commercial Projects

- *www.shareyourworld.com*
- *www.photostogo.com*
- *www.programfiles.com*
- *www.viri.com/what.htm*
- *www.corbis.com*
- *www.christies.com/christiesimages*
- *www.stockphotodirectory.com*
- *www.comstock.com*
- *www.stockfood.com*
- *www.artres.com*
- *www.ecophotography.com*
- *www.mira.com*

Store Many Images Online

- *www.idrive.com*
- *www.xdrive.com*
- *www.bigvault.com*

Index

We Have EVERYTHING!

Everything® **After College Book**
$12.95, 1-55850-847-3

Everything® **American History Book**
$12.95, 1-58062-531-2

Everything® **Angels Book**
$12.95, 1-58062-398-0

Everything® **Anti-Aging Book**
$12.95, 1-58062-565-7

Everything® **Astrology Book**
$12.95, 1-58062-062-0

Everything® **Baby Names Book**
$12.95, 1-55850-655-1

Everything® **Baby Shower Book**
$12.95, 1-58062-305-0

Everything® **Baby's First Food Book**
$12.95, 1-58062-512-6

Everything® **Baby's First Year Book**
$12.95, 1-58062-581-9

Everything® **Barbeque Cookbook**
$12.95, 1-58062-316-6

Everything® **Bartender's Book**
$9.95, 1-55850-536-9

Everything® **Bedtime Story Book**
$12.95, 1-58062-147-3

Everything® **Bicycle Book**
$12.00, 1-55850-706-X

Everything® **Build Your Own Home Page**
$12.95, 1-58062-339-5

Everything® **Business Planning Book**
$12.95, 1-58062-491-X

Everything® **Casino Gambling Book**
$12.95, 1-55850-762-0

Everything® **Cat Book**
$12.95, 1-55850-710-8

Everything® **Chocolate Cookbook**
$12.95, 1-58062-405-7

Everything® **Christmas Book**
$15.00, 1-55850-697-7

Everything® **Civil War Book**
$12.95, 1-58062-366-2

Everything® **College Survival Book**
$12.95, 1-55850-720-5

Everything® **Computer Book**
$12.95, 1-58062-401-4

Everything® **Cookbook**
$14.95, 1-58062-400-6

Everything® **Cover Letter Book**
$12.95, 1-58062-312-3

Everything® **Crossword and Puzzle Book**
$12.95, 1-55850-764-7

Everything® **Dating Book**
$12.95, 1-58062-185-6

Everything® **Dessert Book**
$12.95, 1-55850-717-5

Everything® **Digital Photography Book**
$12.95, 1-58062-574-6

Everything® **Dog Book**
$12.95, 1-58062-144-9

Everything® **Dreams Book**
$12.95, 1-55850-806-6

Everything® **Etiquette Book**
$12.95, 1-55850-807-4

Everything® **Fairy Tales Book**
$12.95, 1-58062-546-0

Everything® **Family Tree Book**
$12.95, 1-55850-763-9

Everything® **Fly-Fishing Book**
$12.95, 1-58062-148-1

Everything® **Games Book**
$12.95, 1-55850-643-8

Everything® **Get-A-Job Book**
$12.95, 1-58062-223-2

Everything® **Get Published Book**
$12.95, 1-58062-315-8

Everything® **Get Ready for Baby Book**
$12.95, 1-55850-844-9

Everything® **Ghost Book**
$12.95, 1-58062-533-9

Everything® **Golf Book**
$12.95, 1-55850-814-7

Everything® **Grammar and Style Book**
$12.95, 1-58062-573-8

Everything® **Guide to Las Vegas**
$12.95, 1-58062-438-3

Everything® **Guide to New York City**
$12.95, 1-58062-314-X

Everything® **Guide to Walt Disney World®,**
Universal Studios®, and
Greater Orlando, 2nd Edition
$12.95, 1-58062-404-9

Everything® **Guide to Washington, D.C.**
$12.95, 1-58062-313-1

Everything® **Guitar Book**
$12.95, 1-58062-555-X

Everything® **Herbal Remedies Book**
$12.95, 1-58062-331-X

Everything® **Home-Based Business Book**
$12.95, 1-58062-364-6

Everything® **Homebuying Book**
$12.95, 1-58062-074-4

Everything® **Homeselling Book**
$12.95, 1-58062-304-2

Available wherever books are sold!
Visit us at everything.com

Everything® **Home Improvement Book**
$12.95, 1-55850-718-3

Everything® **Horse Book**
$12.95, 1-58062-564-9

Everything® **Hot Careers Book**
$12.95, 1-58062-486-3

Everything® **Internet Book**
$12.95, 1-58062-073-6

Everything® **Investing Book**
$12.95, 1-58062-149-X

Everything® **Jewish Wedding Book**
$12.95, 1-55850-801-5

Everything® **Job Interviews Book**
$12.95, 1-58062-493-6

Everything® **Lawn Care Book**
$12.95, 1-58062-487-1

Everything® **Leadership Book**
$12.95, 1-58062-513-4

Everything® **Learning Spanish Book**
$12.95, 1-58062-575-4

Everything® **Low-Fat High-Flavor Cookbook**
$12.95, 1-55850-802-3

Everything® **Magic Book**
$12.95, 1-58062-418-9

Everything® **Managing People Book**
$12.95, 1-58062-577-0

Everything® **Microsoft® Word 2000 Book**
$12.95, 1-58062-306-9

Everything® **Money Book**
$12.95, 1-58062-145-7

Everything® **Mother Goose Book**
$12.95, 1-58062-490-1

Everything® **Mutual Funds Book**
$12.95, 1-58062-419-7

Everything® **One-Pot Cookbook**
$12.95, 1-58062-186-4

Everything® **Online Business Book**
$12.95, 1-58062-320-4

Everything® **Online Genealogy Book**
$12.95, 1-58062-402-2

Everything® **Online Investing Book**
$12.95, 1-58062-338-7

Everything® **Online Job Search Book**
$12.95, 1-58062-365-4

Everything® **Pasta Book**
$12.95, 1-55850-719-1

Everything® **Pregnancy Book**
$12.95, 1-58062-146-5

Everything® **Pregnancy Organizer**
$15.00, 1-58062-336-0

Everything® **Project Management Book**
$12.95, 1-58062-583-5

Everything® **Puppy Book**
$12.95, 1-58062-576-2

Everything® **Quick Meals Cookbook**
$12.95, 1-58062-488-X

Everything® **Resume Book**
$12.95, 1-58062-311-5

Everything® **Romance Book**
$12.95, 1-58062-566-5

Everything® **Sailing Book**
$12.95, 1-58062-187-2

Everything® **Saints Book**
$12.95, 1-58062-534-7

Everything® **Selling Book**
$12.95, 1-58062-319-0

Everything® **Spells and Charms Book**
$12.95, 1-58062-532-0

Everything® **Stress Management Book**
$12.95, 1-58062-578-9

Everything® **Study Book**
$12.95, 1-55850-615-2

Everything® **Tall Tales, Legends, and Outrageous Lies Book**
$12.95, 1-58062-514-2

Everything® **Tarot Book**
$12.95, 1-58062-191-0

Everything® **Time Management Book**
$12.95, 1-58062-492-8

Everything® **Toasts Book**
$12.95, 1-58062-189-9

Everything® **Total Fitness Book**
$12.95, 1-58062-318-2

Everything® **Trivia Book**
$12.95, 1-58062-143-0

Everything® **Tropical Fish Book**
$12.95, 1-58062-343-3

Everything® **Vitamins, Minerals, and Nutritional Supplements Book**
$12.95, 1-58062-496-0

Everything® **Wedding Book, 2nd Edition**
$12.95, 1-58062-190-2

Everything® **Wedding Checklist**
$7.95, 1-58062-456-1

Everything® **Wedding Etiquette Book**
$7.95, 1-58062-454-5

Everything® **Wedding Organizer**
$15.00, 1-55850-828-7

Everything® **Wedding Shower Book**
$7.95, 1-58062-188-0

Everything® **Wedding Vows Book**
$7.95, 1-58062-455-3

Everything® **Wine Book**
$12.95, 1-55850-808-2

Everything® **World War II Book**
$12.95, 1-58062-572-X

Everything® is a registered trademark of Adams Media Corporation.

For more information, or to order, call 800-872-5627
or visit everything.com
Adams Media Corporation, 57 Littlefield Street, Avon, MA 02322

We Have

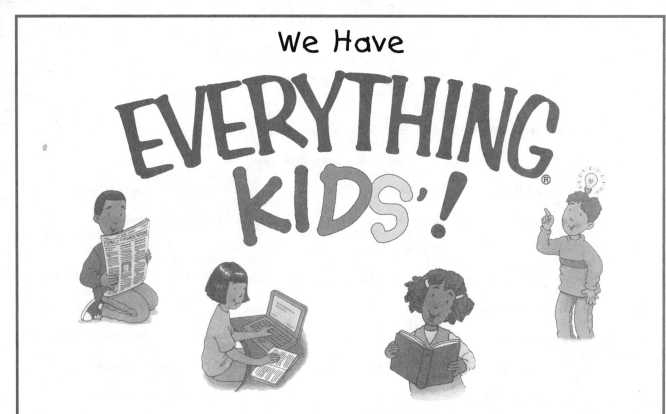

EVERYTHING KIDS'®!

Everything® Kids' Baseball Book $9.95, 1-58062-489-8	Everything® Kids' Online Book $9.95, 1-58062-394-8
Everything® Kids' Joke Book $9.95, 1-58062-495-2	Everything® Kids' Puzzle Book $9.95, 1-58062-323-9
Everything® Kids' Mazes Book $6.95, 1-58062-558-4	Everything® Kids' Science Experiments Book $6.95, 1-58062-557-6
Everything® Kids' Money Book $9.95, 1-58062-322-0	Everything® Kids' Space Book $9.95, 1-58062-395-6
Everything® Kids' Nature Book $9.95, 1-58062-321-2	Everything® Kids' Witches and Wizards Book $9.95, 1-58062-396-4

Available wherever books are sold!

For more information, or to order,
call 800-872-5627 or visit everything.com

Adams Media Corporation, 57 Littlefield Street, Avon, MA 02322

Everything® is a registered trademark of Adams Media Corporation.